American Bisque

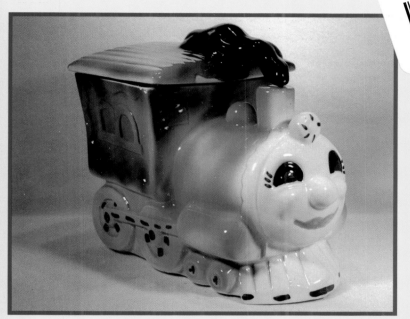

A COLLECTOR'S GUIDE WITH PRICES

Mary Jane Giacomini

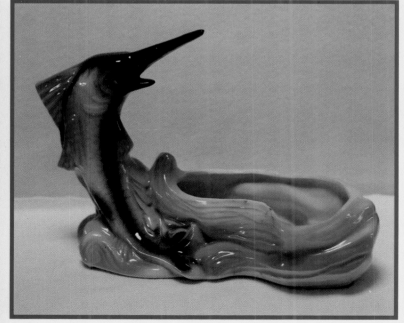

Schiffer Publishing Ltd

77 Lower Valley Road, Atglen, PA 19310

Dedication

To my husband Mark, life companion, best friend and photographer. The man who has never said, "NO"! Just smiled, nodded and said, "GO"! Everyone should be so lucky.

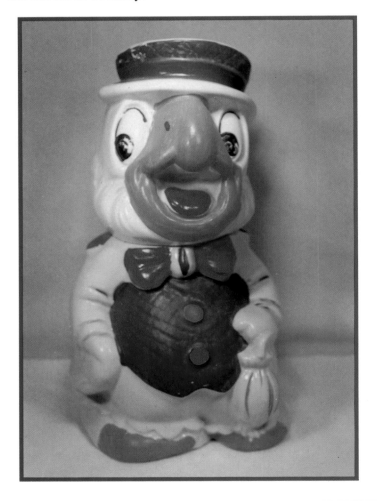

Printed in China
ISBN: 0-88740-623-8
We are interested in hearing from authors with book ideas on related topics.

Published by Schiffer Publishing Ltd.
77 Lower Valley Road
Atglen, PA 19310
Please write for a free catalog.
This book may be purchased from the publisher.
Please include $2.95 postage.
Try your bookstore first.

Contents

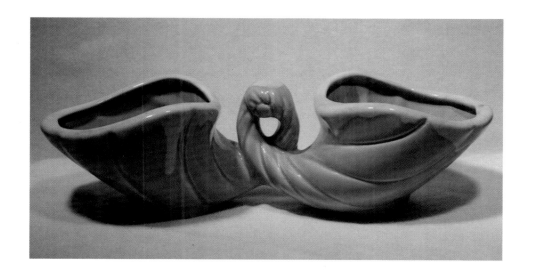

Acknowledgements

We found in the course of writing this book that no one person can know or own everything. Our thanks go out to those special people who assisted us by picking up pieces or by telling us where to find leads. We thank all of you for your sharing spirit - most especially the following people:

Our children; Melanie, Dean and Voni who managed to grow to adulthood in a home full of "Early American Funk," special gratitude for never hosting a party (that we are aware of).

Lou and Nanci Moore friends and traveling companions for decades, who think nothing of making an $8 phone call cross-country to see if they should spend $8 on a planter they believe to be missing from our collection.

Tim Pratt who sent "Little Mo" the Mohawk Indian cookie jar on an unannounced overnight journey 2,500 miles across country to live with us - just because Tim thought he belonged in our collection.

Charles & Rose Snyder of Charlie's Collectibles and Keith & Judy Lytle of Cookie Jar Antiques - special friends and business competitors who willingly share their knowledge and continually find great pieces for our collection.

Betty & Floyd Carson who have added some of the harder to find pieces including the Piggy wall hanging banks now known as "Betty & Floyd". Betty's willingness to provide information to anyone who asks has been a dream come true to collectors and authors alike.

Paul Jeromack long time cookie jar collector and researcher extraordinaire, who gladly shared every piece of research material he had tucked away and "ran" us through the 26th St. Flea Market.

Dennis and Arlene Roth our friends and New Jersey home base who shared their collection, home and hospitality. They taught us how "New Jerseyite's" take "people bags" into a restaurants instead of "doggie bags" out.

Steve Horelica self-proclaimed non-camera person who got us the shot we needed.

William Schneider Sr. long time sales representative for American Bisque and his son Bill Jr. who shared a wealth of experiences, knowledge and trade materials.

Denise & Bud Teeters and Anna & Harry Yoder who always provide the best entertainment and food in Ohio.

Shelda Cloud for sharing her mother, a former American Pottery Company employee, and an eye-opening collection.

Our extended family at Schiffer Publishing, most especially fellow author Mike Schneider who always came to the phone, listened patiently and kept our feet on the ground.

Last but foremost on our mind is the Johnston family of Brooklyn, New York. This book would have been something very different without Wendy and John's contribution of the country's best collection, research, time, energy, love, a good supply of California wine and the introduction to a variety of ethnic foods not soon to be forgotten. We give special thanks to Oscar, who gave us his room for more than a week and sat quietly while we took photos, teaching us about patience and proper demeanor in the presence of pottery. It's difficult to know whether the company, outings, food or the pottery collection was the best, but for sure the dinner with Mel Gibson was an incredibly outstanding surprise experience. ENCORE!

Introduction

This book is a beginning - far from the end. It was inevitable, initially beginning simply to catalog our own collection. Friends and acquaintances with the same field of interest have commented that a book on American Bisque was long overdue ... only to come back with, "It's so confusing, such a tangle of potteries, who will ever be able to figure it out." Amen! We have driven over 9,000 miles, queried, searched, phoned, photographed and done everything possible to acquire what is printed here. Though this is a fair representation, we are sure previously unknown pieces are being found every day and we welcome further input and enlightenment on the subject.

Pottery was not our first collection. We have been spending our weekends at flea markets, street fairs and antique and collectible shows for many, many years, collecting everything from ruby glass to vintage vehicles.

One day my mother brought us the cookie jar from my childhood, Smily Pig, made by Shawnee Pottery. Smily was granted a place in the kitchen atop the cabinets but he looked a little forlorn sitting there alone. At a street fair, in search of ruby glass we came upon an American Bisque cookie truck. Later on during the same day we found a Milk Wagon. Smily Pig was granted two new companions and our cookie jar madness began. That was well over a decade ago. Way back then we had never even heard of potteries named American Bisque, American Pottery, Leeds or Ludiwici Celadon, let alone know that the cookie truck and the milk wagon were produced in the American Bisque factory. All we knew was that we loved the style and colors of the jars and they were too reasonably priced to pass up. Note: If you don't intend to collect, don't ever buy two of anything.

Typical of new collectors, we bought just about every affordable cookie jar we saw. We bought jars we didn't even like just because they were cookie jars. We suppose, like most new collectors, we were playing a numbers game. We had family members, friends and mere acquaintances bringing us cookie jars. In a very short time it was apparent that we were completely out of control, and so was our cookie jar collection. Every minute of our spare time was devoted to cookie jars, also every nook, shelf and corner of the house. We never in our wildest dreams thought so many cookie jars could be in existence. Our kids started to frown and mumble in hushed voices every time new jars came through the door. There were even days when the kitchen counters and the dining room table were so covered that we had to shuffle jars to the floor just so we could cook and eat. Space, having become a real problem, led us to focus and define our collection.

This was our turning point and the point when we turned to American Bisque. It was an easy choice for us. The cookie jars were easily identified by the wedge bottom, the colors were usually bright and cheerful, the designs were wonderful and the jars were fairly plentiful. The added bonus was that they were made in the U.S. and were in our price range. The decision was made to sell or trade every cookie jar in our collection that was not American Bisque. Thus began our cookie jar business. We admit with regret that we even sold off some of our American Bisque "keepers" thinking we'd find them again quickly, only to have years pass before they finally came home to stay. Live and learn!

We made phone calls to dealers and other collectors. We queried authors; we were STARVING for information about American Bisque. Just about everyone we talked with had about the same knowledge we did: a large pottery in Williamstown, West Virginia, somehow mixed up with a couple of other potteries, "Oh well, who knows - but its nice stuff."

Once we started to have problems either finding or affording cookie jars missing from our collection, planters and other pieces satisfied our collecting habit. Our cookie jar collection became an American Bisque obsession. Finding something new still puts us on a natural high and cookie jars seem to have taken a back seat to many other pieces we have found.

We have included a collective sampling here and believe the pottery has been well represented. Still, we find new pieces on a fairly regular basis and believe many more exist. These wares were typical dime store/chain store offerings and are plentiful. If it looks right, feels right, is consistent, and doesn't cost a months rent - take a chance, you probably won't be sorry.

More than anything this book is intended to be an identification guide. The pottery shown in the pages to follow can be found in almost any shop or mall from coast to coast misidentified and mislabeled as Royal Copley, Shawnee, Hull, Shafer, USA Pottery and sometimes even McCoy. Enough! Probably the most unsung potteries ever in existence, American Bisque and affiliated potteries deserve to be recognized and identified for what they are.

We have tried to include sizes and footing style to aid collectors. With our use of single photo identification it may be difficult to discern, for example, the difference in size between a cookie jar and a bank. Hopefully measurements will help. We also hope sizing will help collectors with authentica-tion even though some size variation is normal merely because of different firing temperatures and different clays. Watch out for **unmarked** reproductions, especially of the more expensive character cookie jars.

Cherish every piece, they are part of the American dinosaur family of pottery. Environmental standards, labor costs and general government over-regulation will probably never allow us to see the likes of these pieces produced again in the United States.

Above all *SHARE* your knowledge with fellow collectors.

Sales brochure handed out at New York Gift Show, 1974

History of American Bisque

During the years American Bisque was in operation it was linked to and interlaced with a number of other pottery companies. Reconstructing company history is analogous to building a house without a blue print, confusing is an understatement. For this reason, we are approaching the history of the company in the manner that a genealogist might try to reconstruct a family tree, one branch at a time.

operation in the factory and firing required ten days. The wares of the day were produced by pouring liquid clay, also known as slip, into molds and also using a process known as jiggering. By 1935 Mr. Allen had invested in a modern circular continuous kiln which reduced firing time to one day thus enabling more efficient production.

WILLIAMSTOWN, WEST VIRGINIA

Williamstown is centrally located so as to conveniently serve the nation's principal marketing areas. We are also fortunate in being located on Interstate 77 North and South, which gives us the advantage of good commercial trucking facilities.

The main company, and the oldest dealt with here, is the American Bisque Company. American Bisque began operation on the Williamstown, West Virginia bank of the Ohio River in 1919. Commonly referred to in the Williamstown area at that time as "The Doll Factory", American Bisque produced the popular Kewpie doll in a six inch size. Previously a product of Germany, World War I import restrictions stopped the flow of dolls into this country. By 1921 the company had expanded its product line and added vases, planters and lamp bases.

In 1922 Mr. B.E. Allen a part-owner of the Sterling China Company of Wellsville, Ohio purchased American Bisque. The pottery at this time had fifteen employees. Three beehive kilns were in

Beginning January 18, 1937 and continuing for several days the Ohio River rose until its banks could no longer hold the swell. The result was 10 feet of water inside the American Bisque Factory. All materials, molds and inventory became a total loss. Mr. Allen began again and added banks, cookie jars, planters, vases and flower pots to the product line.

Fire, an ever present threat to all pottery companies, arrived on July 28, 1945 and the factory burned to the ground. Once again Mr. Allen undertook the task of rebuilding the factory. This time adding new kilns, including a decorating kiln and a ram press which replaced casting from molds. This is the approximate time frame in which we add a branch to the family tree of potteries.

Stoin-Lee Pottery of Byesville, Ohio incorporated in 1942. By 1944 it was under the control of a gentleman named Joseph Burgess Lenhart. Mr. Lenhart changed the name from Stoin-Lee to American Pottery Company and opened a second pottery in Marietta, Ohio across the Ohio River from the American Bisque factory in Williamstown. Now there are two potteries in the family tree operating in

was also referred to in the area as "The West Side Pottery" and "The Marietta Pottery". These two companies operating at fifty/fifty ownership probably handled each others overflow.

The Ludiwici Celadon Company of New Lexington, Ohio was a producer of expensive roofing tiles. World War II came along and the country held building in abeyance while devoting itself to the war

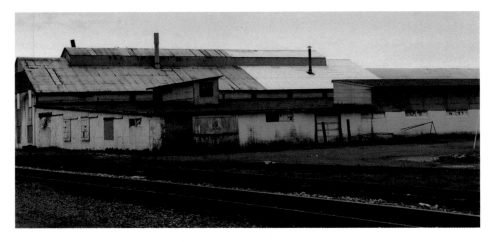

A side view of the building inhabited by American Bisque Pottery, Williamstown, West Virginia as it looks in 1993.

three locations: American Bisque Company in Williamstown and American Pottery Company in Byesville and Marietta. During this time Mr. Lenhart not only owned the American Pottery Company but functioned as the Sales Manager for the American Bisque Company. The two companies became further interlaced when Mr. Lenhart sold half of his interest in American Pottery to A. Neal Allen, son of American Bisque owner B.E. Allen. Product lines included mixing bowls, covered casseroles, tea pots, refrigerator storage containers and wall-pockets. During its operating years the American Pottery Company which was located in Marietta on Westview Avenue

effort. Demand for building materials, including roofing tiles, dropped and Ludiwici like many other companies producing tiles began producing other products to survive. Ludiwici began production of cookie jars, salt and peppers, creamers & sugars, etc. in 1941 and continued into 1945. Amazingly enough 70 people were employed to produce these new products. With the end of the war came the building boom. Ludiwici ceased production of cookie jars and the other pieces that sustained them and returned to the roofing tile business. At this time many, if not all, of Ludiwici's molds were sold to American Bisque and American Pottery. Some of the designs were

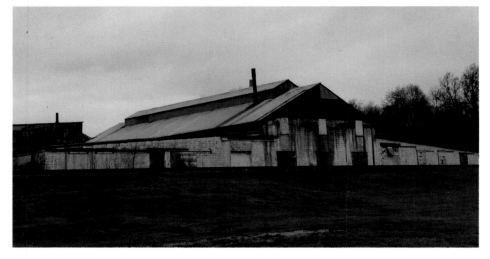

Frontal view of the American Bisque Pottery building in 1993 from the river side.

modified slightly before use, most probably because of the use of the ram press rather than casting from molds. With the addition of the Ludiwici designs to American Bisque Company, we now add Ludiwici Celadon to a branch of our family tree.

The main designer for American Bisque for roughly a decade was Mr. Al Dye. Mr. Dye was employed from sometime in the 1960s through the early 1970s and he did drawings as well as prototype molds. It is believed that Mr. Dye also designed for the American Pottery Company for a time.

It has been previously recorded that for several years the entire output at American Bisque was a ware produced in brown glaze with a white drip edge. These pieces were apparently sold by grocery store chains as premiums. Regrettably we have no examples of this ware.

Joseph Burgess Lenhart resigned from American Pottery Company in 1961 and the company was sold. Mr. John F. Bonistall became president and general manager in 1962 and remained in that capacity until 1964. Mr. Bonistall formerly of the Shawnee Pottery Company, Zanesville, Ohio owned Terrace Ceramics, Inc. of Marietta, Ohio simultaneous to his employ at American Pottery. Mr. Bonistall and Terrace Ceramics became the sole distributor for the products produced at the American Pottery Company until it went out of business in 1965. Terrace Ceramics then moved its operation from Marietta to Zanesville, Ohio.

The two decades between 1955 and 1975 must have been landslide sales years for pottery. As an indication we are including a chart showing the sales to chain stores in New York by Mr. William Schneider Sr. Mr. Schneider originally worked for the George Borgfeldt Corporation and in the early 1950s became associated with Colonial Glass Company, Weston, West Virginia and American Bisque Pottery as a sales representative. Mr. Schneider specialized in selling to chain stores only. Mr. Schneider's sales record for the year 1974 is included

American Bisque Company 1974 New York Chain Store Sales William Schneider, Sr.	
9.6% Grant	$66,484.30
51.5% Kresge	$355,274.09
8.7% McNew (includes Britts)	$60,198.10
4.6% Murphy	$31,995.86
9.4% Pennys (includes Treasury Stores)	$65,000.27
1.2% Roses	$8,502.60
.98% Thrift (includes Treasury Drug)	$6,789.00
13.8% Woolworth	$94,975.69
99.78 Totals	$689,219.91
Kresge: Ratio of 7000 to 1000=4:1 20,435 dozen to 5,452 dozen	

here to illustrate the incredible amount of pottery put into circulation. These sales figures represent wholesale prices and items were sold by the dozen. S.S. Kresge appears to have been the top mover of American Bisque Pottery in New York.

Vice President and General Manager for American Bisque Mike O'Brien began his career with the company in the early 1960s and ended it in the early 1980s, shortly before the sale of the company. Mr. O'Brien was responsible for giving the "go ahead" on many of the production pieces. He would often show a sample to his sales staff and ask for input as to whether they thought it would sell or not and if they thought any modifications would be necessary.

Three more companies join our family tree. They are G.C.Shafer Company, Zanesville, Ohio; Cardinal China Company, Carteret, New Jersey; and Leeds China Company, Chicago, Illinois. These companies, though not manufacturers of the pottery pieces being dealt with here, can definitely be considered collateral family.

Some of the pottery pieces can be found marked Shafer 23k gold guaranteed. G. C. Shafer Company acted as a decorator and it was their function to apply gold to pottery pieces. Many pieces laden with gold bear the Shafer stamp. American Bisque and American Pottery also had decorating kilns, thus having the ability to apply and fire gold and decals in-house but because of the Shafer mark it is obvious that some jobs were contracted out or pieces were purchased directly by Shafer for resale after decoration.

Leeds China Company was a distributor licensed by Walt Disney Productions to produce Disney's characters in pottery form. We know some of these pieces were produced by American Bisque, American Pottery, Ludiwici Celadon, Regal China and Ungemach Pottery Company. Ungemach, though not directly related, produced pottery that can easily be confused with the pottery pieces we are dealing with. There may also have been other potteries involved that we are not aware of. For this reason Leeds China Company is being treated as a separate entity. (See Chapter 9)

Cardinal China Company was also a distributor of pottery. Pottery pieces identified as Cardinal in these pages were made in the American Bisque factory.

The year 1968 brought a brand new American Bisque product line to the marketplace which included ashtrays, hanging pots, candy dishes, salad sets, tiered serving trays, etc. These pieces were brilliantly colored and introduced and marketed under the name of Berkeley ware with a clover logo and Sequoia ware with a tree logo. "Berkeley" was sold in chain stores such as S.S. Kresge and "Sequoia Ware" was sold in gift shops.

The American Bisque Company was sold in August 1982 to a man named Bipin Mizra who produced serving dishes for Eastern Airlines. Mr. Mizra changed the pottery name to American China Company and operated for only a couple of years before going out of business.

Identification

Most American Bisque and American Pottery pieces can easily be identified by the "wedges" on the bottom. Each unglazed wedge shape is also known as a dry foot. The foot is a portion of the pottery piece left unglazed so that when kiln firing takes place the item will not stick to the kiln shelf. Glaze which is actually a form of glass liquifies and if placed directly on the kiln shelf or floor will adhere. Pottery made with totally glazed bottoms require "stilting" or placing of a three or four footed stilt to keep the glaze off the kiln floor. Pottery made with a dry foot saves the extra step of stilting.

Initially we thought every piece of pottery produced had wedges on the bottom. Not so. Many pieces can be found with totally flat bottoms, circular footing, outline footing and generally in the case of salt and pepper shakers a "U" footing.

We have been told that most all pieces started with wedges, the result of pressing rather than pouring the form. Many of the wedges were removed thus producing a flat bottom. Pottery once poured or pressed and allowed to sit is called greenware. Greenware is nothing more than dried clay and it is very fragile until it is fired. Before firing, greenware is trimmed. This is accomplished by the use of trimming tools and a wet sponge. Seams are trimmed or scrapped away and smoothed with a damp sponge. An over zealous or inexperienced trimmer could scrape or wash away so much clay that the piece became wobbly or unbalanced. Thus more trimming was required to get a piece to sit flat. This solves the mystery of why identical pieces can be found with wedge bottoms as well as flat bottoms.

Unless indicated in the photo description, the reader can assume all the pottery pieces have a wedge bottom.

"U" foot with stopper hole of a bank.

"U" foot of a Santa Claus mug.

Wedge bottom with double sets of holes on a bank.

Full outline footing on the base of a cookie jar.

Triple wedge bottom on a planter.

Wedge footing on a cookie jar.

Triple wedge bottom on a train cookie jar.

Wedge bottom of the Saddle cookie jar.

Wedges of a planter.

Condition

Let's start by recognizing that unless you have tapped into some secret stash or warehouse find, the pottery pieces we are dealing with here are used or second hand merchandise. Pieces will be found in varying conditions which range from broken, repaired, restored, chipped, cracked and crazed to good, excellent and occasionally mint. It is not realistic to believe everything can be found in mint condition. If you want mint perfect you should be buying new pottery at the local department store, not collecting someone else's old "stuff". Sounds harsh but it is reality, collect using good common sense.

Collectors need to make a conscious decision as to what condition they are willing to accept. Ideally, mint is what we want but since this is not always possible we need to take rarity and price into consideration.

Pieces with damage do not command full price. Prices should be reduced accordingly. Cold paint, in our opinion, should not be a factor at all. Any piece with cold paint detail that was washed any number of times now has the paint missing. We personally like pieces to look like they were intended to look and feel any cold paint detail should be replaced *skillfully*. We also do not believe this devalues a piece. Please note in our estimation artistic license is NOT appropriate. The repainting should be in the exact likeness of the original. If the mouth on a clown, for instance, had red paint, pink is not an appropriate replacement. Repaints should always be labeled accordingly when being bought or sold.

Crazing, in our opinion, has very little to do with value. It goes with the territory. Age and extreme exposure to heat and cold will cause crazing. The only time we believe crazing enters into loss of value is when the lines are very dark and stained. This is often evidenced in the bottoms of cookie jars. Cookies baked with butter, lard and heavy shortening and stored in cookie jars in hot kitchens were the worst offenders. Often one only needs to lift the lid of the jar to know what awaits them, the heavy grease odor will tell you the bottom has very dark discoloration with heavy crazing without ever looking inside. Someone recently told us they bought a cookie jar that was obviously used for crayon storage. We laughed, that's exactly the smell we are talking about.

There are some hot controversies over restoration of pottery pieces. Some people are quite accepting of restorations while some find it perfectly abhorrent. Though we are not intending to "ride the fence" on this issue we can see both sides. Restoration by a reputable professional is generally expensive. There is absolutely no reason to pay $25 to have a rim chip repaired on a planter worth $15, unless you have some undying need to own that particular planter. It is our belief that a professionally restored piece will bring about 85% of full value and regardless of whether the piece is being bought or sold it should be represented as restored.

Pieces decorated with 22k - 24k gold generally command 50% to 100% more in price than plain pieces. However, the price should also reflect the condition of the gold. Only a minimal price increase is warranted if the gold is very badly worn.

Hairlines reduce value anywhere from 25% to 40%, open cracks about 75%. Chips on the outside that show reduce value about 40% and inside about 15% to 20%.

Would we buy a broken Casper the Ghost bank? Yes! If the price was commensurate with the damage we would buy and restore it. Why? Rarity! Would we buy a broken Coffee Pot with Pine Cone decor cookie jar if the price was commensurate with damage? No way! They are plentiful and another will come along. Professional restoration is an art. Although most thirteen year old children could fill a chip given the proper material and instruction, the matching of color and painting are totally different ball games and require someone who really knows their craft. If you want to consider restoration, get references from someone you know. If that is not possible, consult the yellow pages then follow up with a visit so you can look at the work the professional is doing. Ask for an estimate before the work is performed. There are both good and bad restorations to be had.

Choose Wisely!

Planters

Planters provide a lot of fun because of the diverse variety available. They are very plentiful and affordable even on a modest budget. They also require minimal space for display. Many of ours still bear the original retail price marking of $.39, $.49 and $.59.

We found our collection of planters growing into many little sub-collections. One grouping of cats, one of bears, one of birds, etc. Most styles can be found in an assortment of colors as well as with and without 22-24k gold accents.

Unless indicated, all planters pictured are on wedge bottoms.

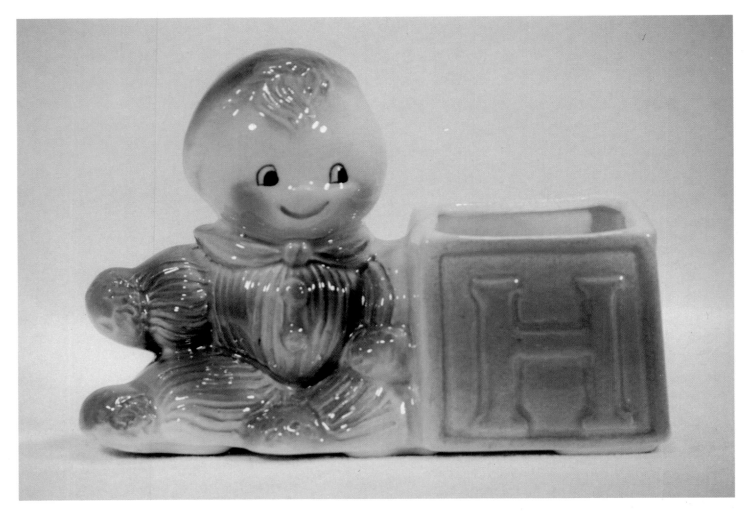

Yarn Doll with Block. Unmarked, 5 3/4". Other colors available.

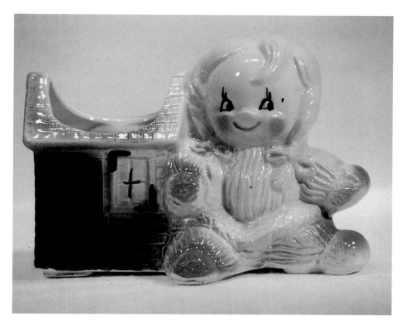

Yarn Doll with House. Unmarked, 5 1/4". Other colors available.

Whether an Elf or Leprechaun this little fellow looks quite comfy on his mushroom. Unmarked, 6".

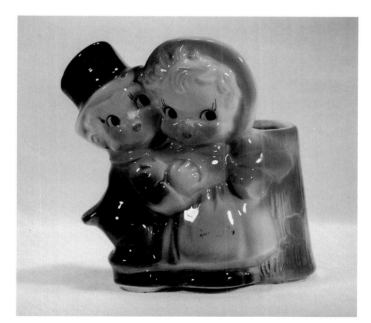

Winter Couple. Unmarked, 7 1/2".

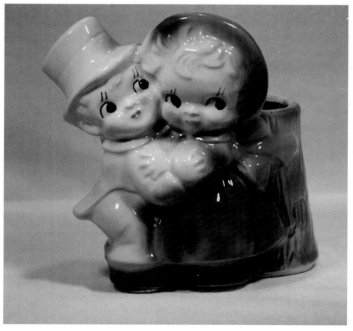

Winter Couple, another color scheme.

A complimentary piece to the next planter, the Elf figurine stands 3" on a flat open bottom. Unmarked.

The Reclining Elf. Unmarked, 2 3/4".

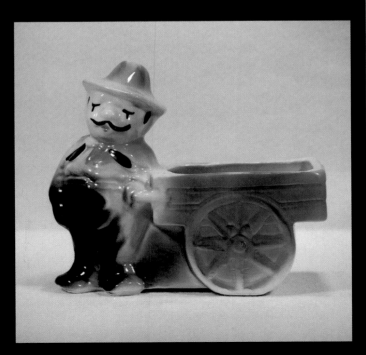

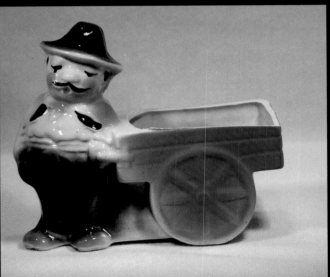

Same planter in another color scheme.

Gypsy with Cart. Unmarked, 6".

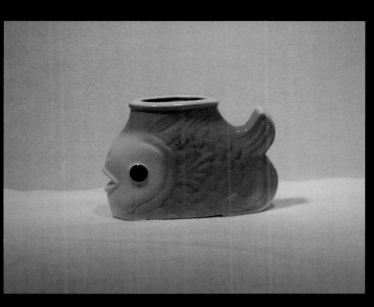

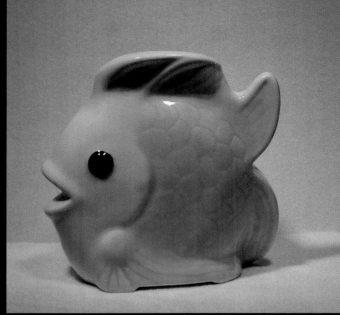

Fish made by APCO. Unmarked, 6".

Fish made by APCO. Unmarked, 3 1/4".

Not the most attractive Fish, this green variety is unmarked, 3 1/2".

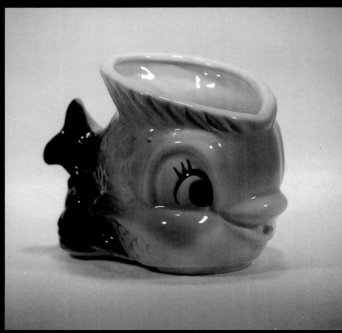

The Happy Fish. Unmarked, 4 3/4". Also found in other color schemes.

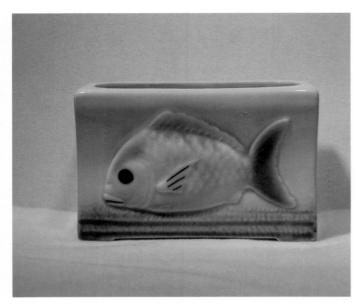

Rather than being figural this Fish seems to have grown to fit the aquarium. Also made by APCO, this planter sits on a rectangular footing and measures 6"w X 4"h. Unmarked.

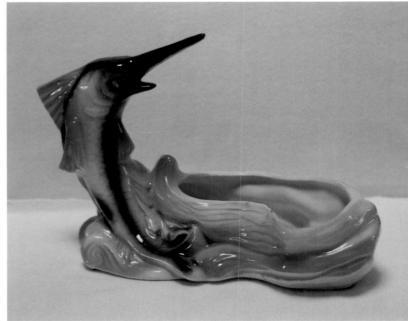

The Sailfish. Larger than it appears it is unmarked and measures 8"h X 10 1/2"l.

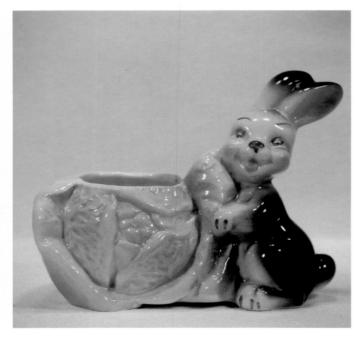

The Happy Rabbit. Unmarked, 5".

The Rabbit in the Log. Unmarked, 5 3/4".

The Circus Horse. Unmarked, 7".

Mare and Foal. Unmarked, 5 3/4".

The Bashful Donkey. Unmarked, 5 1/4".

A Horse of a different color. Made by APCO it is unmarked, 6".

The Whimsical Donkey. Unmarked, 6 1/2".

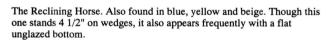

The Reclining Horse. Also found in blue, yellow and beige. Though this one stands 4 1/2" on wedges, it also appears frequently with a flat unglazed bottom.

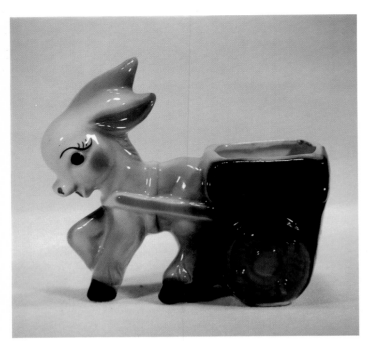

The Donkey with Cart. Unmarked, 6 1/2".

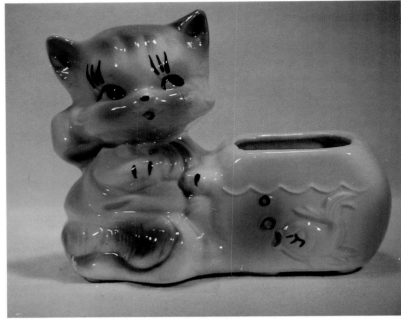

Same planter with brown and white Kitten. Also 6" this one is unmarked.

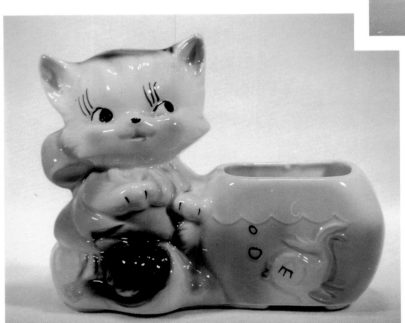

Grey and White kitten with Fishbowl. Marked "USA", 6".

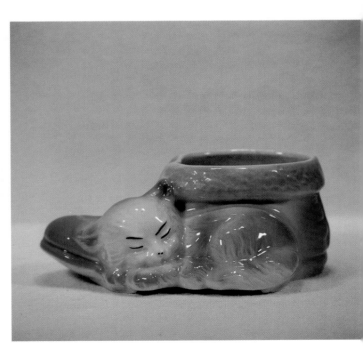

Sleeping Kitten with Slipper. Unmarked, 2 3/4".

Same as the previous Kitten with Slipper, different color scheme.

Another Wailing Kitten. This one is marked "USA".

The Wailing Kitten. Unmarked, 5 3/4".

The Kitten and Shoe. Marked "USA", 3 1/2"h X 6 1/2" l.

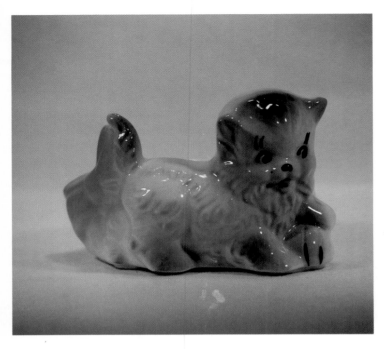

Brown and white Kitten with Ball. Marked "USA", 4".

Another version of "Figaro", this one decorated with an airbrush. Unmarked, 5".

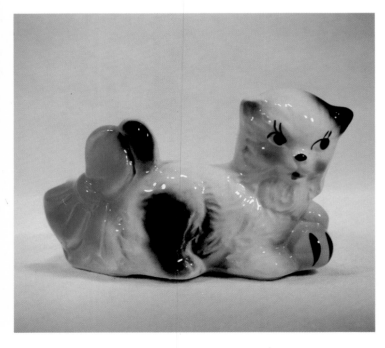

Note the subtle differences between this Kitten with Ball and the previous one. Unmarked it also measures 4".

Our little friend "Figaro" appears here in greenish brown. Also available in yellow. Unmarked, 6". (see Chapter on Families for further information).

The Spaniel with Basket. Made by APCO. Marked "USA", 5 3/4".

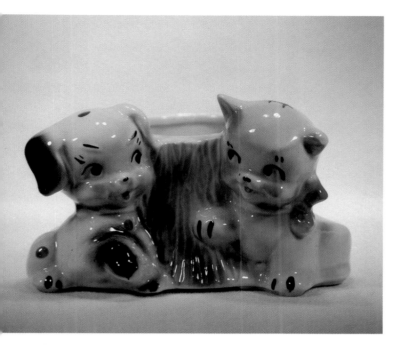

Dog and Cat at Stump. Marked "USA", 4 1/2".

Another color variation of the Spaniel with Basket, this planter is slightly larger at 6 1/4" and is unmarked.

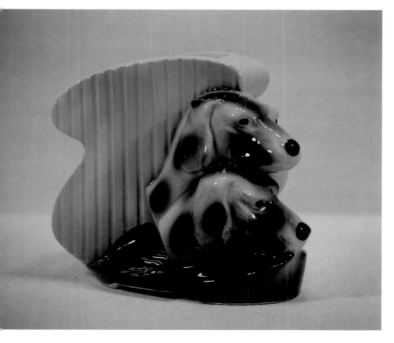

Dalmatians. Unmarked, 5 1/2".

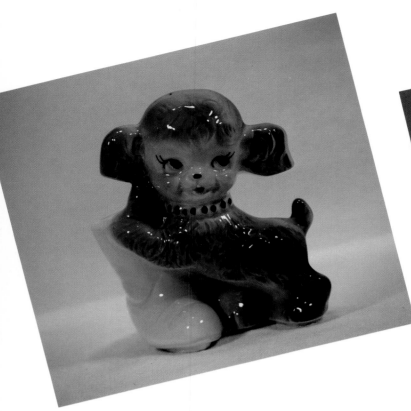

The Puppy with Slipper. Unmarked, 5 1/2".

The Puppy planter is decorated entirely in 22-24k gold. This particular one was made by APCO. Unmarked, 3 1/2".

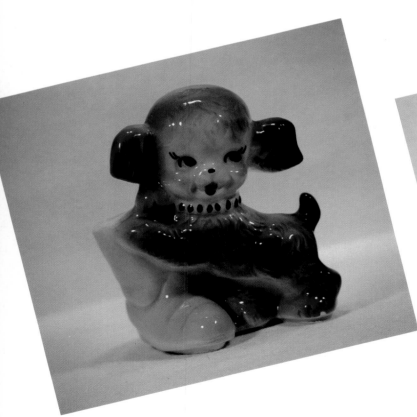

Identical to the previous planter this one has an alternate color scheme and is marked "USA".

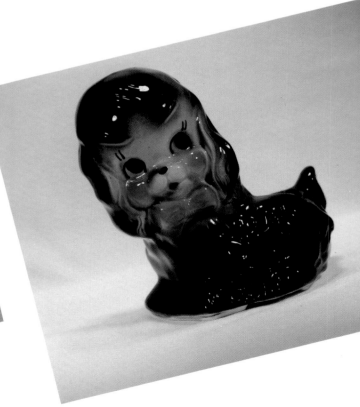

The Poodle planter is a nice size at 7", unmarked.

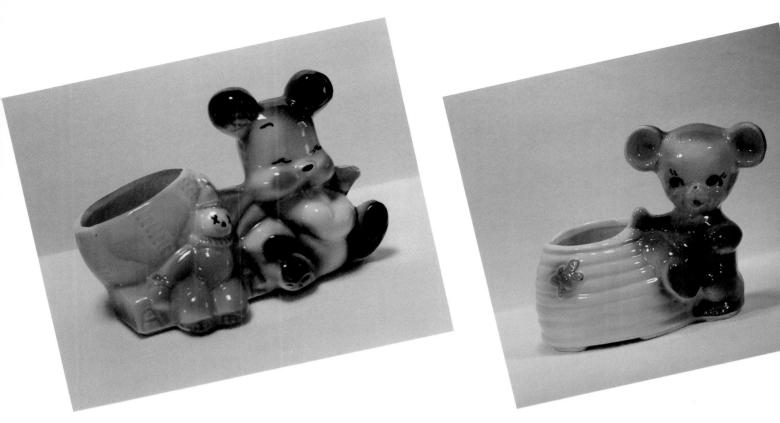

This planter seems to contain all the elements required to make a youngster happy, a stuffed bear, clown rag doll, blocks and baseball. Unmarked, 5 1/4".

The Bear with Beehive planter makes us wonder if there might also be one with a kitten as it would make a wonderful match to the Kittens on Beehive cookie jar. Unmarked, 5 3/4".

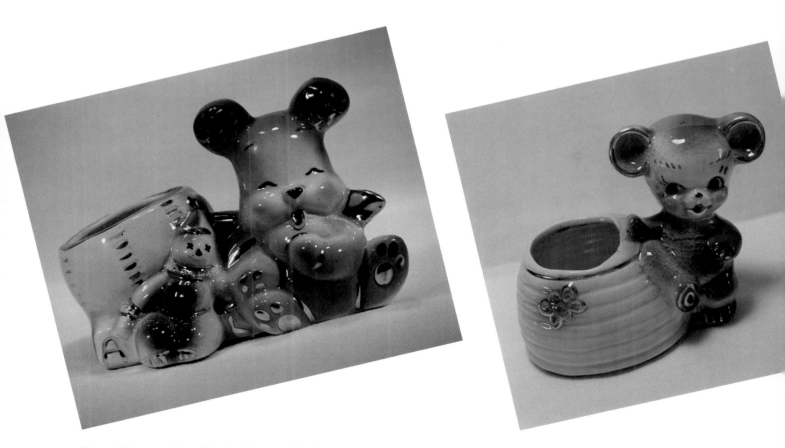

What a difference a little gold makes! Compare this planter to the previous one.

Once again - what a difference a little gold makes!

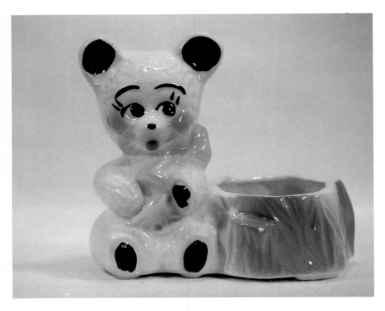

This Bear at the Stump can also be found with airbrushed detail on the bear rather than the solid black. Marked "USA", 6".

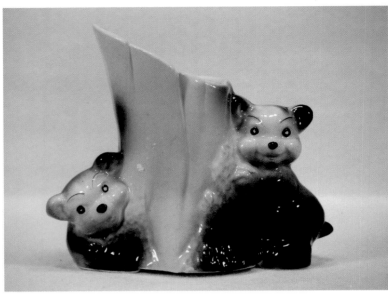

Black Bear Cubs on the Tree. Unmarked, 5 1/2".

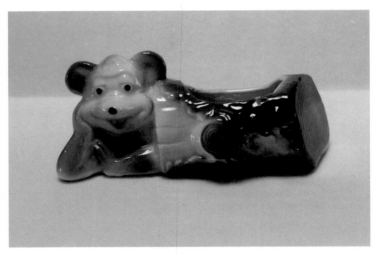

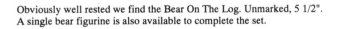
Looking as though he's ready to settle down for a long sleep the Bear in the Log planter measures 3"H X 7"L and is unmarked.

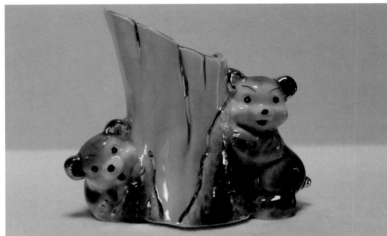

Gold detail adds sparkle and character to the cubs.

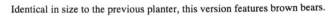
Obviously well rested we find the Bear On The Log. Unmarked, 5 1/2". A single bear figurine is also available to complete the set.

Identical in size to the previous planter, this version features brown bears.

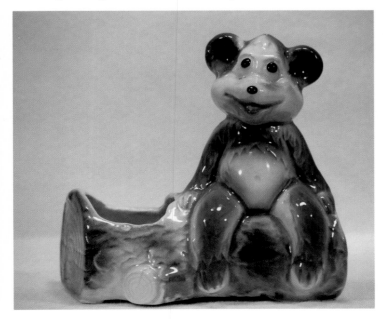

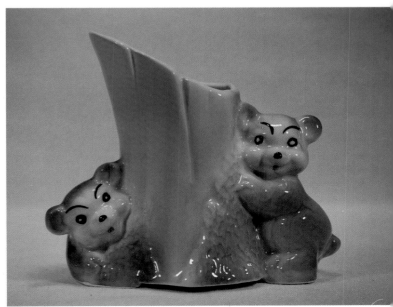

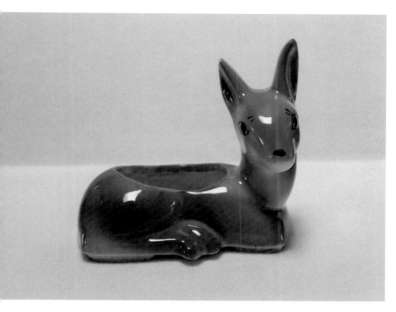

Reclining Deer. Made by APCO. Unmarked, 5 3/4".

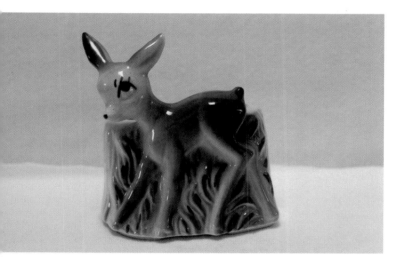

Deer. Marked "USA", 5 1/2".

Just slightly larger than the previous deer, this one stands 5 3/4" tall, the added color detail makes it appear very different. Unmarked.

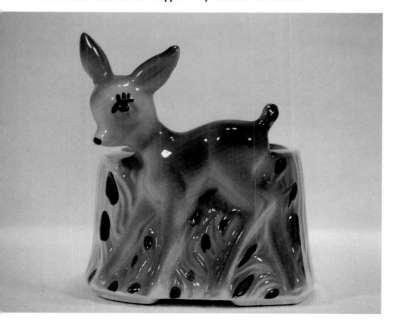

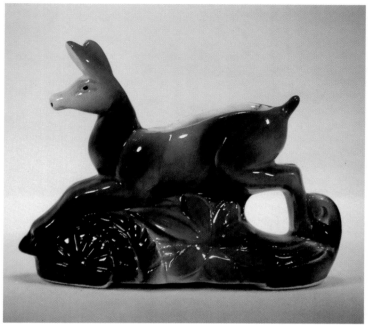

Gazelle. Unmarked, 5 1/4".

Again the Gazelle appears, this time with a huge flower bloom. Slightly shorter at 5" it is also unmarked.

Similar to the Gazelle, the Black Panther also appears to be sitting astride a large flower bloom. Unmarked, 5".

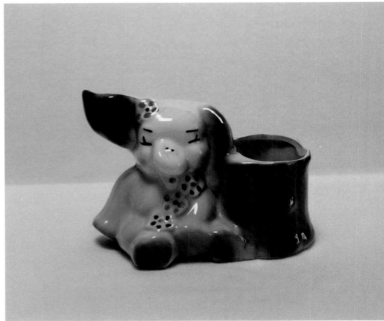

Little Elephant. Marked "USA" this 4" planter has a flat bottom.

Another version of the Panther. Unmarked, 5 3/4".

Elephant in a Basket. Unmarked, 3 3/4".

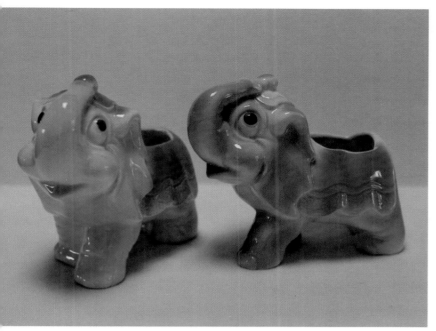

A fine pair of Circus Elephants. Unmarked, 5 1/2".

Farmer Pig with Corn. Made by APCO. Unmarked, 6 1/2".

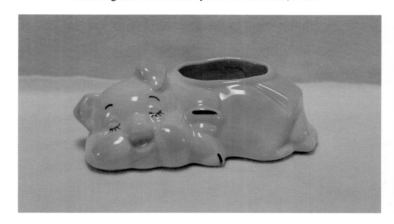

Wearing a yellow dress the Sleeping Pig is also available in green, blue and burgundy. Marked "USA", 2 1/2", this planter was made by APCO.

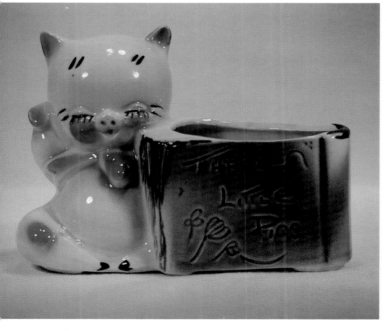

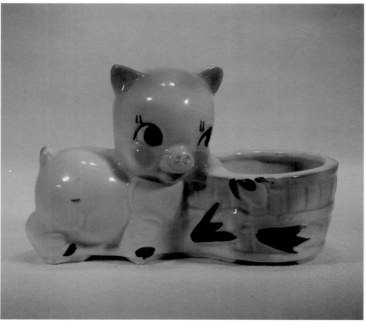

The Three Little Pigs. Unmarked, 5 1/2". Other color schemes available.

Little Piggy with Wooden Basket. Unmarked, 4 3/4".

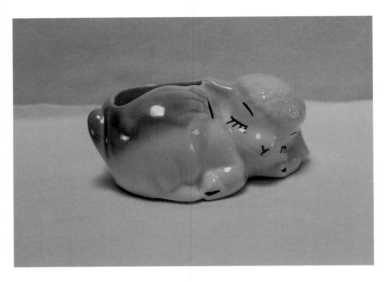

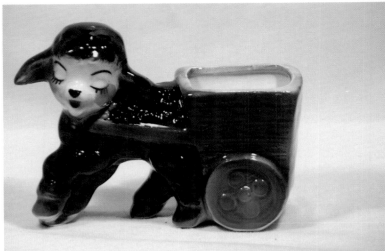

Similar in styling to the Sleeping Pig, the Sleeping Lamb also made by APCO is 3" and unmarked.

Similar cart, different animal. The Lamb with Cart is unmarked, 4 3/4".

Don't let the size of the photo deceive you. The Lamb planter measures a full 11 1/2"L X 6"H. Unmarked.

Little Lamb. Unmarked, 4 3/4".

Lamb with the Watering Can. Unmarked, 6 1/2".

Same as the previous Lamb with slightly different decor.

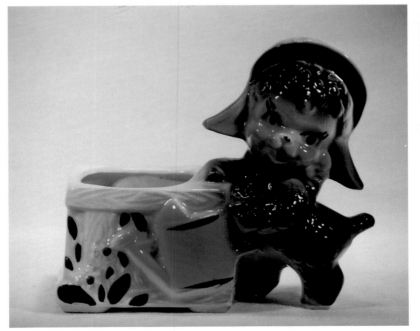

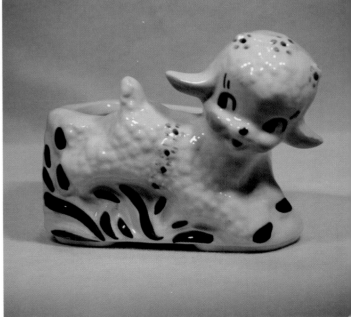

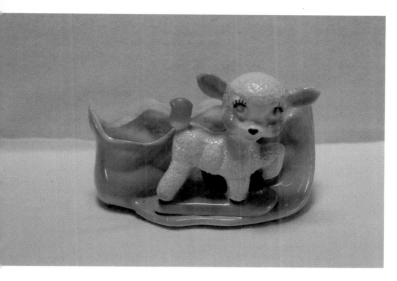

We're guessing this Lamb is standing in front of a sack. Marked "USA", 5 1/4".

The base on this planter is similar to many others. This Reclining Lamb is unmarked, 4".

Heavy gold decor adorns Bird with Blossom. Unmarked, 4".

The Parakeet is available in other color schemes. Unmarked, 6".

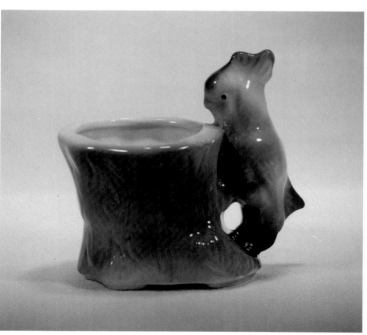

Cockateel on the Stump. Unmarked, 5".

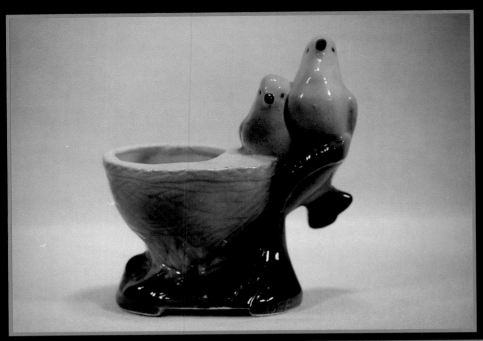

Must be Lovebirds. Unmarked, 6 1/2".

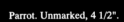

Parrot. Unmarked, 4 1/2".

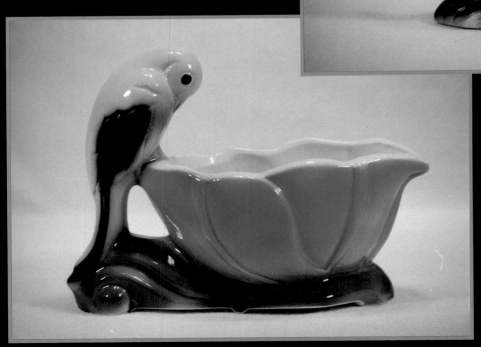

Bird on the Blossom. Unmarked, 5 3/4".

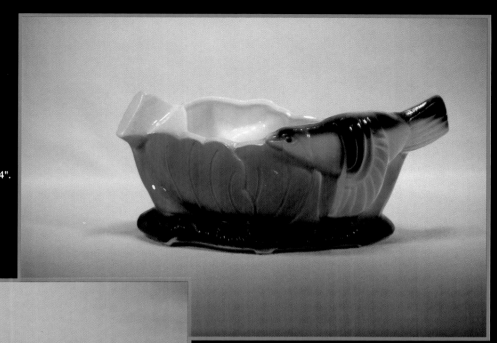

Bird in Flight. Unmarked, 4".

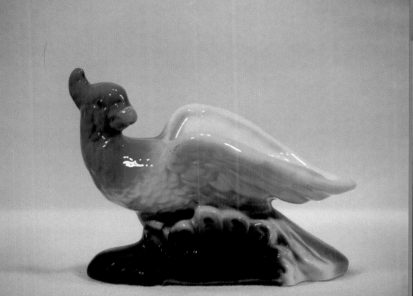

Another color scheme.

Bird of Paradise. Unmarked, 5 1/4".

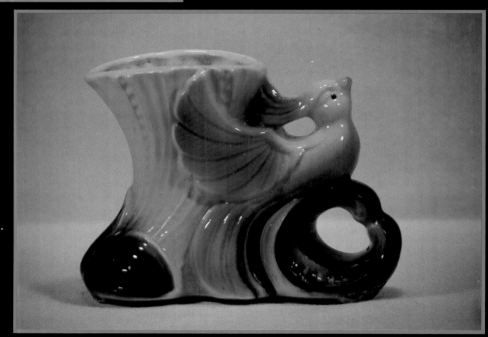

Another color variation.

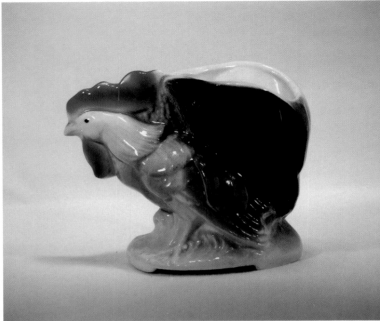

Rooster. Unmarked, 5".

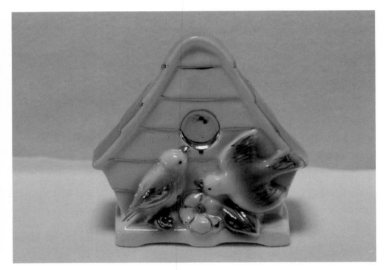

Birdhouse Wallpocket. Also found without the gold trim in other color schemes. Unmarked, 5 1/2".

Hen with Chicks. Unmarked, 5 1/4".

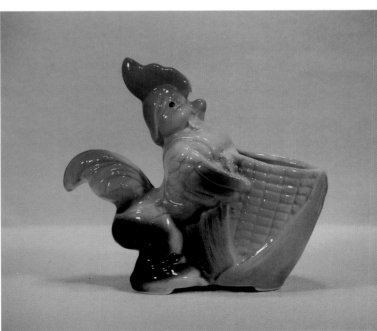

Rooster with Cob of Corn. Unmarked, 6".

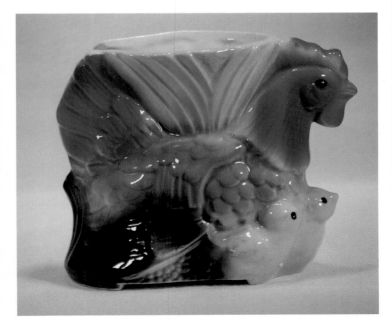

Chick. Also found without the gold trim. This one is gold marked, Shafer 23k gold guaranteed, 3".

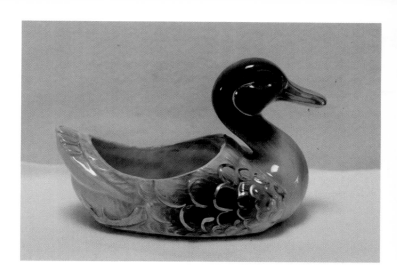

Mallard Duck with gold trim. Unmarked, 4 3/4".

Duck in Flight. Marked "USA", 4 1/2".

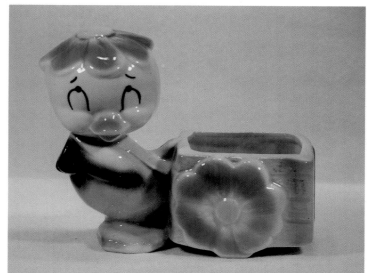

Duck with Flower Petal Hat. Unmarked, 5 3/4".

Duck Face. Very similar in style to the Elephant. Unmarked, 3 1/4".

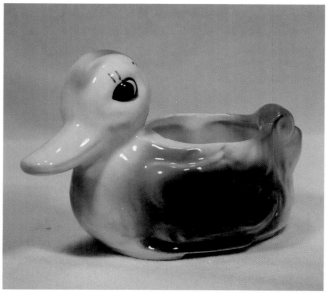

Duck. Also found with gold trim. Unmarked, 4 1/2".

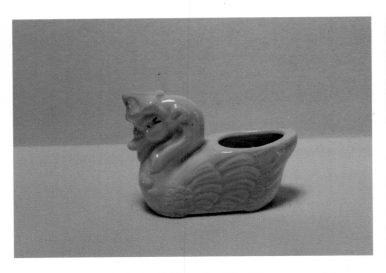

Another version of a Duck with Flower Petal Hat. This one was made by APCO. Marked "USA", 3 1/4".

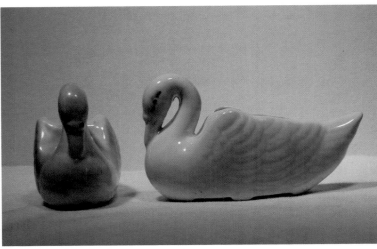

Swans. Made by APCO and available in other colors. The yellow Swan sits on wedges while the pink one has a flat bottom. Unmarked, 6".

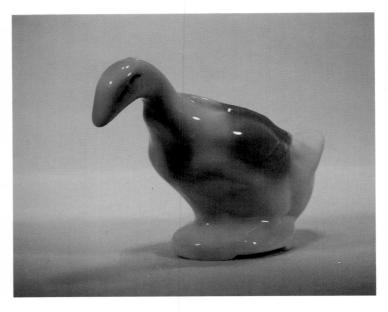

Modern Goose. Made by APCO. Unmarked, 4 3/4".

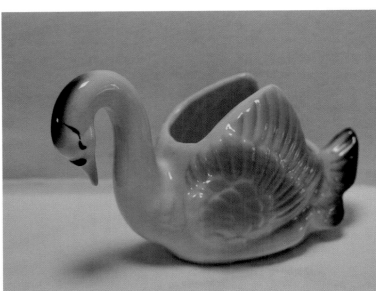

Graceful Swan. Marked "USA 7001", 6".

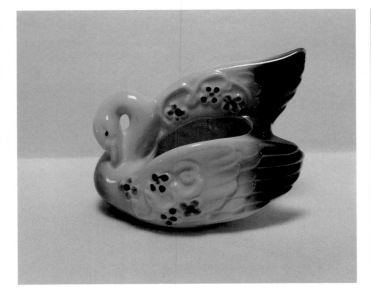

Swan. Marked "USA", 4 1/4", flat bottom.

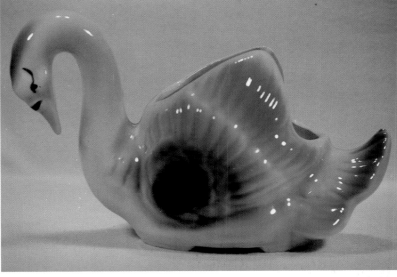

The Graceful Swan in an alternate color scheme. Identically marked.

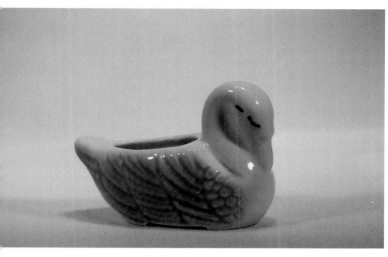

Another Swan. Made by APCO it is unmarked, 3 1/4".

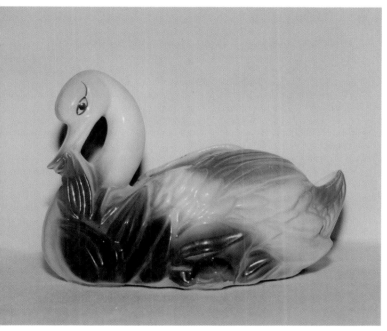

Huge in comparison to the other Swans, this one measures 7"h x 9 3/4" l. Unmarked.

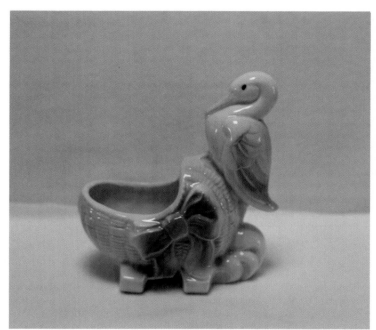

Stork with Bassinet. Unmarked, 6 1/4".

Stork with Cradle. Marked "USA", 6 1/2".

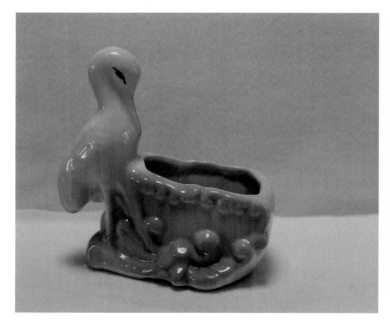

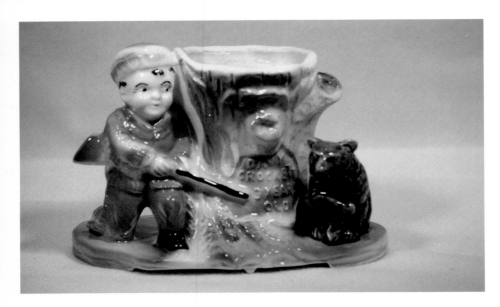

Davy Crockett. In raised letters on the front of the tree trunk reads, "Davy Crockett 3 years old." Unmarked, 4 3/4".

The previous Davy Crockett planter showing the wedges plus a center bar.

Boy Davy Crockett. Marked simply "©", 4 1/2".

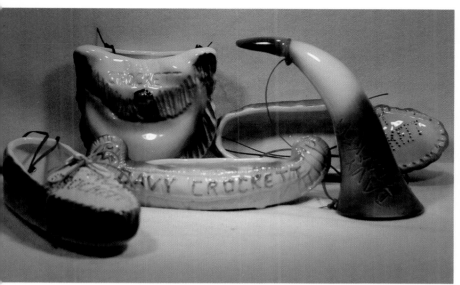

Miscellaneous Davy Crockett planters.

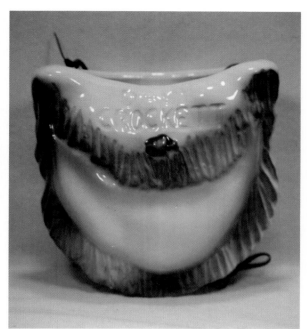

Davy Crockett Pouch. Unmarked, 5".

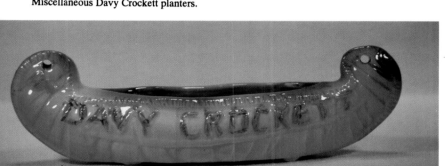

Davy Crockett Canoe. Unmarked, 2 3/4"H X 8 1/4"L.

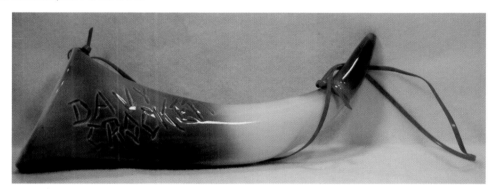

Davy Crockett Powder Horn. Unmarked, 8".

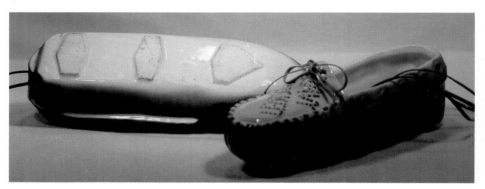

Davy Crockett Moccasins. Unmarked, 8 1/2" in length.

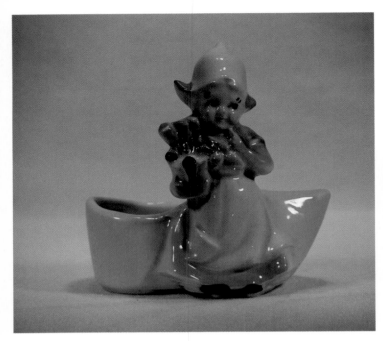

Dutch Girl with Wooden Shoe. Unmarked, 6".

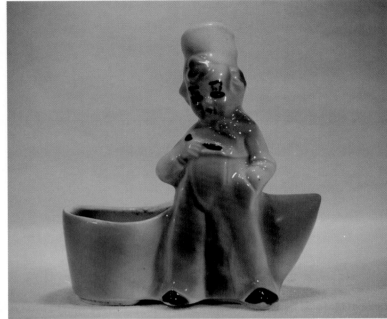

Dutch Boy with Wooden Shoe. Unmarked, 6 1/4".

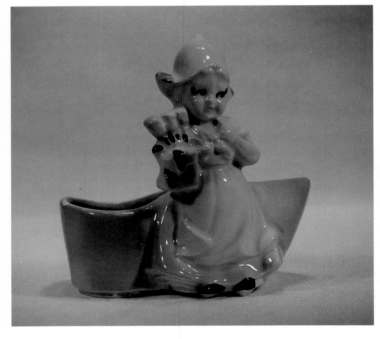

Dutch Girl with Wooden Shoe in another color scheme. Unmarked, 6".

Southern Belle. Unmarked, 7 1/2".

Double sided Southern Belle. Unmarked, 11 1/2" w X 6 1/2" h.

Lady Head vase. Totally done with cold paint detail, this vase was produced by APCO. Unmarked, 6" on a full outline footing.

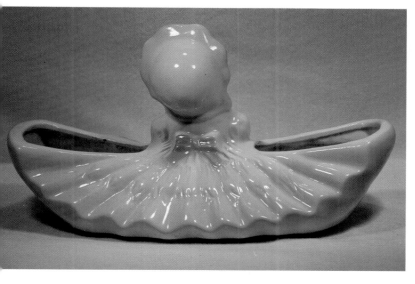

Reverse side of the double sided Southern Belle.

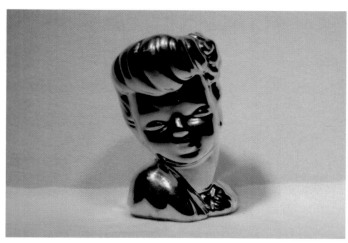

The same vase previously shown, also done by APCO. This one is totally done in 24k gold. Unmarked, 6" on a full outline footing.

Bottom view of the double sided Southern Belle. Due to the size of the piece a middle wedge was added.

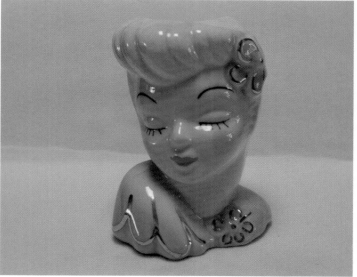

Lady Head vase. Another version also made by APCO. This one is airbrushed, decorated with gold and her lips are cold paint. Marked "USA", 6" on wedges.

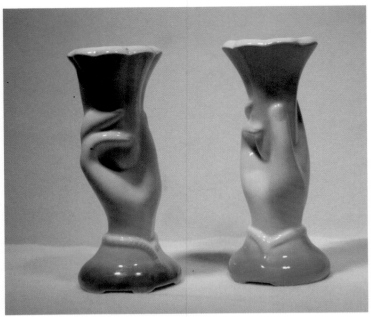

Lady Hand vases. Front and side views shown in green and blue, these are also available in yellow and burgundy. Made by APCO these are unmarked, 6".

Cradle. Made by APCO. Unmarked, 3 1/2".

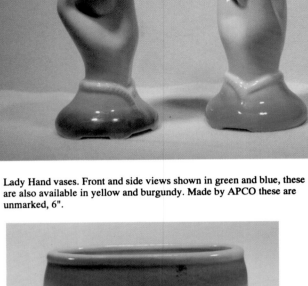

Lone Pine Tree. Made by APCO. Unmarked, 3 1/4".

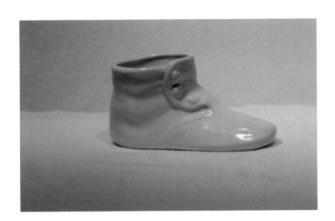

Baby Shoe. Made by APCO. Unmarked, 2 1/4", full outline footing.

Flower pot. Made by APCO and clearly marked "USA", 3". Possibly other colors.

Cabbage. This is one of a series of vegetables made by APCO. Unfortunately this is the only one we have ever seen. Unmarked, 2 1/2".

Golf Bag. Unmarked, 6".

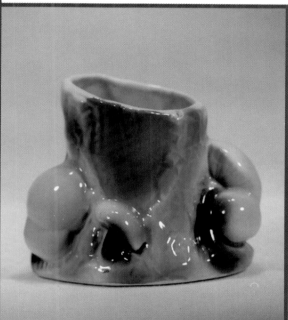

Mushrooms and Tree Stump. Unmarked, 4 1/2", flat bottom.

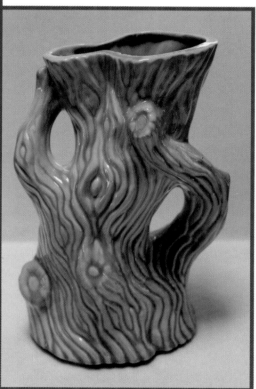

Tree Trunk. Unmarked, 9".

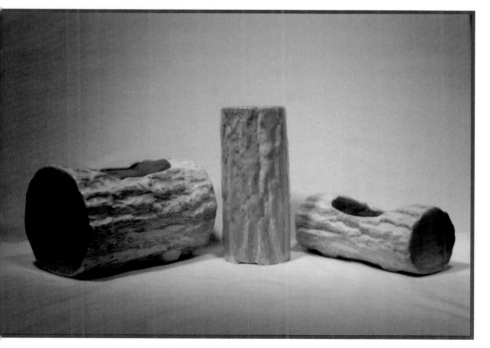

Log Planters. Made by APCO note the similarity between these planters and the Smokey The Bear banks. All unmarked, the sizes are L to R: 6"long with a 4 1/4" diameter; 6" tall with a 2 1/2" diameter; 6" long with a 2 1/2" diameter.

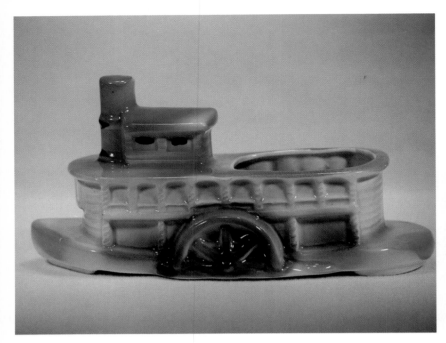

Paddle Boat. Unmarked, 4 1/4"H X 9 1/2"L.

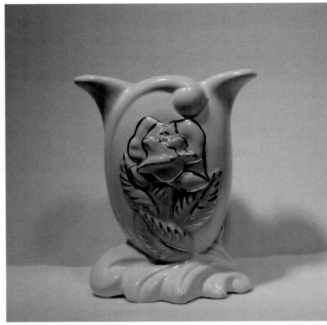

Rose motif vase with 22-24k gold trim. Made by APCO. Unmarked, 6 1/2".

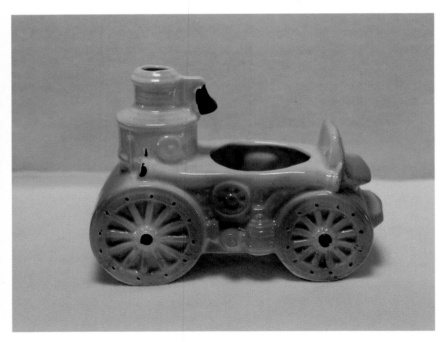

Steam Fire Wagon. Unmarked, 6".

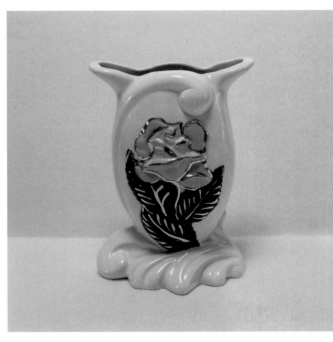

Rose motif wallpocket with 22-24k gold trim. Made by APCO. Unmarked, 6".

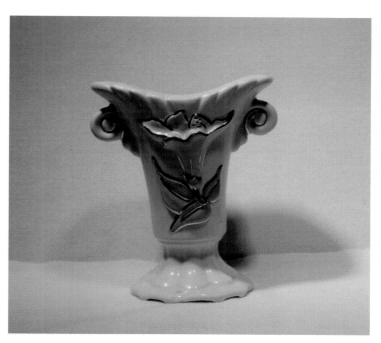

Gardenia motif vase with 22-24k gold trim. Made by APCO. Unmarked, 6".

The reverse side of the Rose motif wallpocket showing the footing.

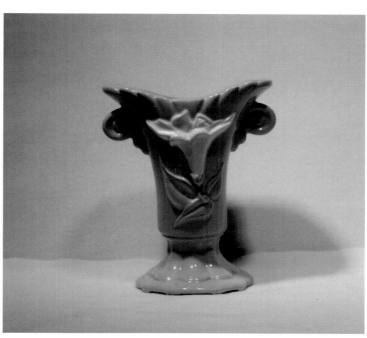

Gardenia motif vase in blue. Made by APCO. Unmarked, 6".

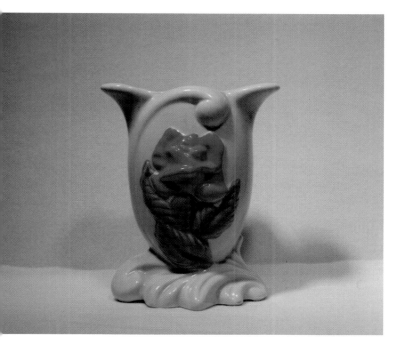

Rose motif vase. Made by APCO. Unmarked, 6 1/2".

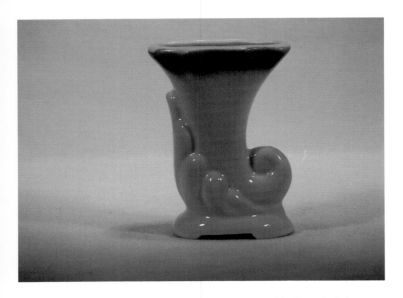

Cornucopia vase. This is the plain version made by APCO. Unmarked, 4 1/2".

Calla Lily. Trimmed in 22-24k gold and made by APCO. Unmarked, 6".

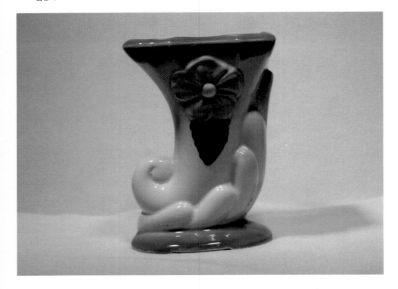

Larger than the last version of the Cornucopia, this one also has a flower motif. Made by APCO. Unmarked, 6".

Philodendron Leaves. The gold decoration was done by Shafer on this piece. Unmarked, 7 1/4".

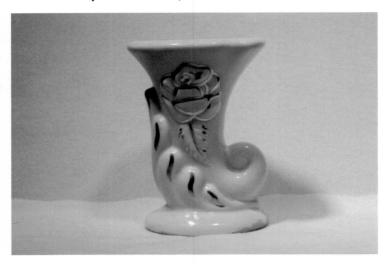

The Cornucopia appears this time with a rose. Completely devoid of color this one is decorated with 22-24k gold. Made by APCO. Unmarked, 5".

Photo shows the Shafer "signature" on the Philodendron vase.

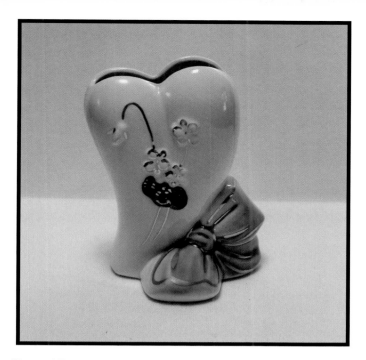

Heart and Flowers wallpocket. This piece can be located in a variety of colors, both on the bow and the flowers. Made by APCO the wallpocket is marked "USA", 6".

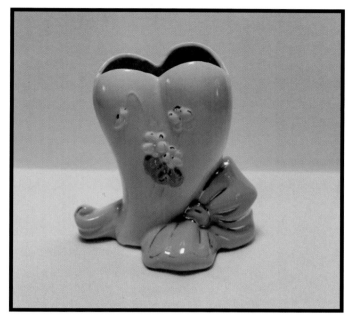

Almost identical in style, this is a vase rather than a wallpocket. Made by APCO. Marked "USA", 6".

Double Cornucopia. Made by APCO this piece, though not marked as such, closely resembles the Marietta Modern Line. Overall length is 12".

Banks

Banks must have been made by every pottery in every form, size and shape imaginable. Though still plentiful in the marketplace it seems those with stoppers in the bottom had a better survival rate.

Many were produced with holes in the bottom far too small for coin retrieval. These literally required breaking the pottery away between holes to retrieve one's savings.

The boy and girl pig wall-hanging banks are the only two hanging banks we have been able to locate. We class them as *very rare*.

Other banks produced range from a variety of pigs, truly making them "piggy" banks, to copyrighted characters.

Banks remain a very collectible item and are available in a broad price range.

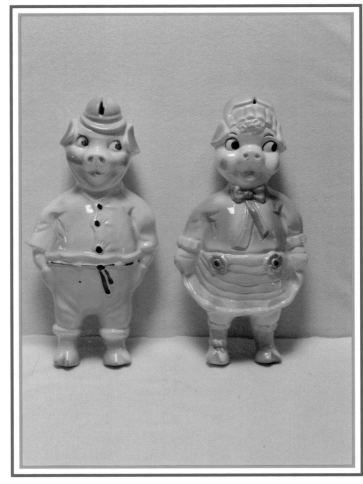

Betty & Floyd.

Something New! Wall Pin-up Banks

"Piggy Banks"

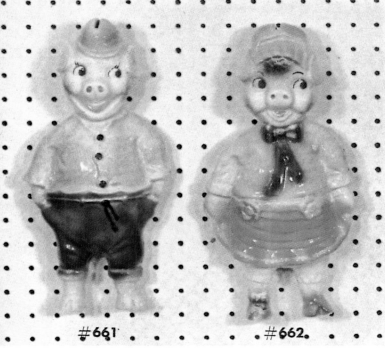

#661 #662

Pkd. 1 dz.
Assorted or Solid
12″ high, 6″ wide

Crown of hat is Removable to Retrieve Monies, Coin Slot in back, Feathers in Assorted Colors.

#700 Paddy Pig
Pkd. 1 doz. Wt. 26#
6″ high, 6″ long

A-480 Pig Bank
4½″ high, 7″ long
Pkd. 2 doz. Wt. 35#

A-660 Pig Bank
5½″ high, 10¼″ long
Pkd. 1 dz. Wt. 34#

A-112 Pig Bank
7″ high, 13½″ long
Pkd. individually, 6 to
master carton Wt. 32 #

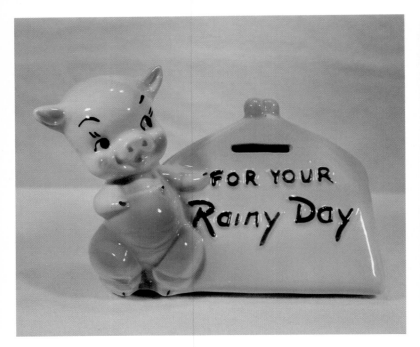

For Your Rainy Day. This bank has the holes in the bottom rather than a stopper. Unmarked, 6 1/4" H X 7 1/2" L.

Reverse view of the Diaper Pin Pig.

Diaper Pin Pig. This piece is very easily confused with Regal Pottery as the identical design was made into a cookie jar by Regal. Heavily trimmed in gold and marked "USA", 9".

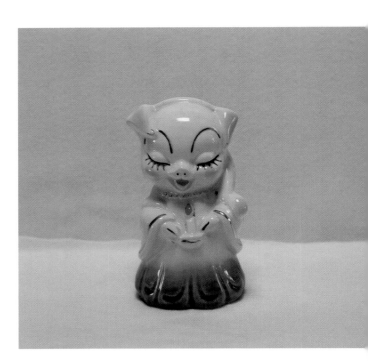

Bedtime Pig. Made by APCO. Trimmed in 22-24K gold. Unmarked, 6 1/2", double hole bottom.

Mr. Pig. Made by APCO. Unmarked, 6".

Floyd. Flat back-side with two holes. Marked "USA-661", 13".

Betty. Flat back-side with two holes. Marked "USA-662", 12 3/4". Produced in other colors, both Betty and Floyd are very rare.

Bow Pig. Marked "USA", 5 1/4", this pig has a full outline footing with a center stopper.

Dimples. Rather than in her cheeks this little girl pig has dimples in her knees. Unmarked, 6".

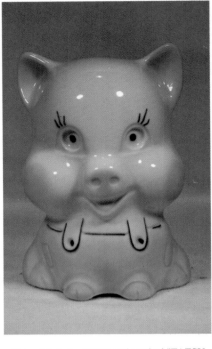

Fatsy. Made by APCO and marked "FATSY USA", 5 3/4".

Little Girl Pig. Made by APCO and detailed in cold paint. Unmarked, 5 3/4".

Fatsy. Another color scheme and obviously a different decorator's hand. Note the differences in the placement of cheek color and thickness of lines.

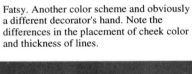

This is a very interesting bank. The bottom is completely flat. Coin retrieval is via a lid on the top side of his back. The lid is held in place with a tiny padlock which inserts through an eyelet on the lid and an eyelet above the bow. The interior lip of the lid is similar to that of a teapot, so that if you turn the bank upside down the lid can't fall off. Marked "USA 912", 10 1/2".

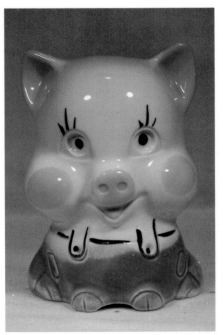

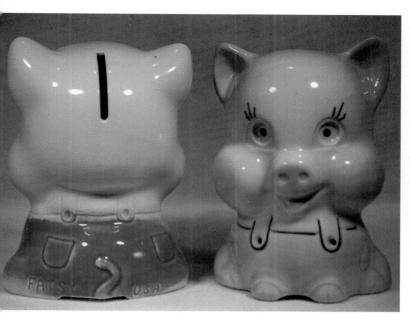

Both "Fatsy's", front and back views.

Attitude Papa. Unmarked, 8 1/2".

The Attitude Pig Family. Made by APCO. Remind you of anyone you've ever met? Hands down in our mind these are second only to Betty and Floyd.

Attitude Baby. Unmarked, 7".

Attitude Momma. Marked "USA" on her belly, 8 1/2".

Two of the three sizes available. The smaller of these two is also unmarked, 3 1/4"H X 6"L.

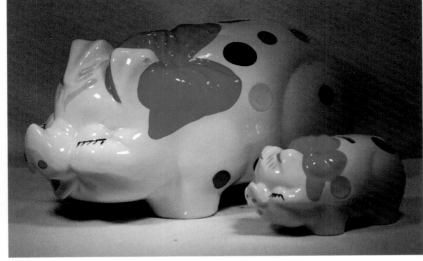

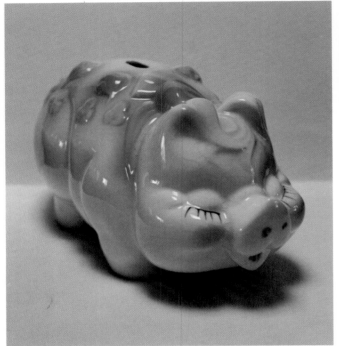

Let the controversy begin! Hull, McCoy, American Bisque, American Pottery? Each of these pottery's has made a pig similar to this one. There are other pieces to match this Piggy with Clover Bloom (see Chapter 7). Unmarked, 6 3/4" H X 14" L.

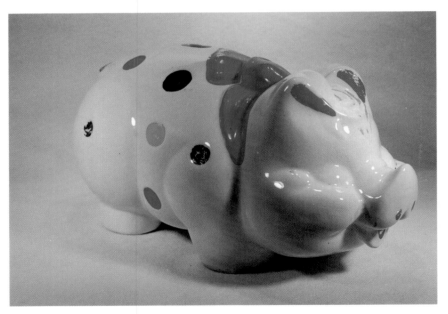

Same style pig as the previous one, this one with the familiar indented dots. Unmarked, 7" H X 14"L.

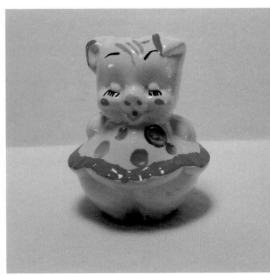

Indented dots again, this time in Dancing Pig form. Unmarked, 4 3/4", full outline footing with center stopper.

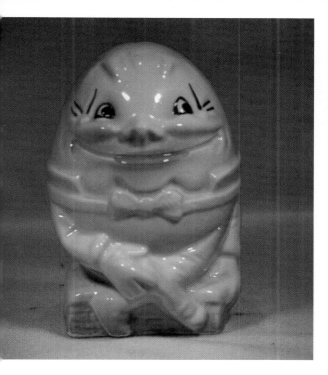

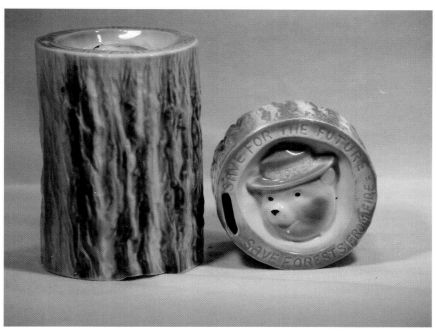

Humpty Dumpty. A contracted advertising piece marked "Alice in Philcoland", 6".

Smokey The Bear. These banks were made by APCO. The top surface reads, "Save For The Future - Save Forests From Fire. Marked "USA" the taller of the two measures 5 3/4".

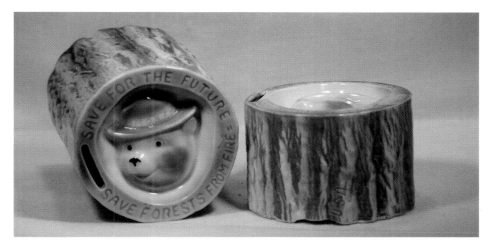

A reverse view from the previous photo, the shorter of the two banks measures 2 1/2".

Front and rear view of Humpty Dumpty.

Bottom view of the Smokey The Bear banks.

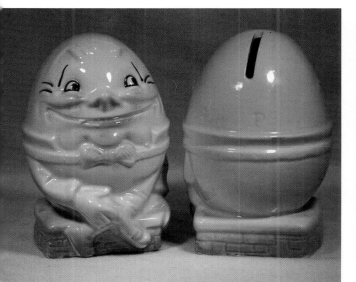

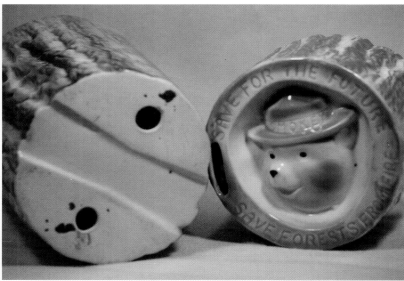

Popeye. Unmarked, 7" with a center stopper. Full outline footing.

Sweet Pea is unmarked and measures 8 1/4"H X 6 1/2"L. Another Sweet Pea bank made by Vandor is on the market. It is small and much lighter in weight.

Sweet Pea cookie jar and bank.

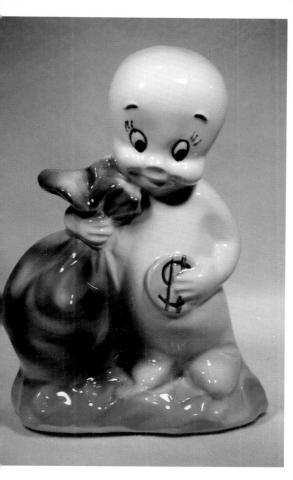

Casper The Friendly Ghost. Marked "USA", 8 1/2".

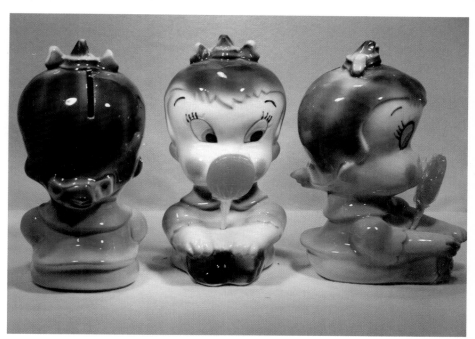

Little Audrey every which way. The hole in her lap is a perfect lollipop holder.

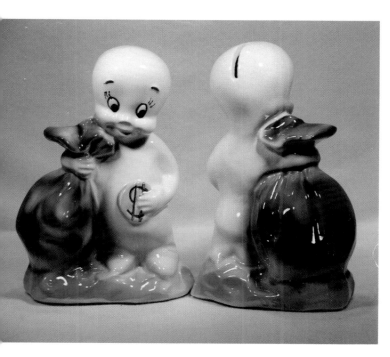

Front and back views.

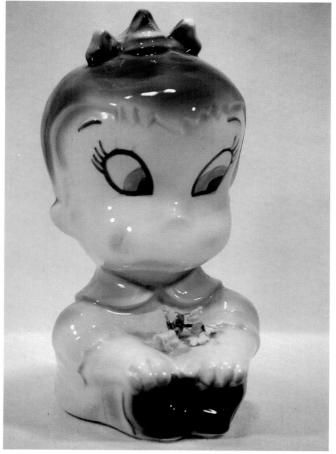

Little Audrey. Unmarked, 8 1/4", full outline footing with center stopper.

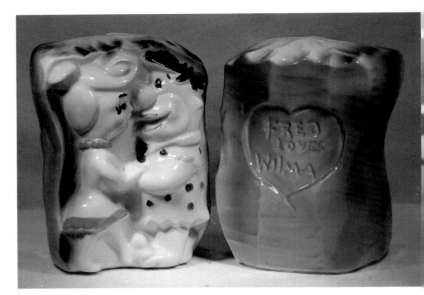

Fred Loves Wilma. Unmarked except for
the inscription in the heart, 8 1/2".

Dino, Fred Flintstones caddy. Unmarked except for the incised "Dino" on
his tail, 8 1/4". Full outline footing with a center stopper.

Little Girl Rag Dolls, three views. Unmarked, 5 1/4". Available in
various color schemes.

Little Girl Rag Doll. Double hole bottom.

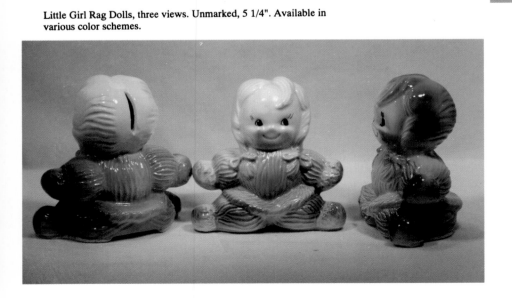

Little Boy Rag Doll. Unmarked, 5",
modified U-foot.

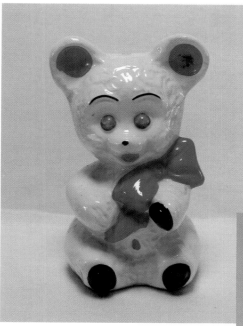

Sitting Teddy Bear. Made by APCO this bear is also available in a nursery lamp. Unmarked, 6 3/4" on a full outline footing with center stopper.

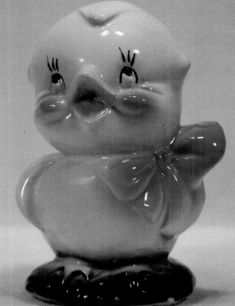

It's doubtful many chickens could be fed with the contents of the little Chicken Feed bank. Unmarked, 4 1/2".

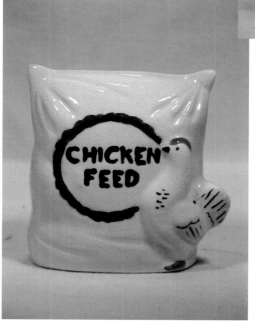

Chick. Decorated in underglaze this Chick is also available as a lamp. Unmarked, 6 1/2" on a U foot with double holes.

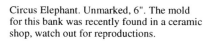

Circus Elephant. Unmarked, 6". The mold for this bank was recently found in a ceramic shop, watch out for reproductions.

Reverse view.

Cookie Jars

Many cookie jars collectors have been gathering jars together for decades. Cookie jars are not a **NEW** collectible. Though many people attribute cookie jar collecting mania to pop artist Andy Warhol, Warhol's collection merely brought notoriety and validation to the hobby. Mr. Warhol's collection of approximately 175 jars sold at Sotheby's auction house in New York for close to $250,000 in 1988. Expecting the cookie jars to sell for approximately $40 each, both Sotheby's and the world was left stunned when the jars went for over $1400 a piece. Since the time of the auction, market prices on cookie jars have continued on the up swing until just recently. Wall Street probably wishes the stock market could boast the same record increases that cookie jars have had.

Many sellers have lost sight of the fact that it was not the rarity or collectability of Andy Warhol's jars that commanded such a high price but the notoriety of the owner. In other words, the jars were not rare, owning a "piece" of Warhol was quite another thing. We chuckle every time we think about these wonderful jars being sold at $11.40/dozen or $.95 each wholesale as late as 1974. Don't let the prices realized from the Warhol auction scare you away. There are still many jars available at reasonable prices. Just remember to choose carefully - they require lots of space.

HO-HO pictured here is the only one in existence. During Sales Representative William Schneider Sr.'s tenure with American Bisque he and Vice President/General Manager, Mike O'Brien became very good friends. Mr. Schneider and Mr. O'Brien envisioned both a Buddha type cookie jar and a bank. They enlisted the services of designer Al Dye to design and cast "HO-HO". Mr. Dye was paid $250 for his design and work. The jar in this photo along with two banks, one in black and one in 24k gold, were produced as a sample pieces for Mr. Schneider's approval. Unfortunately timing coincided with the new Berkeley & Sequoia ware lines and HO-HO was doomed to obscurity. As Mr. Schneider explains, American Bisque suddenly became very busy on such items as ash trays, serving dishes and candy trays and unfortunately HO-HO never went into production in either cookie jar or bank form. From our point of view, perhaps if Mr. Schneider hadn't been such a successful salesman on production items, HO-HO might have become a reality.

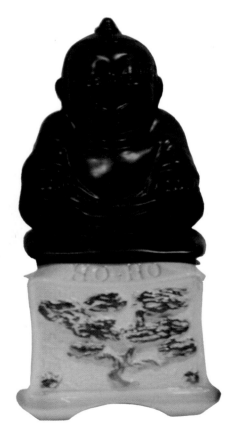

Prototype HO-HO, never produced. At least we can look!
Courtesy of William Schneider, Sr.

Some of the cookie jars in the line were produced for over 20 years. Size differences are apparent in some of the jars produced for long periods of time and the explanation we received was that the company went to "master carton" shipping. Rather than individually, the jars were packed six to a carton and were reduced to a standard size to fit the packing cartons.

NOVELTY COOKIE JARS

American Bisque, competing for market share with other American potteries, added a novelty feature to some of their jars. Our knowledge and research indicate that they were the only American producer of their era to produce cookie jars with a functional blackboard and magnet; serving tray top; and action piece decor. They surely knew they had something special as all three had patents pending when introduced. Out of all the cookie jars produced these are, without a doubt, highly prized favorites among collectors. During the years we've run a retail collectible cookie jar business literally thousands of cookie jars have passed through our hands and none with creativity close to these. This was as much a novelty in its day as it is now.

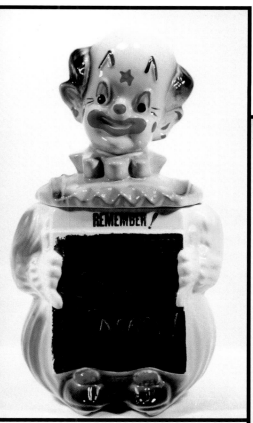

Blackboard Clown, catalog #901, raised letters,"USA". Bottom inkstamp reads, "Patent Pending USA". The clown is 13 3/4" high.

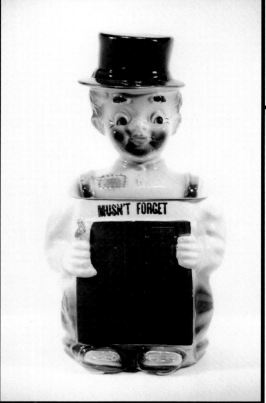

Blackboard Bum, catalog #902, raised letters, "USA". Bottom inkstamp reads, "Patent Pending USA". The bum is 14" high.

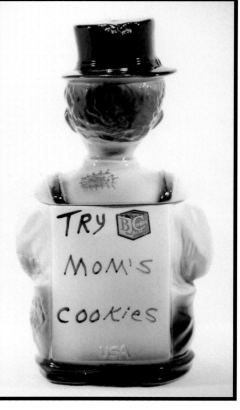

Reverse side of the bum. Reminiscent of the 1930s the bum and the clown have suspenders on their shoulders holding the sandwich board. They both read "Try Mom's Cookies" hand lettered in underglaze. Note the foil ABC block sticker still intact.

63

Blackboard Saddle, catalog #903, raised letters, "USA". Bottom inkstamp reads, "Patent Pending USA". The saddle is 12 1/4" high and differs substantially from the saddle without blackboard. This is the only "non-person" blackboard jar.

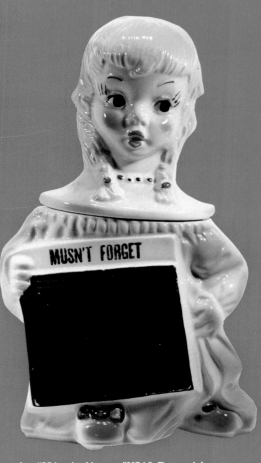

Blackboard Girl, catalog #904, raised letters, "USA". Bottom inkstamp reads "Patent Pending USA". The girl and boy differ from the clown and bum jars in that they are holding signs, not wearing sandwich boards. The girl is 13" high.

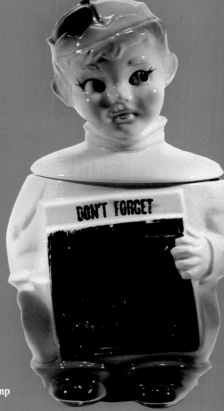

Blackboard Boy, catalog #905, raised letters, "USA". Bottom inkstamp reads "Patent Pending USA". The boy is 12 1/2" high.

Of the three novelty types, five styles are known to have been produced with a blackboard and magnet. They are the Bum, Clown, Girl, Boy and Saddle. All are stamped above the blackboard with the words, "Remember!", "Mustn't Forget", or "Don't Forget". The wording is not specific to any particular jar i.e., the sayings were interchanged between jars. Mom, probably knowing the kids would head straight for the cookie jar after school, could scrawl a brief note in chalk, perhaps "clean your room", "take out the garbage", or "dentist 4:30 p.m." The magnet in the upper right hand corner of the blackboard provided a wonderful place to pin a favorite recipe while cooking. A recipe card with benefit of only a paper clip kept instructions at eye level and out of flour or other ingredients being used.

The second jar with a novel idea was made with a tray-top or lid that doubled as a serving tray. Three styles are known: Picnic Basket, Chef Head and a jar called simply "Modern". Cookies could actually be placed on the lid of the jar for use as a serving platter or tray.

Picnic Basket, catalog #601, marked "601 USA", 6 3/4" high.

Chef Head, catalog #603, marked "603 USA", 7 1/2" high.

Same jar showing tray lid. The third jar in this series is known simply as "Modern". It is a modified square jar with a pear and apple in relief on the sides of the jar. The lid is a black square tray with corners that curve upward like the roof of a pagoda would and it can be found in black or brown. "Modern" is marked "602 USA" in the series of three.

Same jar showing tray lid.

The third type was named the "PAN-EYE-MATIC--COOKIE JARS". These jars are embellished with action pieces which are more commonly referred to by collectors as "flashers". Six styles are known and one of the six, "T.V. Bedtime" was done with two different action pieces.

The action pieces or "flashers" were actually paper pictures laminated to pieces of ribbed plastic. These pieces were glued to the jar after glazing and firing. Movement of ones head up or down, left or right, causes the picture on the action piece to show movement: eyes open/eyes closed, fly on the nose/fly flying, etc. Because these pieces were glued on additions, these jars are often found with the action piece missing. Although still attractive, value of a jar with a missing flasher is reduced to about half.

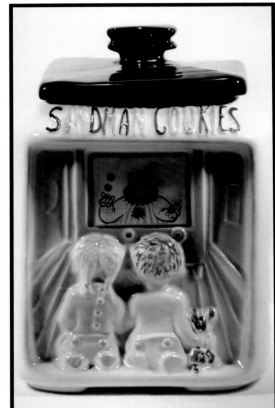

Referred to as Sandman Cookies, the correct name for this jar is "T.V. Bedtime". This jar with the juggling clown action piece seems to be a little more illusive than the next jar with the dog action piece. The jar is 9 3/4" high and marked "801 USA".

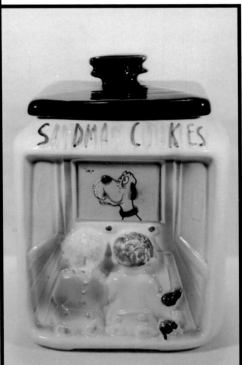

Also marked "801 USA", this is the version of T.V. Bedtime with the dog action piece. Note the open mouth and fly in the air.

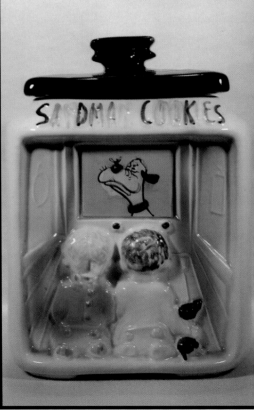

A different perspective on the action piece. Note the dogs mouth is closed and the fly is sitting on his nose.

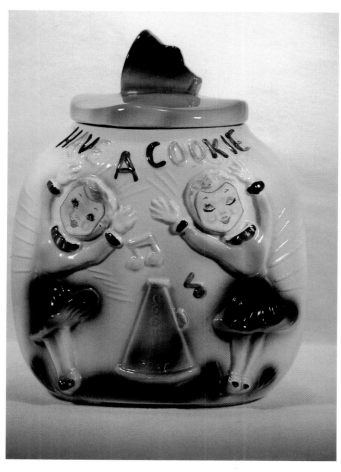

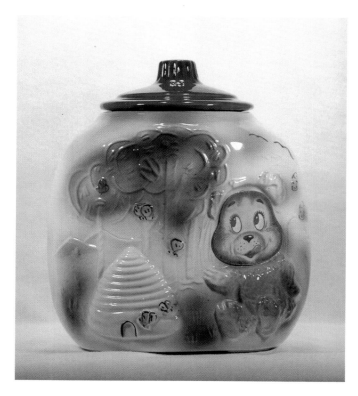

The Bear and the Beehive, similar in design to the Cheerleaders is also a corner jar. This jar is 10" high and marked "804 USA".

Known as Cheerleaders this is a three sided corner jar. The jar is 11" high and marked "802 USA". The action pieces are the girls faces.

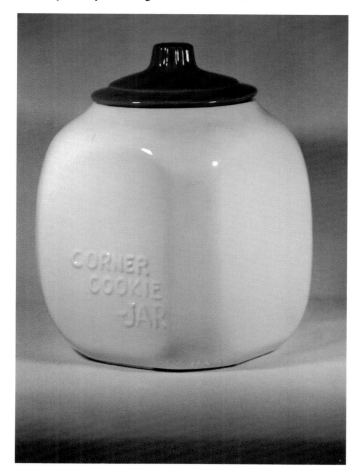

Commonly referred to by collectors as The Tortoise and The Hare, the given name for this jar is "Rabbit & Log". It is 9 3/4" high and marked "803 USA".

The reverse side of the Bear and Beehive cookie jar showing the words corner cookie jar in raised letters. This also appears on the back of the Cheerleaders jar.

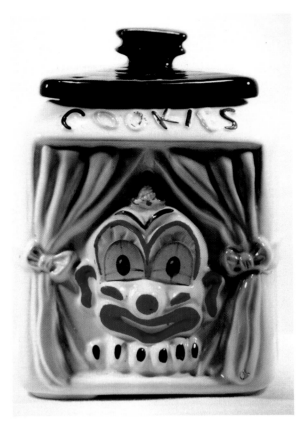

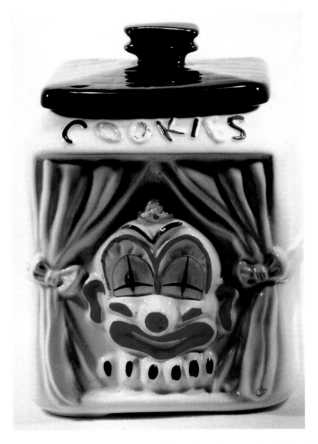

Commonly called The Clown on Stage, the correct name is merely "Clown". This jar can also be found with pink, yellow or green curtains. The lid shown in the picture is not correct. Though black is the correct color rather than being flat with a rectangular knob the correct lid should more closely resemble the top of a circus tent; steeper sides with a pointed top.

Another view of the clown showing his action piece eyes in a different position. The red detail on this jar is cold paint and it is a repaint. The clown is 9 3/4" high and marked "805 USA".

This is the rarest and most prized of the action piece jars. Referred to by collectors as The Cow Jumped Over the Moon, the given name is merely "Cow & Moon". Marked "806 USA" it stands 11" high.

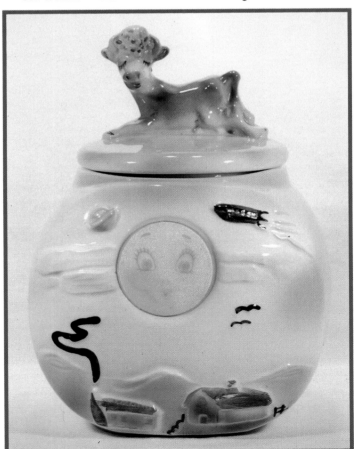

CARDINAL

Cardinal China Company, also known as Carteret China, was located in Carteret, New Jersey. Mainly a distributor or marketing company they used their own mark on cookie jars. The cookie jars featured here as Cardinal were in fact produced in the kilns of American Bisque and labeled Cardinal. Typically they have wedge bottoms with the exception of the School Bus which in spite of its "Z" shaped bottom is perfectly flat.

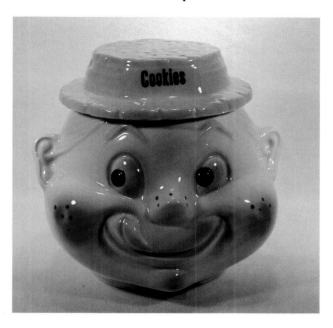

The Girl head is sometimes mistaken for a boy. The reverse side of the jar shows her blond locks tightly tied together with a bow. Since the Cardinal jars are products of the late 1950s, not the 1990s, we'll go with the girl theory. This jar can also be found with red cold paint detail on the mouth. Marked "USA © Cardinal, this jar is 8" high and is catalog number 301 in a series of twelve jars.

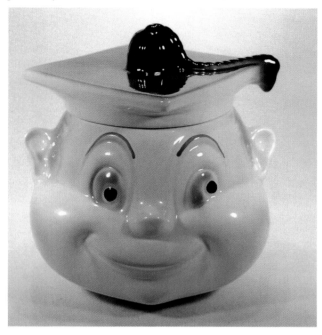

The Graduate is wearing his graduation cap which boasts "For Smart Cookies" on the top surface. Number 303 in the series this jar is 9" high marked "© Cardinal USA".

The Sad Clown proclaims "I Want Some Cookies" on his hat. His pouting unhappy face is certainly convincing. Marked "© Cardinal USA", the clown is 9 1/2" high, number 302 in the catalog series. This jar can also be found with the mouth done in red cold paint.

The French Chef looks more like an artist than a chef given the style of his hat which is labeled "Petits Gateaux". Marked "© Cardinal USA" this little charmer is 9 1/2" high, number 305.

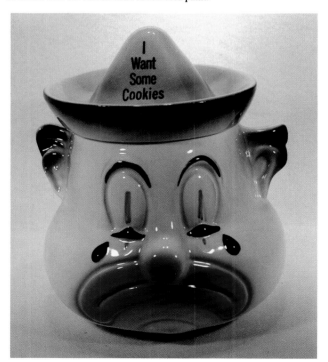

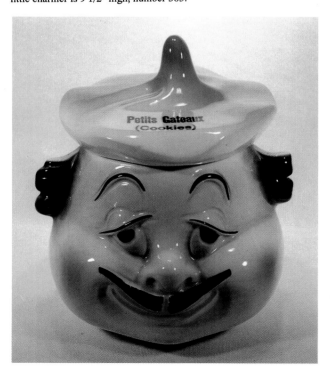

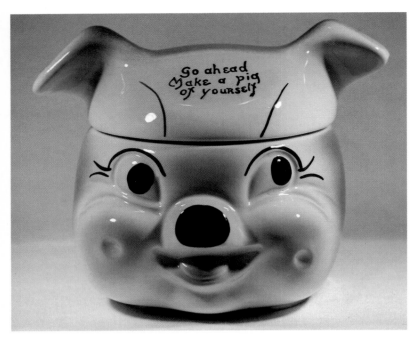

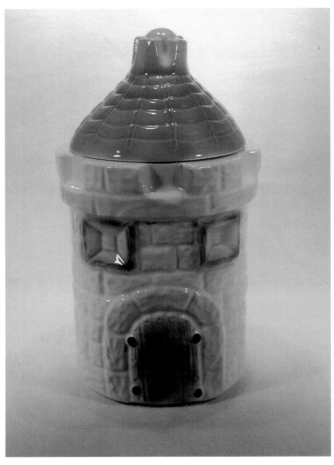

The Pig Head might make you think twice about eating a cookie with the admonishment printed across his forehead. This jar is very similar to one made by DeForrest of California. Typical of ABC production this jar sits on wedges, the DeForrest jar does not. Number 304 in the series this jar is 8" high marked "© Cardinal USA".

The Castle is 11 1/2" high and marked on two lines, "Cardinal 310 © USA".

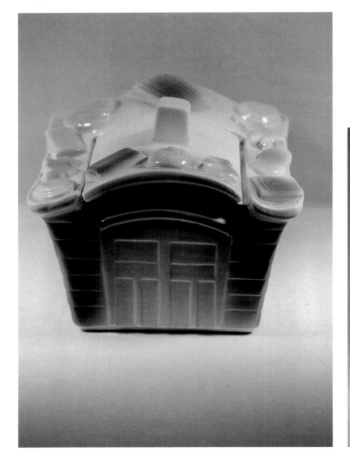

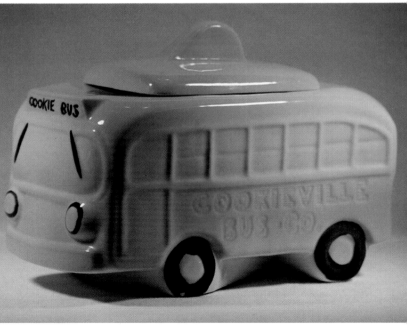

The Parking Garage proclaims "Free Parking For Cookies" above the front doors. Number 306, the garage is 6 1/2" high, marked on the side of the jar, "© Cardinal" and on the bottom of the jar "USA" between the wedges.

The Cookieville Bus Co. bus is probably the most difficult of the Cardinal jars to find. This jar is 7 1/2" high and because of the cut away design between the wheels and under the front this jar is the only one of the twelve not sitting on true wedges. Rather the bottom is cut in a "Z" shape and is perfectly flat. The bus is marked "Cardinal © USA".

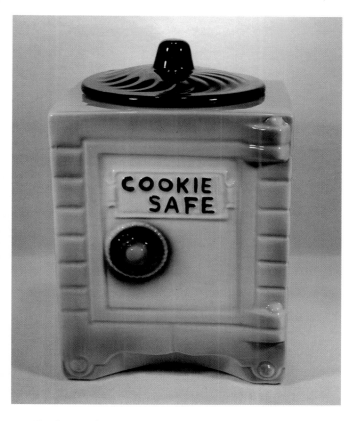

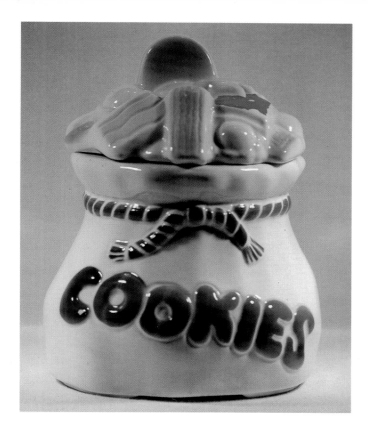

The Cookie safe stands 10 1/2" high and is marked "Cardinal 309 © USA".

The Sack of Cookies is series number 307. Standing 10" high it is marked "Cardinal © USA". This jar can also be found in pastel colors marked Cardinal and in the same coloring as this jar marked simply, "USA" and marketed by American Bisque.

The old Crank Telephone is very similar in design to one made by Sierra Vista. Watch for the wedge bottom and marking "Cardinal © 311 USA" to avoid confusion.

Marked "312 Cardinal © USA" this jar often referred to as the Soldier really looks to be a Drum Major. He stands 12 3/4" high.

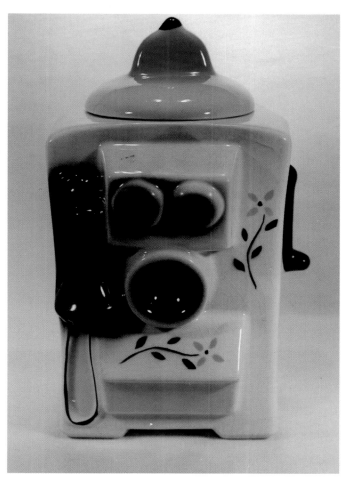

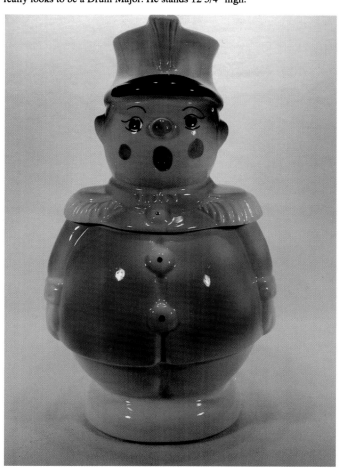

With the exception of a few cylindrical and square cookies jars, most of the production was figural. Of the figurals, fruits and vegetables are notably absent.

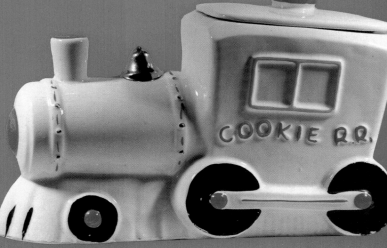

This Train Engine sits on a full outline footing rather than wedges. It is 7 1/2" X 11 3/4", marked "USA 200" and has fired on gold trim on the bell and horizontal cylinder in addition to hand painted color. It certainly appears to be the forerunner to the next jar and was most probably cast from a plaster mold rather than a ram press.

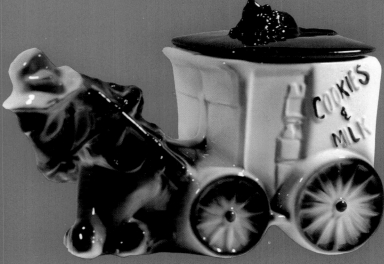

This jar is sometimes referred to as Donkey with Milk Wagon and sometimes as Cookies and Milk. Catalog sheets call it simply "Milk Wagon". The jar in yellow color seems more difficult to find than the standard one shown in the next photo. The Milk Wagon is 9" high and marked "USA 740".

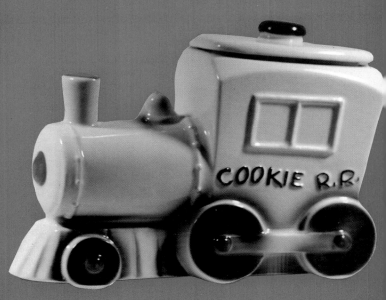

Slightly smaller at 7 1/2" X 9 1/2", this train sits on the typical wedges we are used to seeing. Partially decorated by air-brush this jar is incised, "USA" in the typical fashion.

Same as the previous jar in "standard" colors.

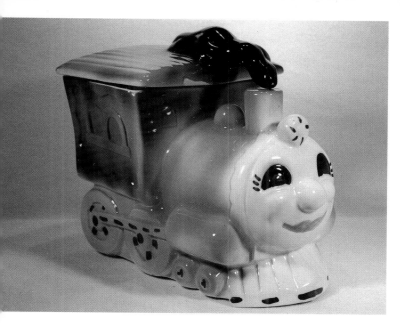

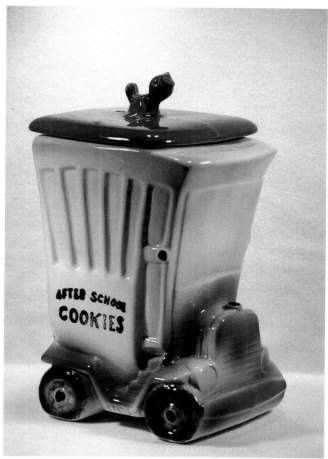

At least four potteries made a smily face train and they all differ in some way. This one came as a great surprise to us. It sits on wedges and is marked "USA", fitting standard ABC criteria. Height is 9 1/2" to the top of the smoke.

The Tall Bus is more difficult to locate than the truck or the train. The bus is 11" high and is marked "USA".

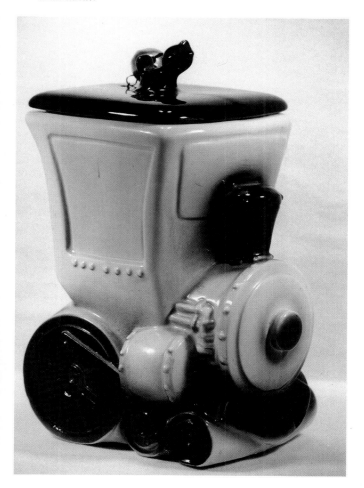

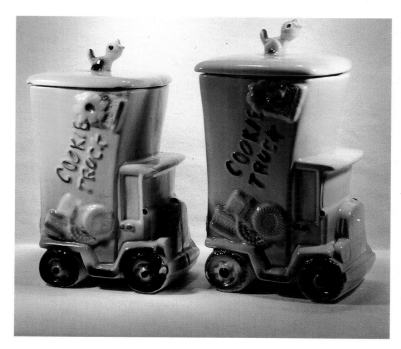

The Tall Train is 12" high and is marked "USA". It bears great similarity to the truck and bus. Note the lids are all identical except for color. The lids also each have a hole beside the bird finial where a bell was suspended from a bent piece of spring steel. Generally the bell hangs inside the jar, this one is backwards. This jar can also been found with brown in place of the black.

The Tall Truck is one of a number of jars produced in two sizes. Both are marked "USA 744". The larger one measures 13" and the smaller 11 1/2" high.

Cartoonish in its styling the Tall Truck remains very plentiful and reasonably priced.

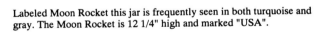

Labeled Moon Rocket this jar is frequently seen in both turquoise and gray. The Moon Rocket is 12 1/4" high and marked "USA".

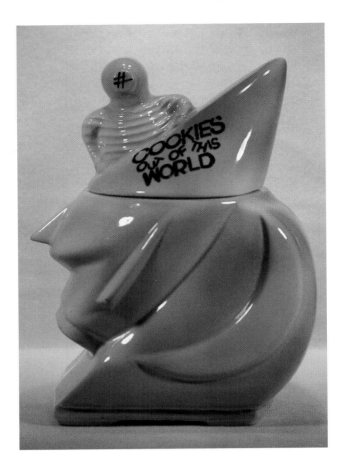

The Space Ship though bearing the same wording, "Cookies Out Of This World" as the Moon Rocket differs greatly. This jar is difficult to find. Marked "USA", the Space Ship is 10 1/4" high.

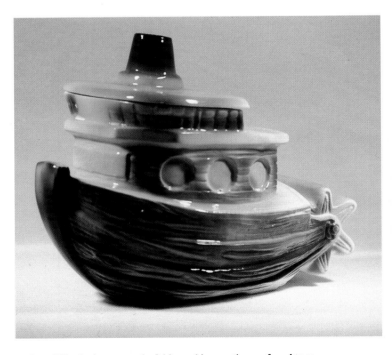

The Stern Wheeler is a very colorful jar and is sometimes referred to as the Tugboat. Like the tall Truck, Bus and Train this jar also has a hole through the lid for the attachment of a bell. Marked "USA", the jar is 8 1/4" high.

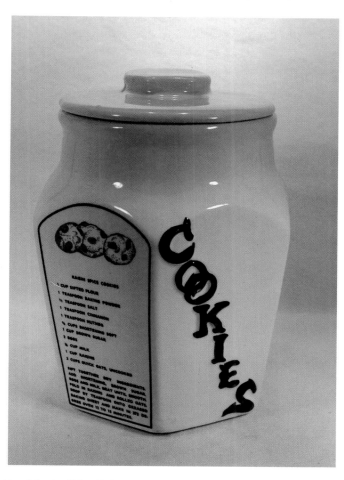

Shows reverse side of the same jar minus any cold paint.

For all its simplicity this is a great jar. Five of the six panels contain recipes as follows: Ginger Cookies, Sugar Cookies, Brownies, Peanut Butter Crisscrosses and Raisin Spice Cookies. The jar is 9 1/2" high and incised "USA" on one of the recipe panels.

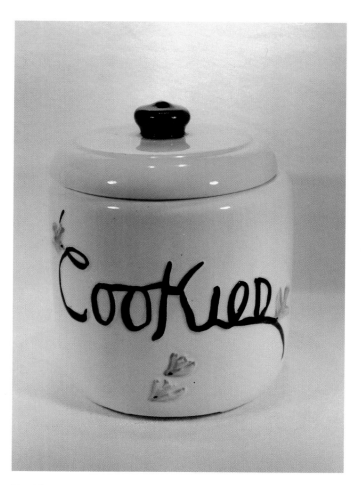

Another jar of rather simple design. The red color is cold paint applied after glazing. The jar is 8 1/2" high and is marked "USA".

Blue Birds on cylinder though plain is not as common as many jars. This 9 " jar is not marked.

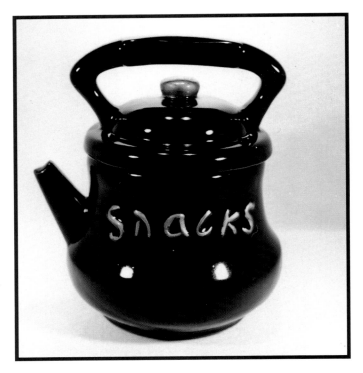

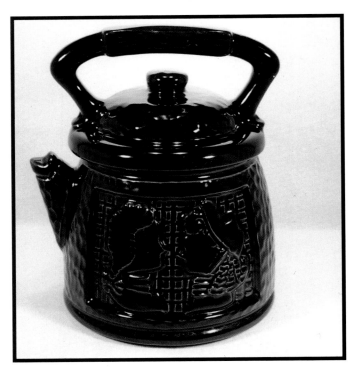

One rendition of the Tea Kettle. This example is marked "snacks" rather than cookies. The gold detail on the jar is probably a repaint as it is un-fired gold. Marked "USA" the kettle stands 10" high.

A Tea Kettle with a slightly different shape than the previous one, the colonial couple depicted here has been dubbed by collectors, "George and Martha". Note the similarity in handles on the two kettles. Marked "USA" the jar is 10 1/4" high.

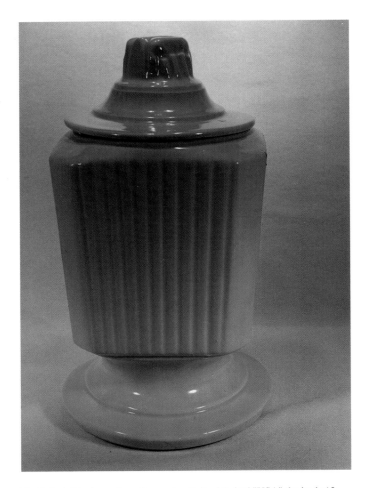

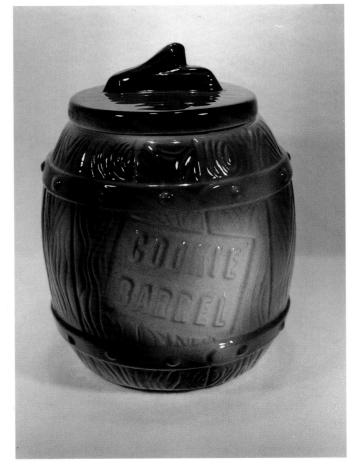

The Pedestal jar is another of pure simplicity. Marked "USA" the jar is 12 3/4" high.

The wood grain Cookie Barrel stands 9 1/2" high and is marked "USA".

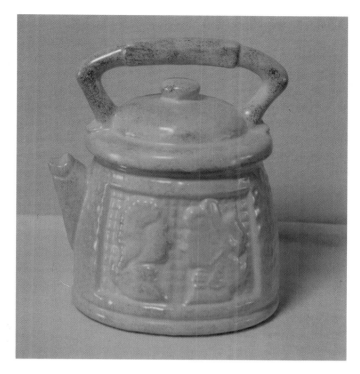

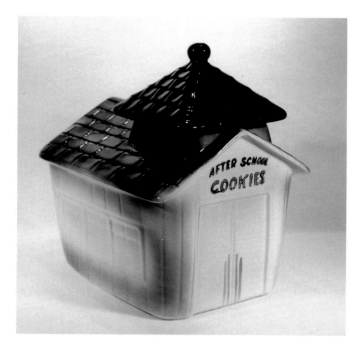

The same Tea Kettle in yellow and 22k gold detail. In **The Collector's Encyclopedia of Cookie Jars**, the Roerig's indicate that the Allen family did not feel this jar looked like their work. This jar, clearly marked in gold with an "American Bisque Co." backstamp should clear up any doubt.

After School Cookies Schoolhouse is a fairly common jar. Like the Tall Train and Modern tray top jars this one can also be found detailed in brown rather than black. The bell in the lid surely rang the children home from school. The Schoolhouse is 10 1/2" high, marked "USA 741".

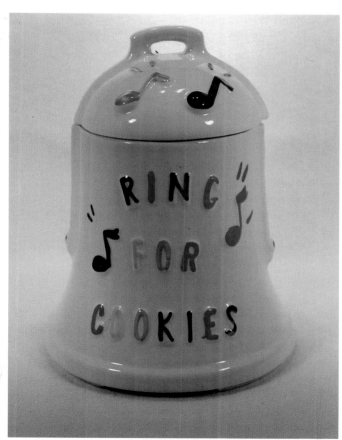

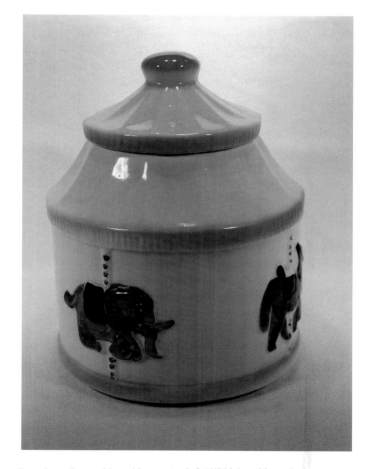

Ring For Cookies Bell does exactly that - ring. This is another jar equipped with a bell in the lid. Colors on this jar are entirely underglaze with the exception of red which is applied cold paint. Marked "USA" the bell stands 10" high.

One of two Carousel jars, this one stands 9 1/4" high and is marked "USA". The second version has a lid with a steeper slope and a pointed finial rather than the flat knob.

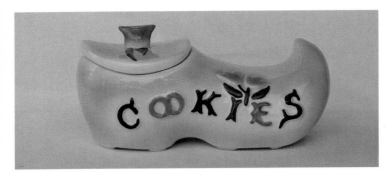

The Dutch Shoe has got to be a AAA width. Long and narrow it measures 5" h X 10" l and probably wasn't the most functional cookie jar. The finial on this unmarked jar is a tulip. Note: This piece is a rarity. We've looked harder for this jar than any other without luck. *Horelica Collection.*

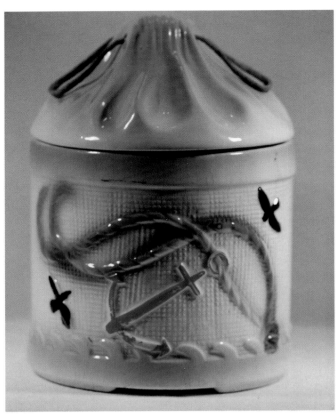

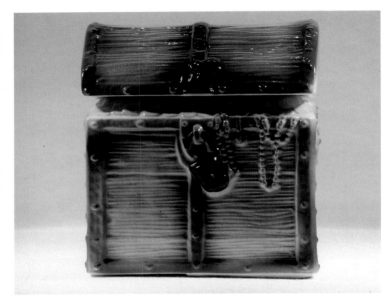

The Sea Bag has four holes in the lid where a cord has been inserted for apparent use as a handle. A very difficult jar to find, we can understand why. There is really no way to hold on to the lid without using the cord and using the cord causes it to sway and swing. The red detail on the anchor is cold paint. Standing 10 1/4" high the Sea Bag is marked "USA".

Of the two Treasure Chests this one with the open lid is the most common. Dripping jewels it is marked "USA" and stands 8 3/4" high.

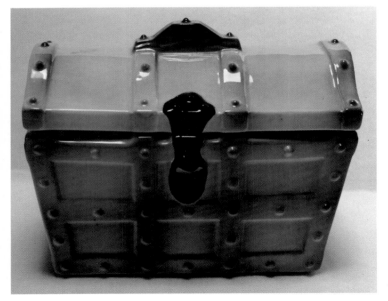

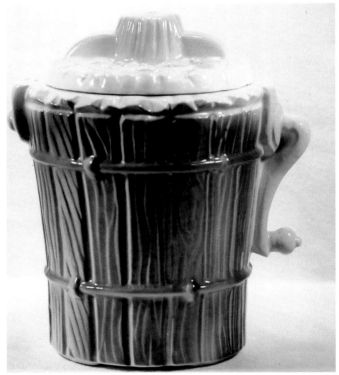

Another Treasure Chest, larger than the first. This one with the lid in the closed position, though only 8" high, is longer and is supported by a third wedge on the underside. Marked "USA".

Another difficult to find jar is the Ice Cream Freezer. Totally air-brushed it stands 9 3/4" high and is marked "USA".

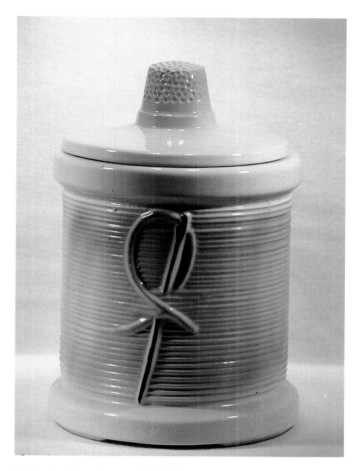

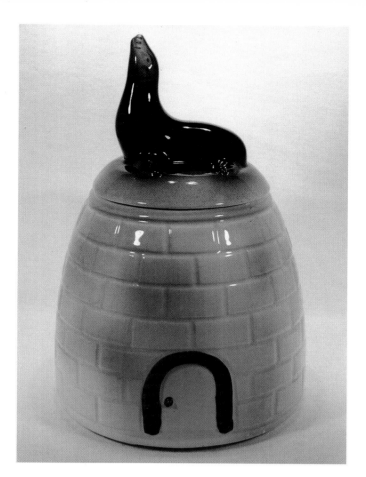

The Spool of Thread sports a thimble finial. Moderately plentiful we have never seen this jar in a color other than green. It stands 10 3/4" high and is marked "USA".

The Seal on the Igloo looks like a good place to store ice-box cookies. This jar measures 11" to the tip of the seals nose and is marked "USA".

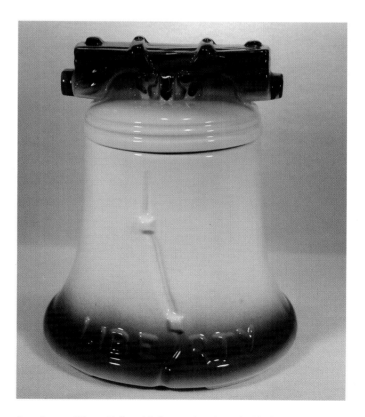

Reminiscent of the days when our kids left the grocery store with a box of Animal Crackers in hand is the Animal Cracker jar. With the exception of the red cold paint detail, all color was applied underglaze. Plentiful in quantity this jar stands 8 1/3" high and is marked "USA".

One of many Liberty Bell cookie jars produced, marked "USA", this one stands 9 3/4" high.

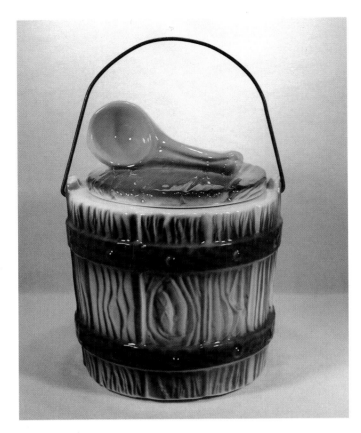

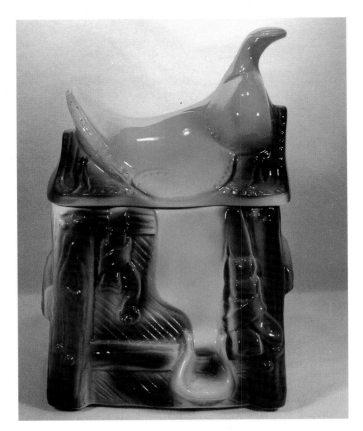

Reminiscent of the Ice Cream Freezer in color and style, the Oaken Bucket with Ladle sports a heavy wire bail. Marked "USA" it measures 10" to the top of the ladle.

A nice companion to the Cowboy Boots is the Saddle. Not to be confused with the Blackboard Saddle this one stands 12" high and is not marked.

A quick find for any collector is the Churn. This jar was also done with blue underglaze on the flower petals rather than the red cold paint. Marked "USA", the Churn stands 10" high. See the chapter on Families for additional Churn pieces.

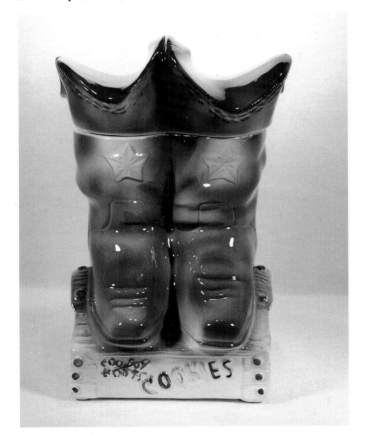

Consistently a favorite among collectors the Cowboy Boots jar stands 12 1/2" high and is marked "USA 742".

Cup of Chocolate with Marshmallows is another common jar. It measures 9 1/4" high and is marked "USA".

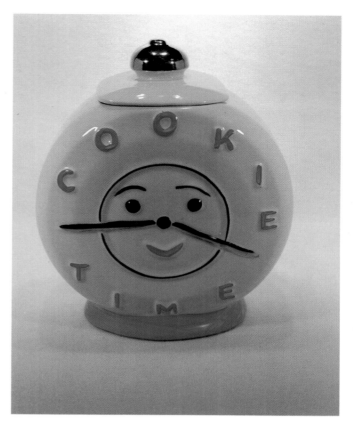

The Cookie Time Clock can be found with gold on the finial and hands like this one or in red. The clock, rather than sitting on wedges, has a full circular footing. This one is marked "USA 203" and stands 9" high.

The Gift Box must have been a wonderful way to present a friend with home baked cookies. Marked "USA", 9 1/2" high.

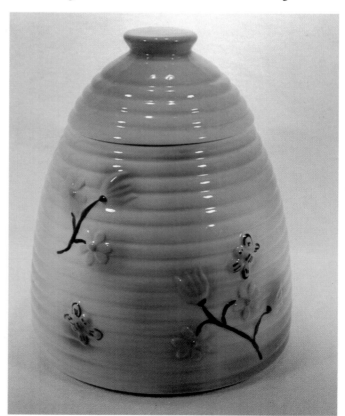

Another version of the Beehive, this one minus the kitten on the lid. This jar can also be found in a beige color underglaze. Marked "USA", it stands 9 1/2" high.

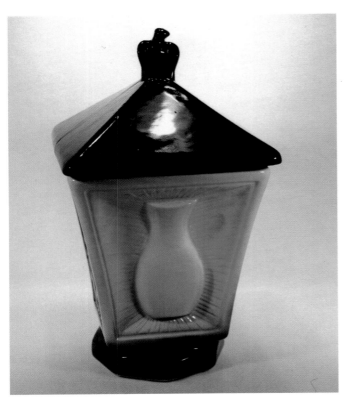

Referred to as the Coach Lantern this jar is rather tall. It measures 13" to the top of the eagle finial. The three sides of this jar, not visible here, have a diamond pattern done in relief and airbrushed in black under the yellow. This Lantern is not marked.

A very common jar, the Cylinder with Rings is not marked. It stands 8 1/2" high and one of the "rings" on the jar is done in red cold paint.

The Basket of Cookies shown here in yellow has also been seen in brown, green and blue. Marked "USA", the basket stands 11 1/4" high.

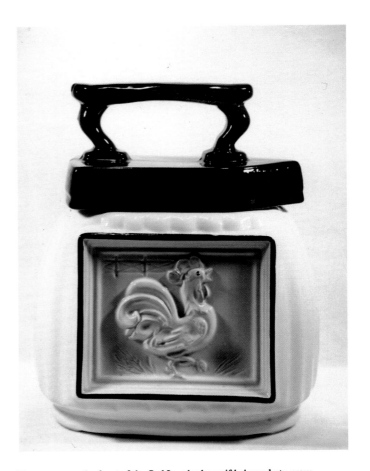

The rooster on the front of the Sad Iron looks as if he's ready to crow about something. Marked "USA", the Sad Iron is 11 1/2" high.

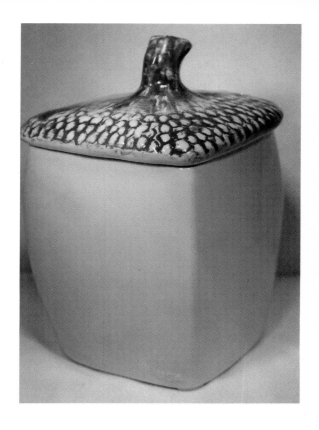

Autumn colors adorn this Acorn and Oak Leaf corner jar. Though not easily found, this jar has been seen in more muted tones.

The reverse side of the Acorn and Oak Leaf shows why it is considered a "corner jar". Note that this one, differs from the Cheerleaders and Bear and the Beehive, in that it does not say "corner jar". Marked "USA" in raised letters it stands 9 1/2" high.

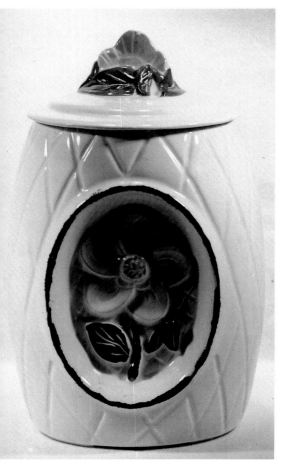

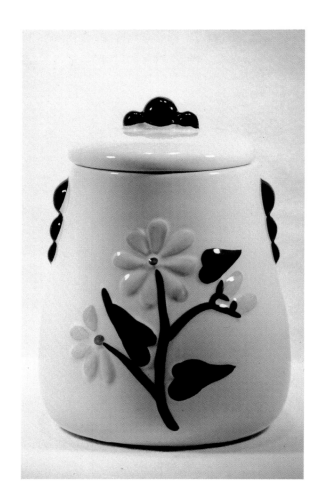

We recently saw this plain Blue Flower Cylinder jar in a kitchen decorated in shades of blue and white. It was a stunning addition which just goes to show that even seemingly plain jars have their place. The jar stands 11 3/4" high and is marked "USA".

Similar in design to the Cylinder with Rings is the Daisy Cylinder. Totally underglazed the Daisy Cylinder standing 9 1/2" high is marked "USA".

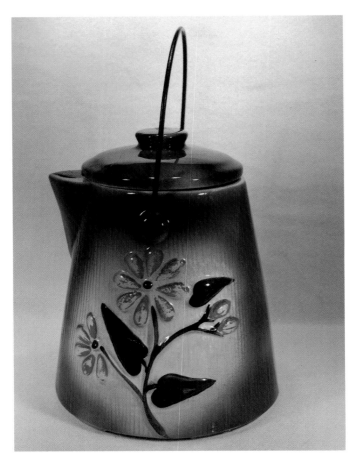

Similar in color and design to the Churn, the Coffee Pot is one of a number of coffee pot's. This one stands 10" and is marked "USA". Like the Churn it was also done with blue flowers and there are accessory pieces available.

Probably the most common coffee pot is the Cup of Coffee and Cookies pot. This jar is 9 1/2" high and is marked "USA". The collector will have no trouble finding this jar.

Another version of the coffee pot, this one will not be so easily found. The entire jar is finished in a spattered design of 24K gold. Also 9 1/2" high, this jar is marked on the bottom surface with an "American Bisque Company" circular gold stamp.

The Pine Cone Coffee Pot differs from the others in that it has a stationery handle rather than a wire bail. The jar is marked "USA" and also stands 9 1/2" high.

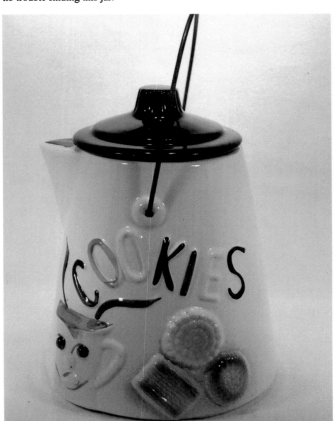

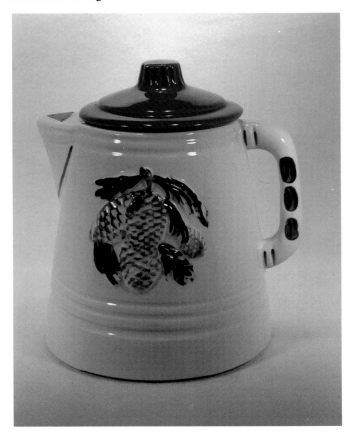

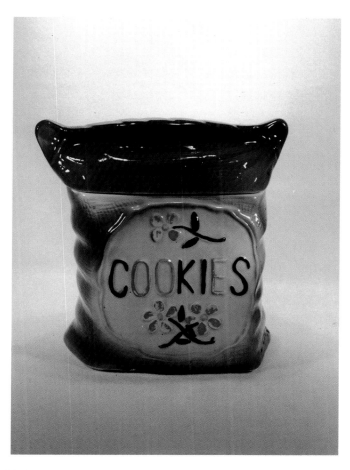

The Feed Sack took a while to locate. Also found with blue flowers and accessory pieces, the red on this jar is done in cold paint. The Feed Sack is marked "USA" and is 9 1/2" high.

Similar in decoration to the yellow coffee pot is this Cookies Cylinder. The lid on this jar is correct though it lacks the spattered 24K gold present on the base. We have also seen this jar in blue. This jar is 10" high, marked,"American Bisque Co. U.S.A 24 Kt. Gold" in a circular gold stamp and additionally has USA incised in the bottom.

The Strawberry jar has a full outline footing and is marked "Sears Exclusively Patent Pending". Another jar with many accessory pieces (see chapter on Families), the Strawberry is 8 3/4" high.

Bottom view of the gold spattered Cookies Cylinder. Note the full circular footing rather than the typical wedges.

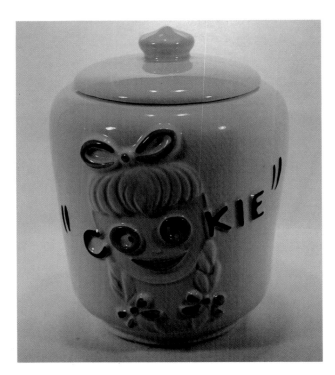

The "Cookie Girl" shown here is the plain version of this jar. Also found with her "glasses" trimmed in 24K gold, this is the more common. This jar with a slightly different knob on the lid was also made by Abingdon and is appropriately marked. "Cookie" is marked "USA" and is 9" high.

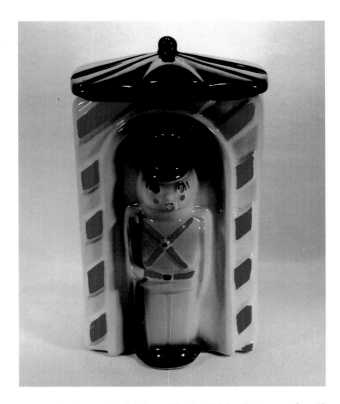

Often referred to as Toy Soldier or Wooden Soldier the name assigned by American Bisque is "Sentry". The jar bears it's catalog number and standing 11 1/4" high is marked "USA 743". This jar can, though not common, be found with blue under glazed stripes rather than red cold paint.

The next five jars are a curiosity to us. Though identified as American Bisque jars in other publications, we believe that they are **NOT**. Without concrete evidence we have some serious reservations for a number of reasons.

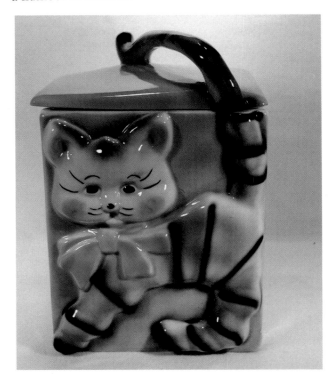

Cat with Tail finial. This jar has a U shaped footing and is 10 1/4" high, marked "USA".

Poodle with Bow finial. Marked "CJ 5, USA" the poodle stands 10 1/4" high on a U shaped footing.

Deer with Log finial stands 9" high on a U shaped footing and is marked "USA".

Known as Candy Baby, this jar can be found in green/yellow and blue/yellow shades. It stands 10 3/4" high also on a U shaped footing without benefit of mark.

The Clown Bust is sometimes called Pinky Lee. This jar is also found in reverse color with a pink hat and base and a turquoise bow tie. This jar like the last four also sits on a U shaped footing. This one however is much wider and faces in the opposite direction. The clown is incised, "USA" and stands 10 1/2" high.

Consistency is the main reason for our doubts and though these jars are "consistent", they seem to be only consistent to each other. First of all, from the earliest to the latest, American Bisque jars all had the interior of the lids glazed. These five do not. Secondly, the "U" shaped footing is common only to salt & pepper shakers and the Santa Claus mugs. Thirdly, the Cat with the Tail finial is very clearly incised "CJ 5". This marking is not even slightly close to any other American Bisque marking we have seen. The argument has been made that the colors are "absolutely" American Bisque. While we don't disagree with that statement one needs to bear in mind that companies producing underglaze commercially could and probably did sell it to any pottery that placed an order. We can only say that the pink and blue coloring also matches the same pink and blue coloring found on many pieces produced by many potteries. Brush is a prime example.

It just seems very strange that out of all the jars produced they would suddenly design five jars, leave the interior lids unglazed and throw a different footing on the bottom. We'll keep these pieces in our collection because we have come to love them like the rest, but we remain unconvinced and reserve judgement as to manufacturer until some better information comes along.

The "Hands in Pockets" series of cookie jars seems to have been a rather ingenious way to produce many jars with only the benefit of a lid change. This series can be found with a pig, rabbit, elephant, cow, lamb and cat head, all on the same hands in pocket base. In addition this jar was done in two different sizes, the smaller of the two more of a candy jar size than a cookie jar size.

This Hands in Pockets Cat, shown in chartreuse can also be found in pink and airbrushed in underglaze in multiple colors. The cat is 11 1/2" high and is marked "USA".

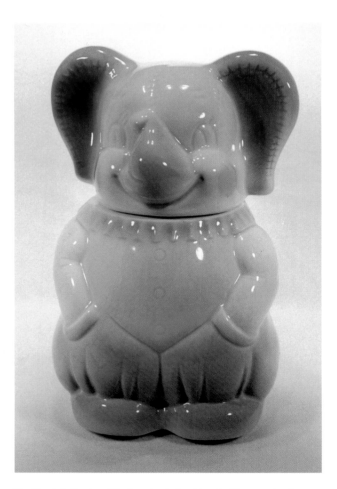

The Hands in Pockets Elephant is nicely airbrushed in an underglaze unlike the cat. It is marked "USA" and stands 10 1/2" high.

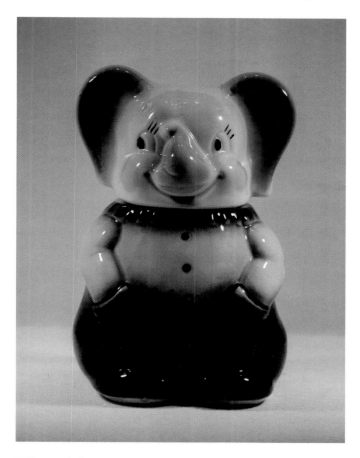

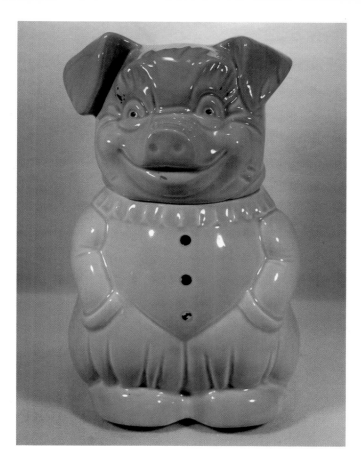

Different coloring and different size. This little guy stands 8 3/4" high and is not marked.

Like the cat we have a chartreuse pig standing 11" high and marked "USA".

Note that the base of the Hands in Pockets Lamb has the same coloring as the elephant. This jar shows black cold paint detail which has almost been washed away. The Lamb stands 10 1/2" high and is marked "USA".

Same as the last jar in pink glaze.

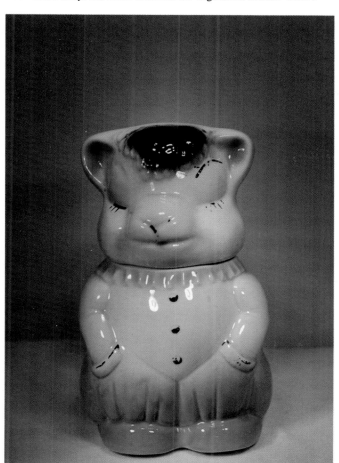

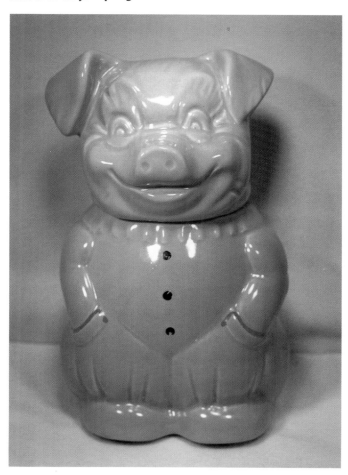

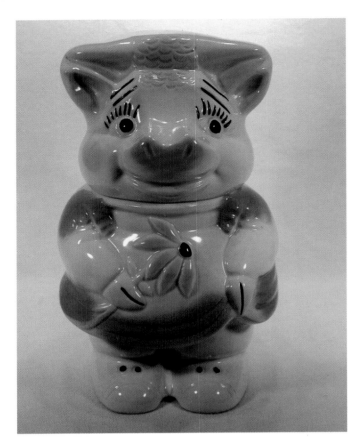

The first view of the cow/lamb turnabout. This jar stands 11" and is marked on the lip of the lid: "© Trade Mark Reg. Turnabout The Four in One." Produced by American Pottery.

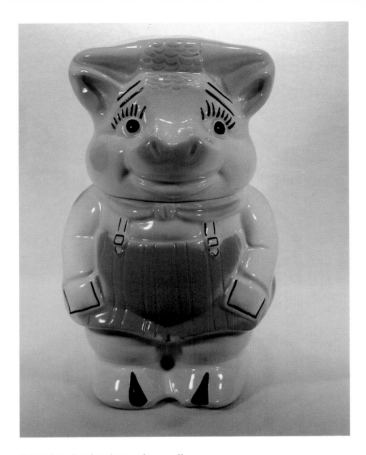

Third view showing the cow in overalls.

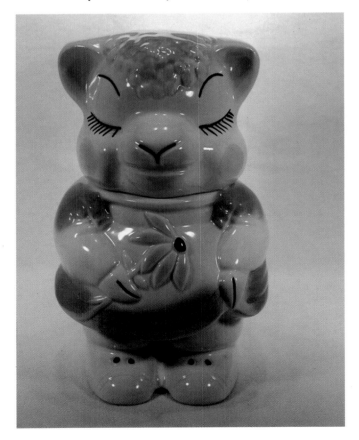

Second view with the lid turned around.

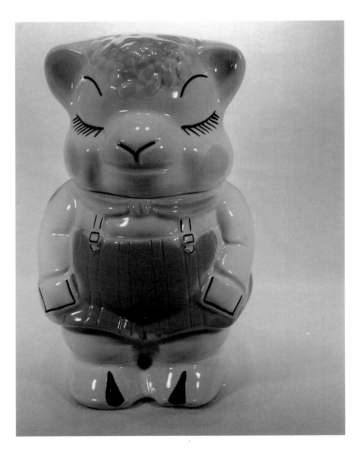

The final view showing the lamb in overalls.

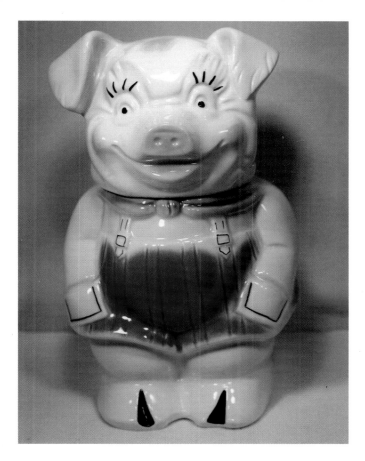

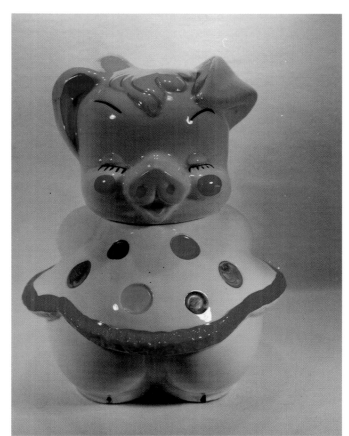

Another turnabout jar produced by American Pottery. On this jar the lid is a pig on both sides of the lid. It stands 10 3/4" high and unlike the previous jar is not marked on the rim of the lid.

The dancing pig with indented dots is decorated in cold paint. Standing 11 1/2" high, this particular jar is not marked and rather than the typical wedge bottom it sits on a outline footing.

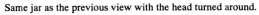

Same jar as the previous view with the head turned around.

Another version of the dancing pig, this jar has indented shamrocks which we have seen detailed in green cold paint. This jar measures the same as the previous one and also has an outline footing.

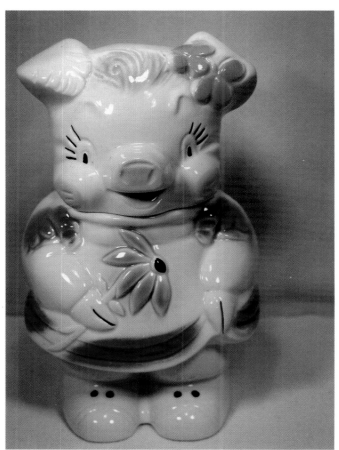

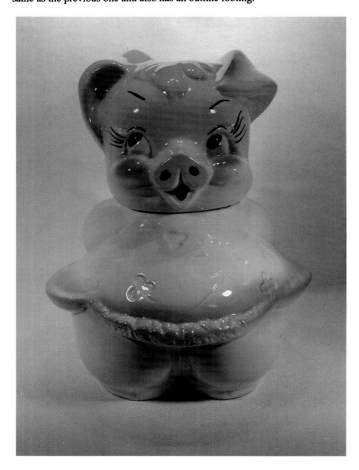

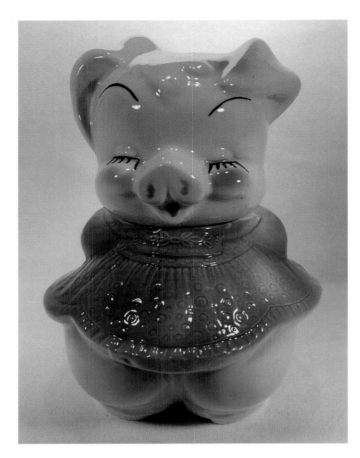

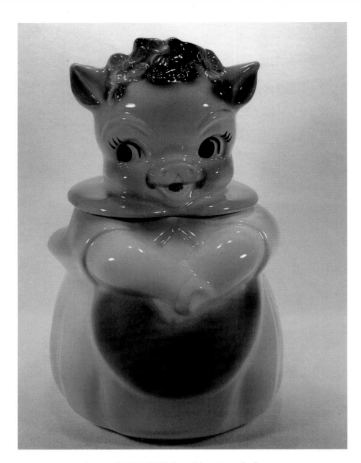

A smaller version of the same pig, this one stands only 10" high. The jar is not marked but this time sits on the typical wedge bottom.

The little lady pig stands 11 1/2" high and is not marked.

The boy pig with the scarf is 11 1/2" high and is not marked.

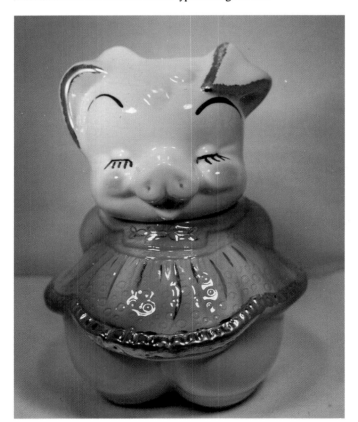

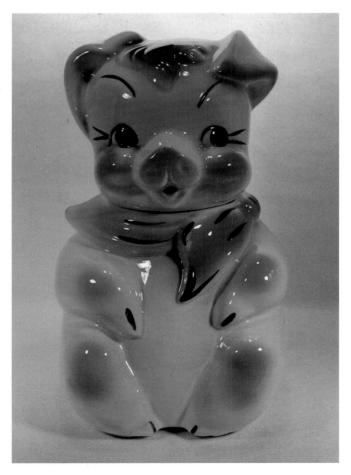

Identical to the last jar with the exception of heavy gold detail. This jar is also not marked.

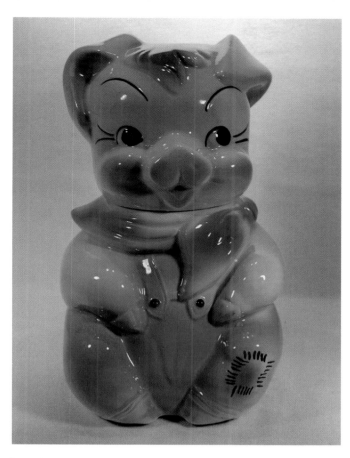

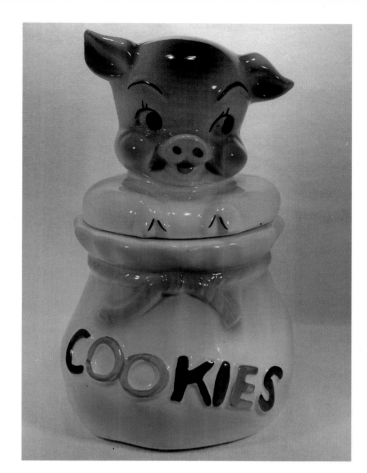

Same pig - look again, this one is wearing overalls. Also 11 1/2" high this one is marked "USA".

Though very similar in appearance to the last two jars, the head is not removable on the farmer pig, just the hat. Not marked this jar stands 13 1/2" high.

The Pig in a Poke stands 12 1/2" high and is marked "USA". This jar can be found in blue and green.

S.S. Kookie the little sailor elephant proves to be a somewhat illusive fellow to find. Standing 11 3/4" high it is not marked.

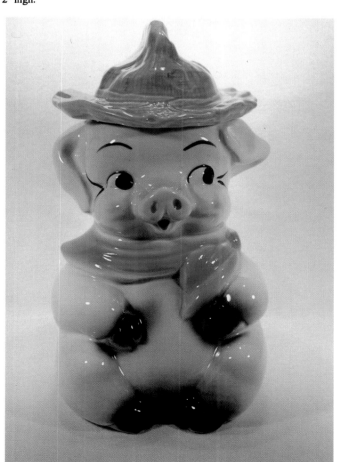

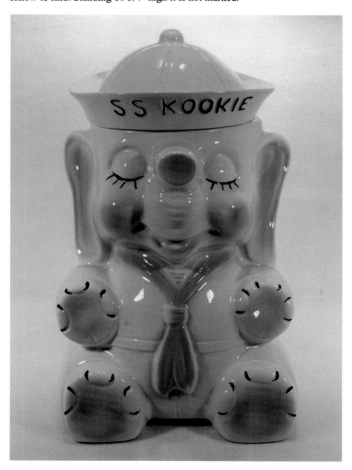

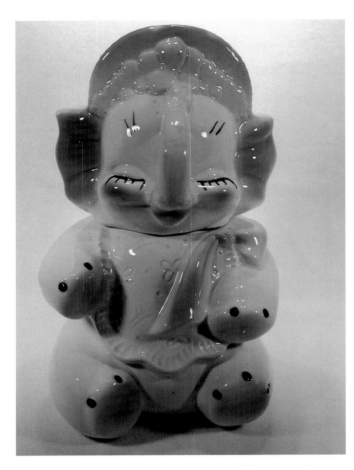

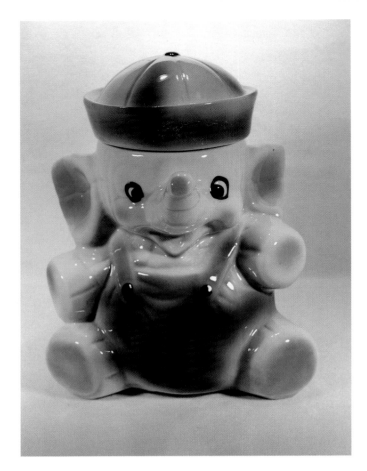

The baby elephant with bonnet can be found in two different sizes. This one measures 11 1/2" and the other version measures in at 13 1/4". Neither this jar or the larger one is marked.

Very similar to the last elephant this one sports a sailor cap, also note the absence of the patch on his overalls. Marked "USA" he sits 10 1/4" high.

The chick can be found in a variety of colors and decor. This one with indented dots seen patterned on other jars. He stands 11 3/4" high on a full outline footing and is marked "USA 129-A".

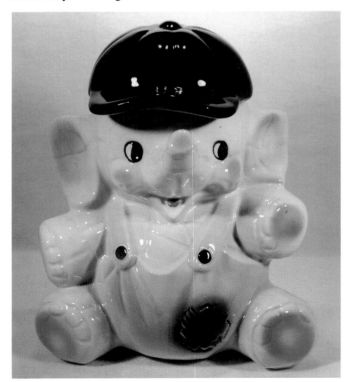

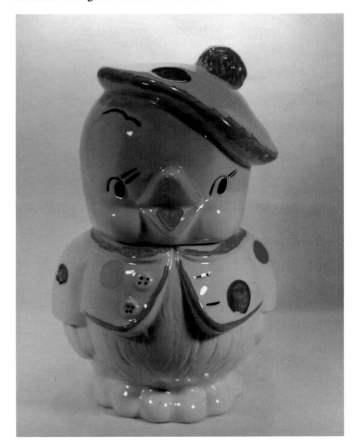

Another baby elephant ready for baseball season. This jar can also be found with different colored overalls and hats. Marked "USA" he sits 10" high.

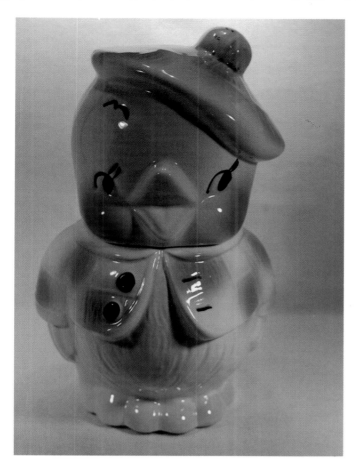

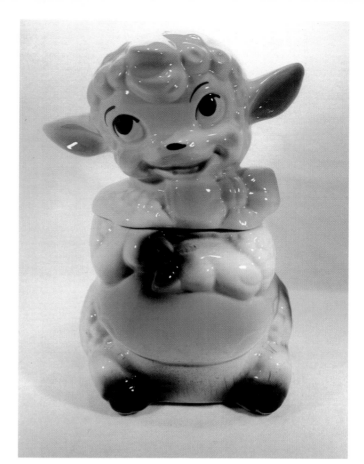

Similar to the last jar this one stands 12 1/4" high on wedges. Note the checkered design in his jacket. Any of the chicks pictured here should be easily found.

Identical to the previous jar, the only difference here is color. In addition to the chick with the indented dots and this jar, another can be found with the jacket absent of the checkered pattern.

The little girl lamb is marked "USA" and stands 10 1/2" high.

The little boy lamb sports a heavy collar with bell and his lid appears to be a flower blossom. Not as easily found as his female counterpart he is marked "USA" and stands 13" high.

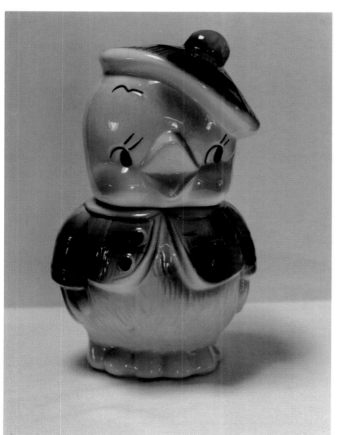

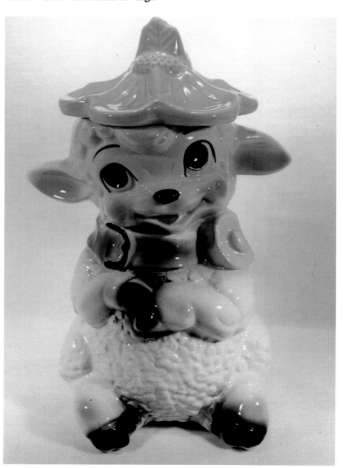

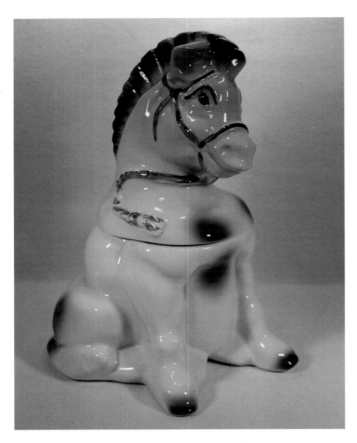

A big favorite among collectors is the sitting horse. Not easily located, he sits 11 1/2" high and is marked "USA".

The little bear on the beehive was produced by American Pottery. Standing 10" high it has a full circular footing and is not marked.

The Magic Bunny stands 12 1/4" high and is marked "USA". Known colors are green, blue and yellow and the bunny lid was also produced in a gray color.

The bear with the visor cap is marked "USA" and stands 11 1/2" high. Also found with blue cap and bow.

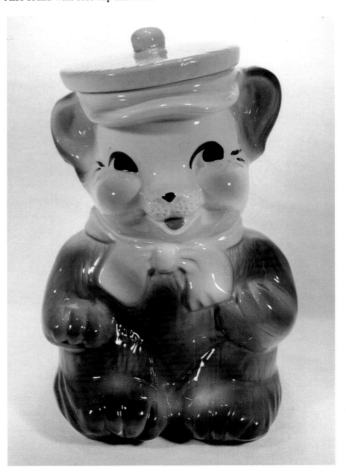

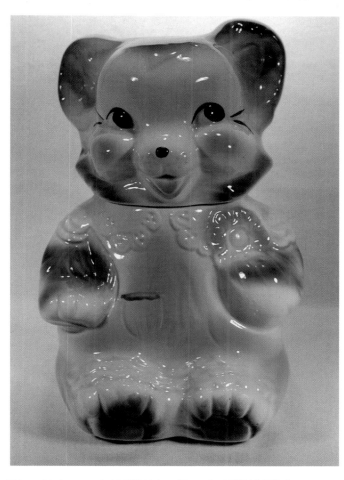

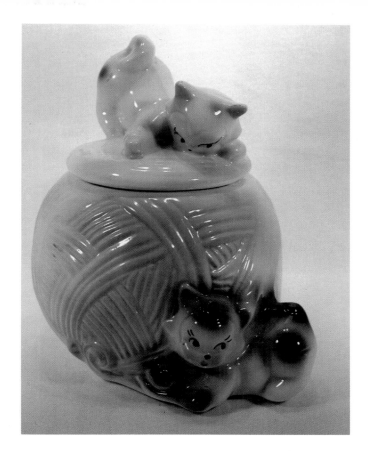

This cookie bear stands 11 1/4" high and is marked "USA". This jar can be found wearing a bib rather than the lacy rompers pictured here. This is also another jar found in two sizes.

This is the smaller or standard version of the Kittens on Ball of Yarn. Standing 9 1/2" high and marked "USA", chartreuse green is the only color we've seen on this jar.

Cat on the Quilt stands 13" high and is marked "USA". The airbrushing on this jar gives the impression of velvet.

Though nearly identical in style to the previous jar, this jar is commonly referred to as Figaro as the kittens are always found in black and white. This larger version stands 10 1/2" high and is not marked.

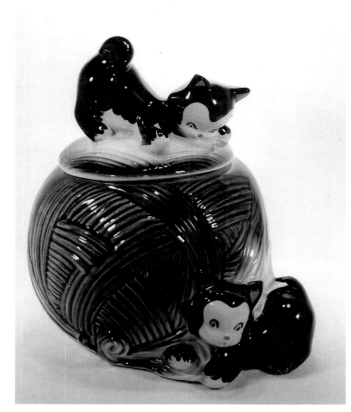

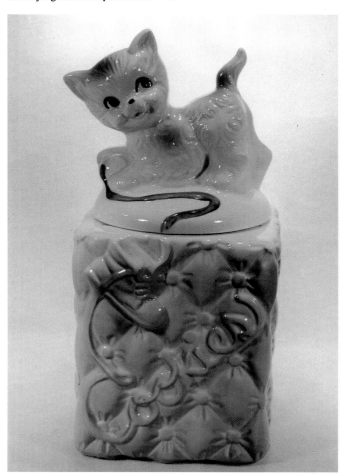

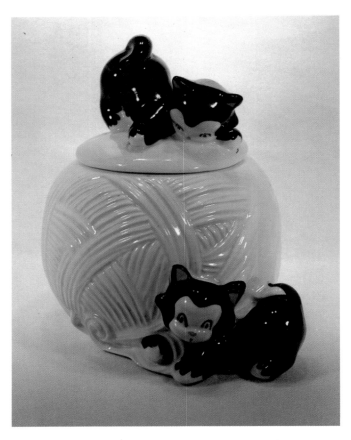

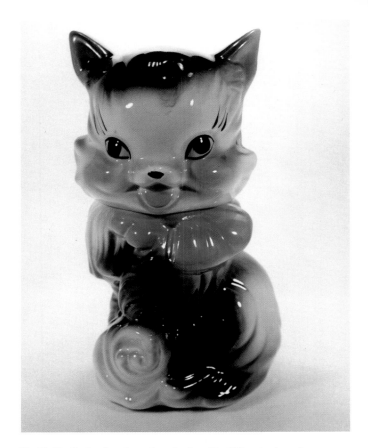

The same "Figaro" jar in yellow. This jar has also been found in dark pink. See the chapter on families for complimentary matching pieces to the cookie jar.

The Kittens on the Beehive is marked "USA" and is more frequently seen in yellow than beige tones. Common and plentiful this jar finds it way into most collections.

The Fluffy Cat is a favorite and can be found in different color schemes. Standing 11 3/4" high, this particular jar is not marked.

Look familiar? Another of the "indented dot" series, also another version of Fluffy though slightly taller at 12 1/4" high. This jar is marked "USA 131A" and has a full outline foot rather than the standard wedges.

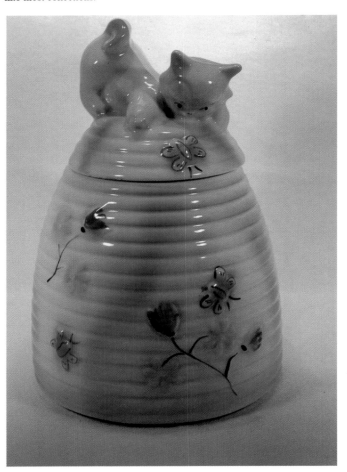

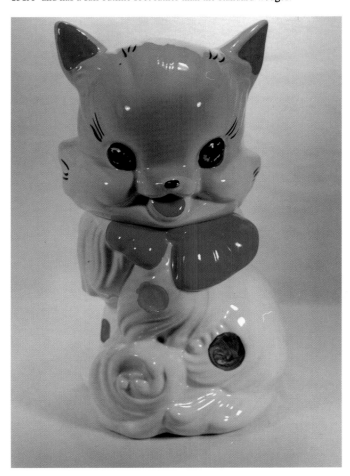

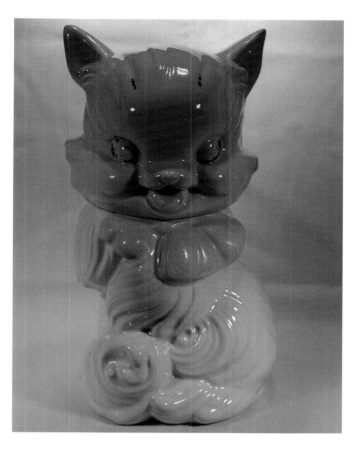

From the Ludiwici Celadon mold, this is most probably the forerunner to the other Fluffy's. Standing 13 1/4" high this jar is incised, "Fluffy" and has a full outline footing.

This little French Poodle is decorated in 22-24k gold. He stands 10 1/2" high and is not marked. This jar is plentiful and can be found in many color combinations.

Same poodle minus the gold.

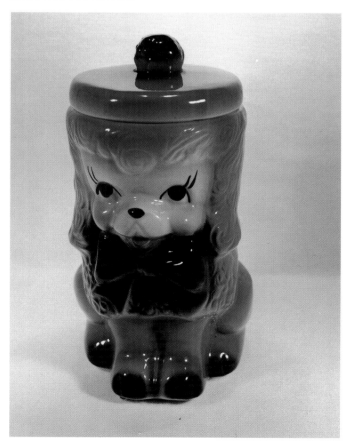

Another color variation. Also commonly seen in white and turquoise and white and burgundy.

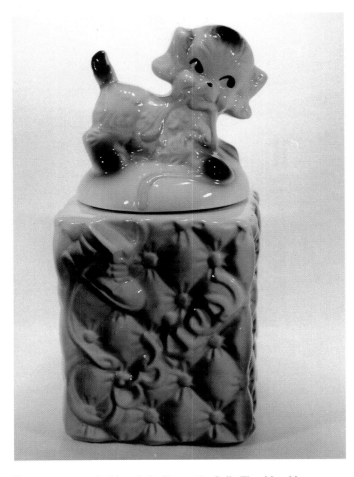

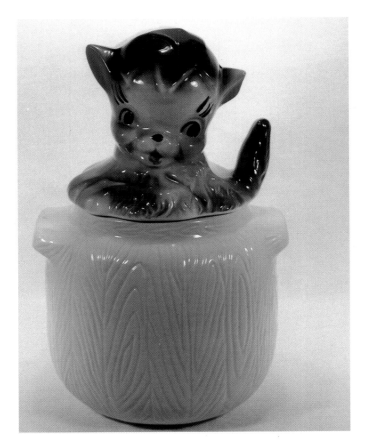

The counterpart to the kitten is the Dog on the Quilt. The airbrushing on this jar also gives the appearance of velvet. Standing 13" high this jar is marked "USA".

This first version of the Puppy in the Pot is the most common. The pup has no adornment on his head and the pot bears the word "cookies". Marked "USA" it stands 11 1/2" high.

Less common than the last version this little pup wears a flower or star on the top of his head. It is sometimes called the Pup in the Pot with Poinsettia, though poinsettia stretches the imagination a little. Note that the pot in this version is plain with the word "cookies" absent. A third version of this jar is available in black and white and, rather than the pup, it has a plain smooth top.

Bear with eyes open can also be found decorated in underglaze. This jar is entirely detailed in cold paint and it is not original. Not marked, the bear stands 11" high and rather than wedges has a full outline footing.

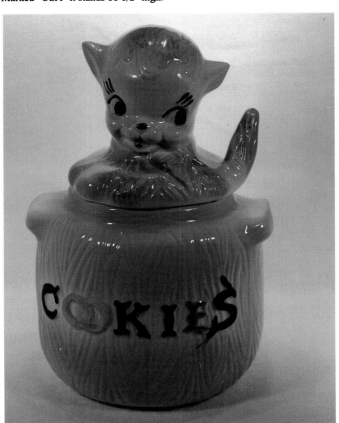

Another of the familiar indented dot series, this bear has his eyes closed. He stands 11 3/4" high, is not marked and also has a full outline footing.

Boy/Girl Bear turnabout stands 12 1/2" high. Originally a Ludiwici Celadon mold this jar is marked "Patent Applied Turnabout, The 4 in 1". The bottom of this jar has a full outline footing. This view is the boy head on the dress bottom.

Same jar, girl head on pants bottom.

Third view, boy head on pants bottom.

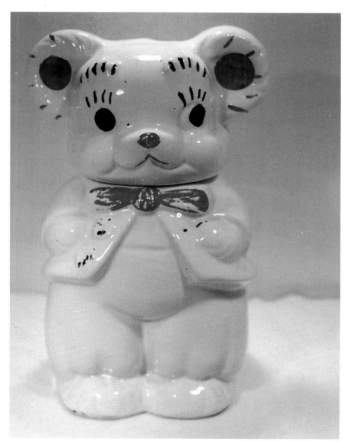

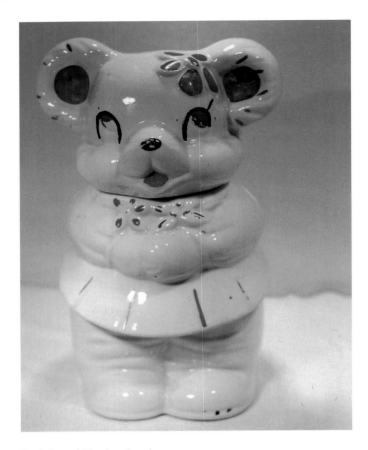

Final view, girl head on dress bottom.

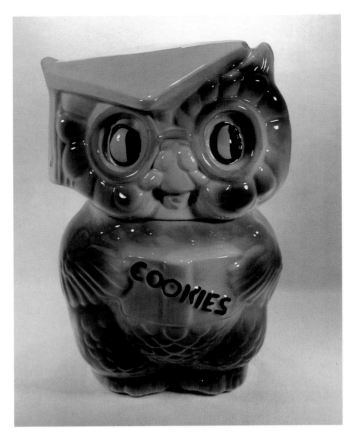

The Collegiate Owl measures 11 1/2" high and is marked "USA". This jar can also be found with 22-24k gold trim.

Difficult to find is the Toothache Dog. He is marked "USA" and measures 13 1/2" high.

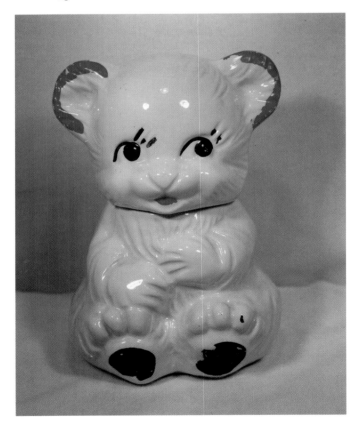

This tiny bear jar is more candy size than cookie size. Standing 8 3/4" high it is marked "Design Patent Applied APCO" inside the outline footing. This is only one of many of these mini jars. Others are rabbit, cow, baby, pig.

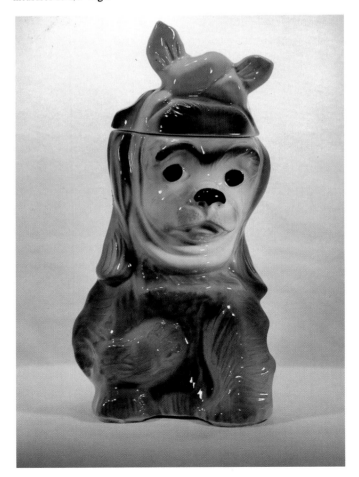

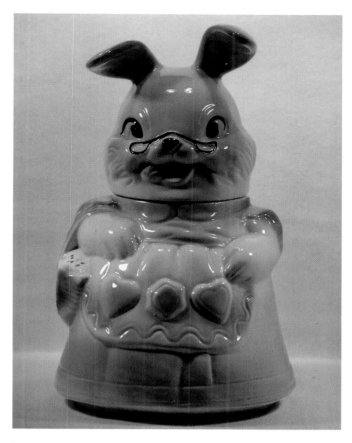

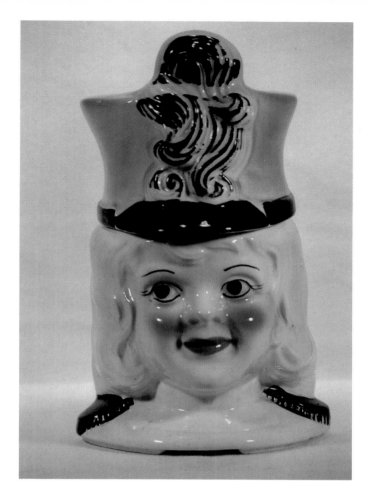

Grandma Rabbit proves to be another challenge to those in search. Her ears are about 3" long and extend forward over her forehead leading us to believe many were broken. She stands 11 3/4" high and is marked "USA".

The Goofy Rabbit seems aptly named. Marked "USA" he stands 11 3/4" high.

The Majorette stands 11 1/4" high and is not marked. Though similar to the Regal China Company Majorette, this one lacks gold detail and is firmly planted on the typical wedge bottom.

Jack In The Box is marked "USA" and stands 12" high.

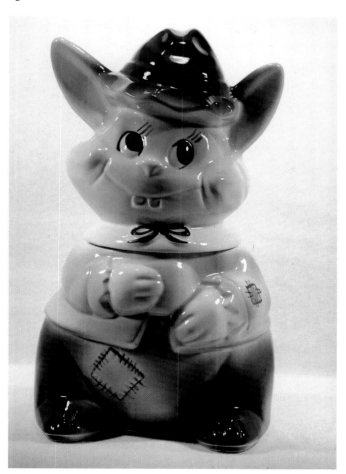

Commonly called the Umbrella Kids the correct name for this jar is "Sweethearts". The jar is marked "USA 739" and stands 11 1/2" high.

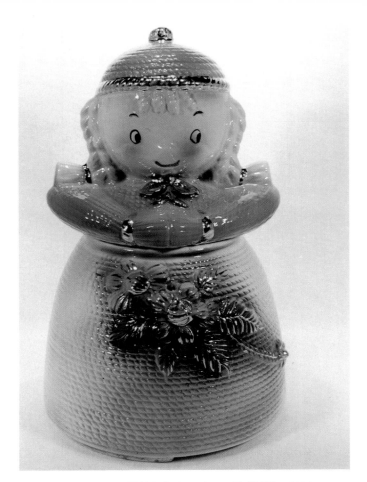

The Yarn Doll, standing 12" high, is shown here with 22-24k gold trim. This jar can be found in turquoise, green, yellow and multicolored. Not marked.

The Churn Boy also bears a strong resemblance to the same jar made by Regal China Company. Like the Majorette the Churn Boy lacks gold trim and sits on wedges. Marked "USA" it stands 11 3/4" high.

Same as the previous jar, this one lacks the gold.

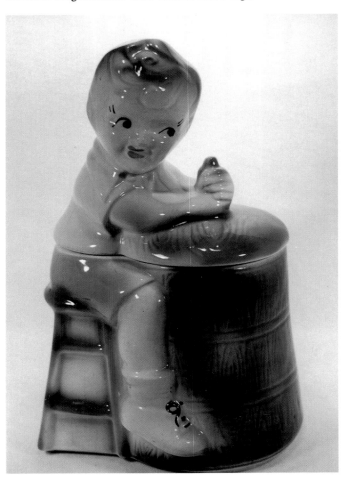

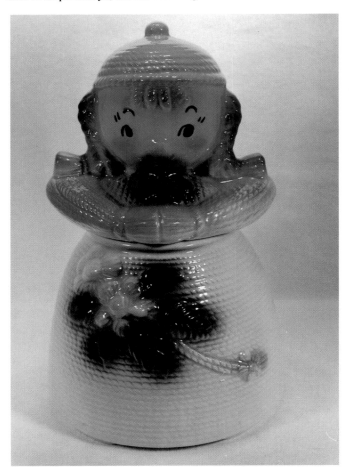

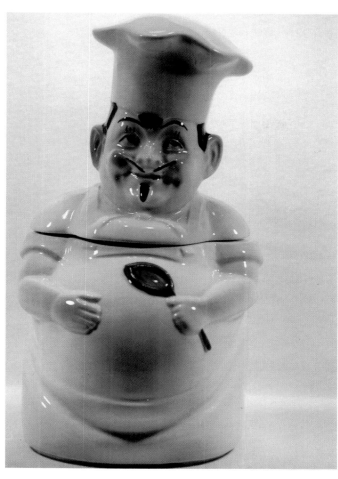

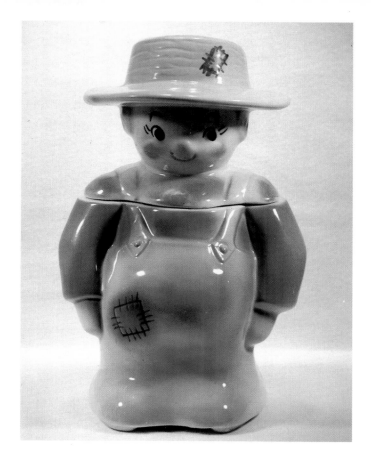

The Little Chef with his up-pointed mustache and goatee looks like an Italian chef dreaming about a steamy dish of gnocchi rather than cookies. Not marked, this jar stands 12" high and is one that can be found in two sizes.

The Pennsylvania Dutch Girl is 11 1/4" high and is not marked. Plan on being patient when looking for this little cutie and her partner.

The Pennsylvania Dutch Boy is also not marked and only slightly taller than his lady at 11 1/2" high.

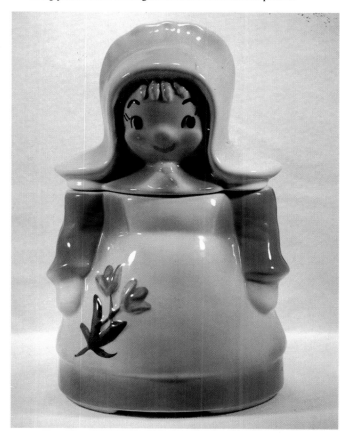

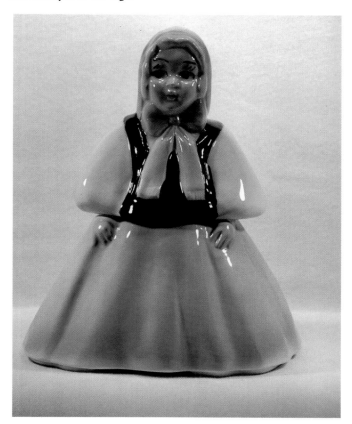

The Peasant Girl will also try your patience when searching. She stands 10 1/2" high and is not marked.

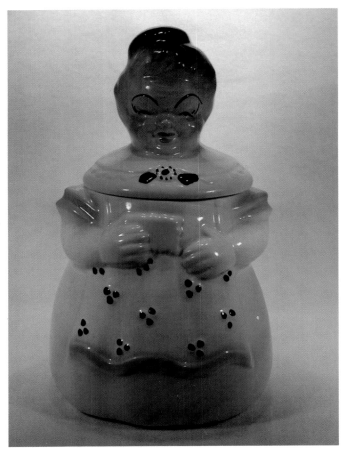

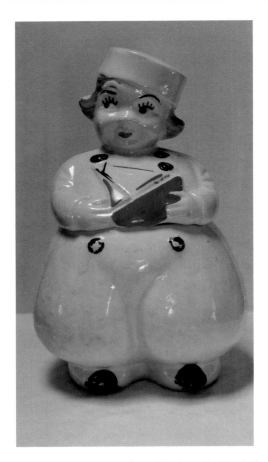

A favorite among collectors is Granny. She can be found in either yellow or green and also with 22-24k gold trim. Marked "USA" she measures in at 12 3/4" high.

Beautifully detailed in a cold paint underglaze is the same Dutch Boy looking quite different. He measures 12 1/2" high and stands on wedges. Marked "USA".

The Dutch Boy with the sail boat is airbrushed. The jar has a full outline footing and is marked "USA APCO". He stands 13" high. A matching Girl is also available.

The Dutch Girl in underglaze makes a fine mate to the boy. She measures 12 1/2" high, also on wedges marked "USA".

Although this jar seems identical to the previous jar, the color of the clay used is different. This one is also 13" tall standing on a full outline footing but the marking differs in that it reads, "USA ABCO".

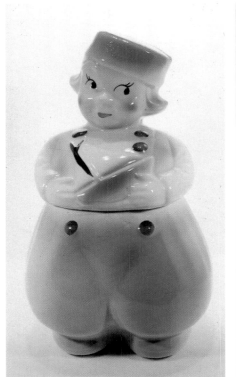

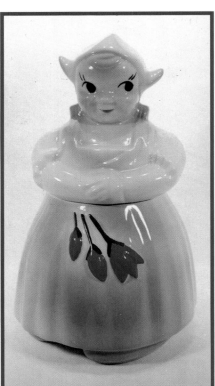

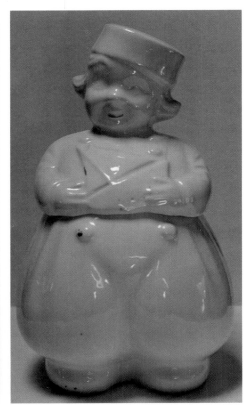

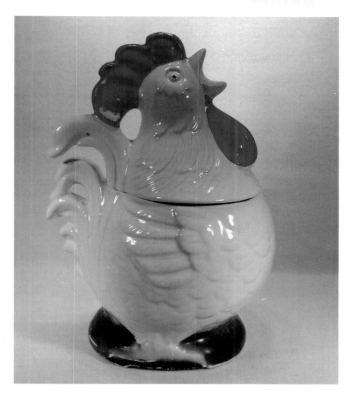

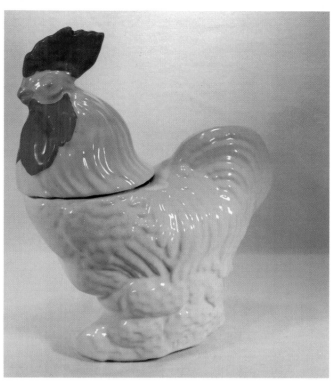

The Crowing rooster is one of two. Note the open spaces between the tail feathers on this jar. Detailed in cold paint he stands 12 1/2" high and is not marked.

Also detailed in cold paint this Rooster seems somewhat more sedate than the last one. He is 11" high, marked "USA" and can also be found in solid yellow as well as multicolored.

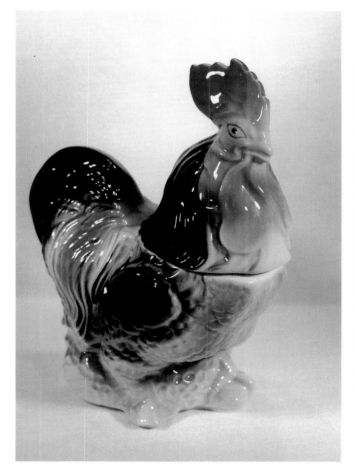

Every rooster needs a hen and this is a particularly fine specimen. She is marked "USA" and stands 9 1/4" high looking rather please with the chick riding on her back. This jar can also be found in plain white with cold paint detail.

Slightly shorter at 10 3/4" high, this colorful airbrushed Rooster is identical to the previous one.

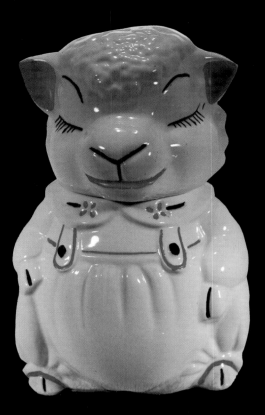

Produced by both APCO and ABCO this Lamb sits on an outline footing. Standing 11 1/2" high it is marked "Design Patent 132170 AB CO".

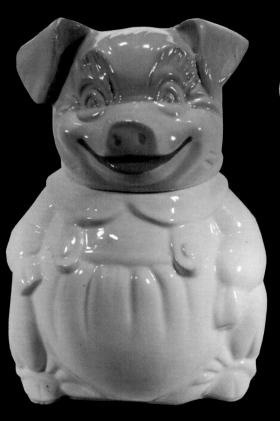

The Bull is identical in marking and size to the previous Lamb jar.

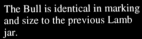

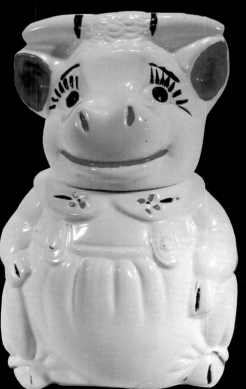

The Pig is slightly shorter than the last two jars, 11" high. The footing remains the same but the marking reads, "APCO". Note the bottom of this jar and the previous two are identical in style.

Produced by Ludiwici Celadon this appears to be the one jar not redone by either APCO or ABCO. The Belmont Lion is 11" high and is marked "Belmont" inside the outline footing. This jar was apparently produced for a private party under contract which explains why it was not redone.

Originally a Ludiwici Celadon mold, the Elephant was one that was modified and reproduced by APCO for sure and probably also ABCO. Standing 11 1/2" high on an outline footing this jar is marked "USA Patent Applied".

One of three with identical bottoms is the Rabbit. The jar stands 11 1/4" high on a full circular footing without mark. Matching salt and peppers are also available.

The Dog in the Basket is identical in size and marking to the previous jar. The third basket jar is a cat which is not shown here. Matching salt and peppers are also available.

CHARACTER

These jars above all others are the most prized pieces in any collection, we might add that they are also the most costly. Not only are they figural but they actually depict some character, fictional or real. Copyrights and patents are held on known characters and the production of these pieces are generally by licensing/contract only. All rights to Casper, for example, are owned by Harvey Productions. It is interesting to note that Casper, Yogi Bear, Herman & Katnip and Ludwig Von Drake are all marked as to ownership, yet none of the Flintstone or Popeye characters are marked in the same manner.

Reportedly made as a promotional item for the Mohawk Carpet Company, "Little Mo" the Mohawk Indian is without question the number one favorite at our house. Very difficult to find, Little Mo stands 12" high and is not marked. Presently being reproduced.

Side profile of Little Mo.

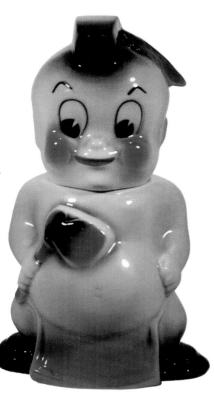

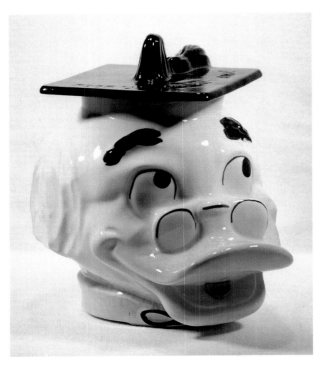

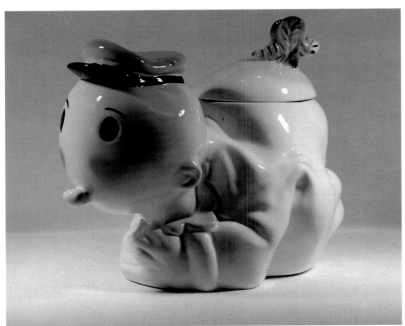

Side view of the same jar.

Ludwig Von Drake sports his name across the top of his hat. He also has a red felt tongue, which may or may not have survived the years. He is 9" high and marked "© Walt Disney Prod 1961".

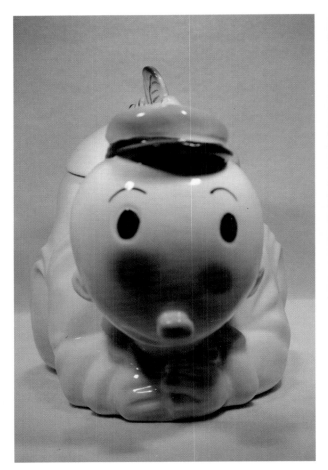

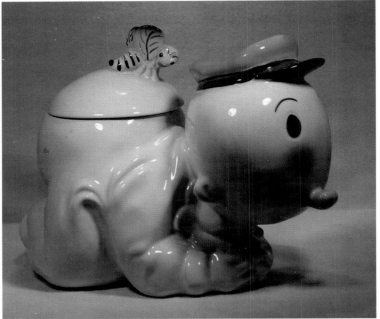

Buyer Beware! Without benefit of marking this Sweet Pea could fool you. This reproduction happens to be clearly marked in black underglaze on the bottom with a number as it was a limited edition. Also incised on the side is, "USA". Slightly lighter in weight, it is also a whiter white and measures 8 1/2" high. The collector must be vigilant as the price tag on the original Sweet Pea is 20 times greater than the price on this one.

Sweet Pea, Popeye and Olive Oyl's little buddy...or child? A very highly prized jar in any collection. Sweet Pea is 9" high and 12 1/2" long and is not marked.

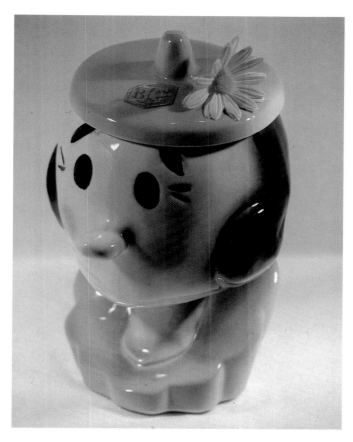

This Olive Oyl still wears her original ABC foil label, the silk daisy is not the original. She is 10 1/2" high and marked "USA". This jar is also being reproduced and copies we have seen have all been marked like the Sweet Pea. Again, Beware.

The original corncob pipe bears a paper label which reads, "Missouri Meerschaum, Corn Cob, Made in USA". It is 1 1/4" long and has a metal tip at the end of the stem.

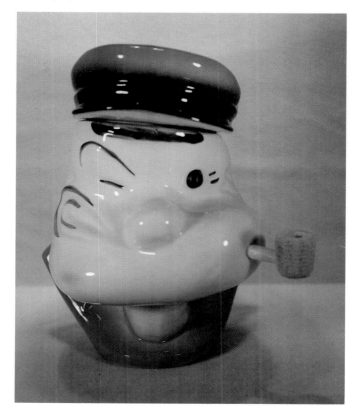

Popeye completes the group. He is also 10 1/2" high and marked "USA".

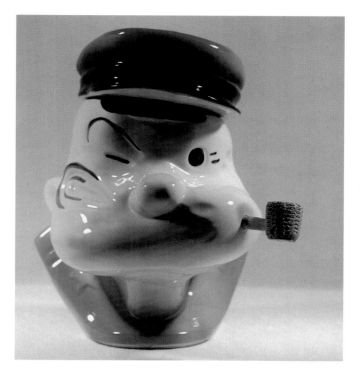

As you would expect, a Popeye reproduction exists. This particular Popeye was made by a bootlegger completely void of conscience. It is marked "USA" but there is no underglaze marking indicating a limited edition. The blue is slightly brighter than the original and the weight is lighter but he does measure 10 1/2" high.

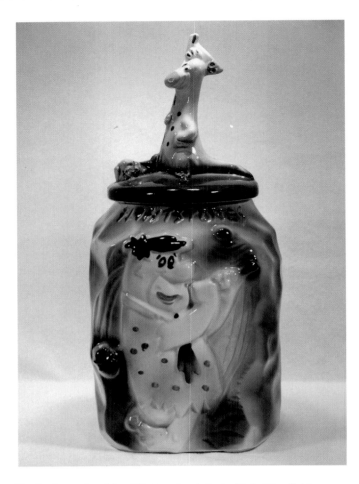

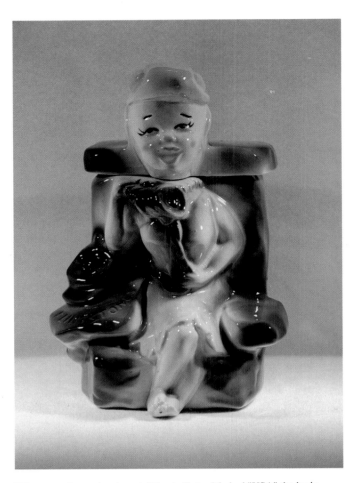

The first in a series of four Flintstone jars is Fred with the Dino finial. This jar, when found, has usually been repaired. For some reason the Dino tends to break in half under the chin. Marked "USA" the jar stands 14 1/2" high due to the 5" Dino finial.

Wilma must be on the phone talking to Betty. Marked "USA" the jar is 12" high.

The final jar is Dino carrying Fred's golf bag. Standing 12 1/2" high this jar is void of the "USA" mark.

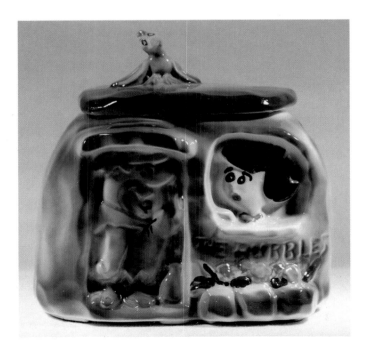

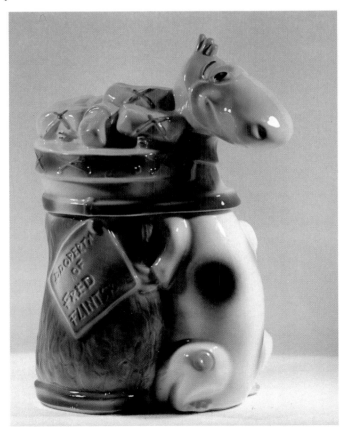

Of the set of four, the Rubbles House should be the easiest to secure. Marked "USA" it stands 10" high.

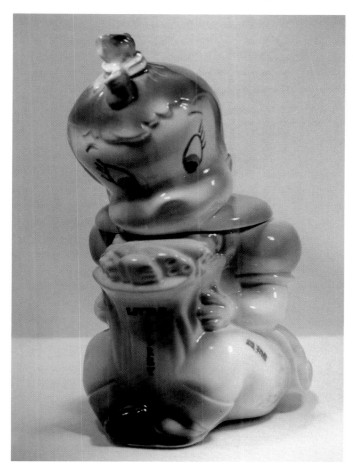

Little Audrey looks ready to devour the contents of her sack. She is marked "USA" and measures 13 1/2"h x 8 1/2" w. Rare!

The Rarest of Rare! Herman & Katnip. Marked "USA" the jar measures 11 1/2"h X 9"w.

Shown from the side you can see the bandaid on her thigh and the detail in her lacy panties.

Reverse view of Herman & Katnip.

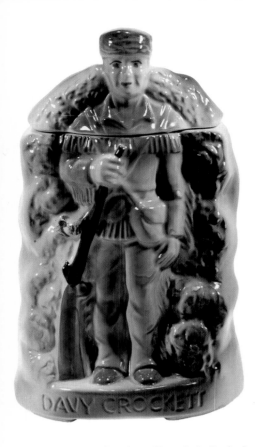

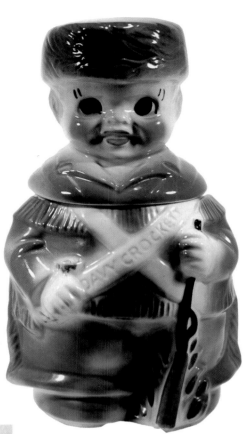

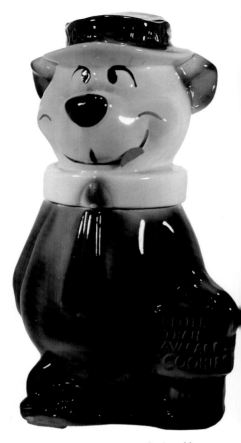

Sometimes referred to as "Davy in the Bushes" this is one of two Davy Crockett cookie jars. Standing 11" high, this jar is not marked.

Yogi Bear is another jar that can be found in two sizes. His tongue is a piece of glued on red felt and due to age and washing is often missing. Yogi stands 10" high and is marked "© Hanna Barbara Productions USA - 1961."

The second Davy Crockett jar is the boy Davy. Standing 12 1/4" high this is also an unmarked jar.

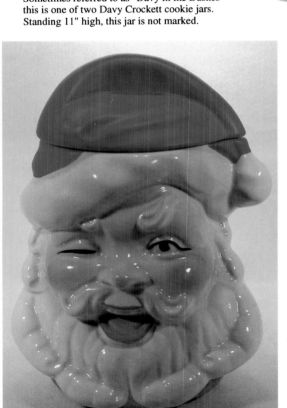

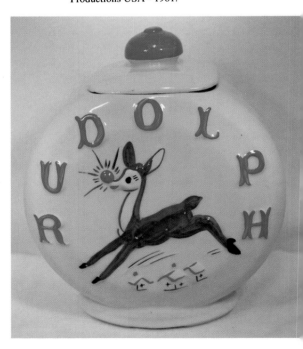

Santa Claus is wonderfully detailed. We have seen this jar many times - always with a yellow face! The red is cold paint and this jar has been repainted. He is 9 3/4" high and is marked "USA".

Rudolph is very similar in style to the Clock jar. The light rays emanating from his nose are done in 22-24K gold. This jar is 9 1/4" high and marked "RLM Copyright" for Robert L. May creator of the childrens classic Rudolph The Red Nosed Reindeer.

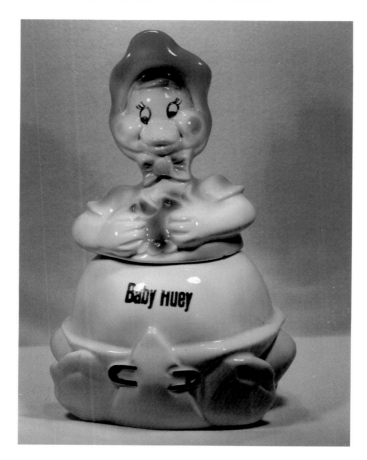

Baby Huey appears rather pleased with his cookie. His name, like Little Audrey's, is stamped underglaze. He stands 13 1/2" high and is not marked.

Side view of Baby Huey showing his wonderful dimples.

Vintage 1993 Baby Huey reproduction. Note the difference in clarity of the letters of the name between the original and reproduction. The blue and yellow on this jar are also brighter than the original. This Huey is slightly taller at 13 3/4" and is clearly marked "Limited Edition 17-200, by G.G." Unlike the original this jar is also incised "USA".

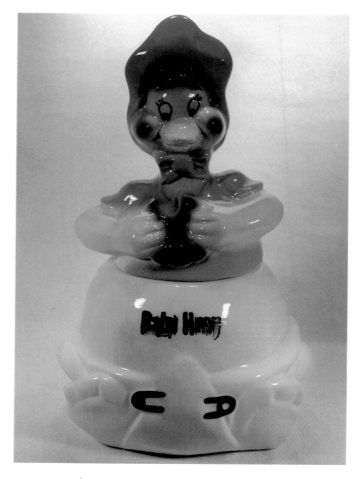

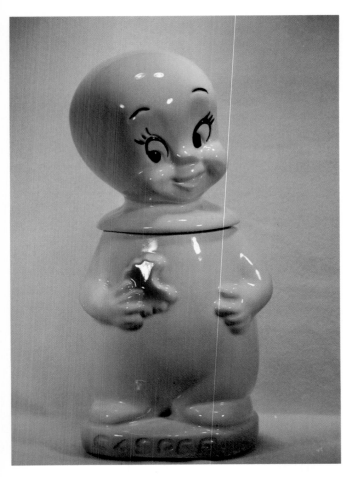

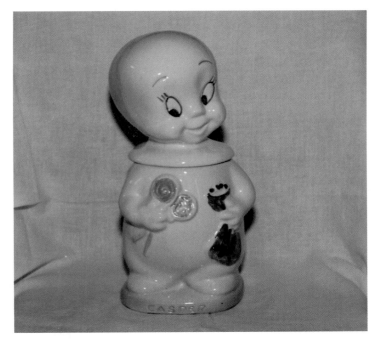

Another version of Casper, this one is considerably smaller. Holding lollipops in one hand we believe this may have been intended to be a candy jar rather than a cookie jar. Marked "USA", the little Casper stands 11 3/4" high. *Yoder Collection.*

Casper The Friendly Ghost stands 13 1/2" high and is marked "Harvey Productions, Inc. USA".

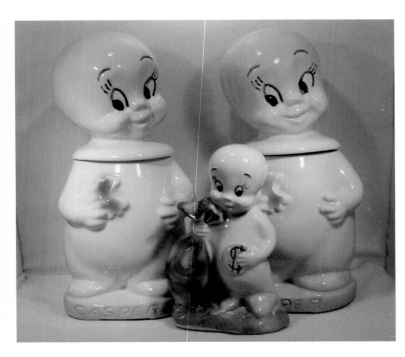

Casper in triplicate.

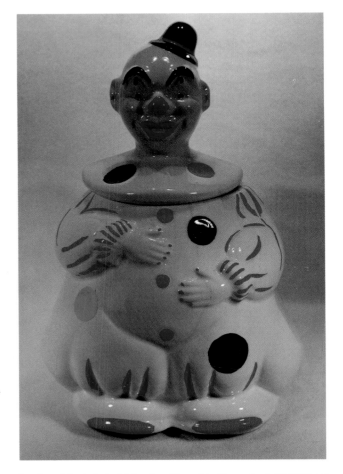

Another of the indented dot series of jars, this Clown stands 11 3/4" high on full outline footing rather than wedges. It is marked "126A".

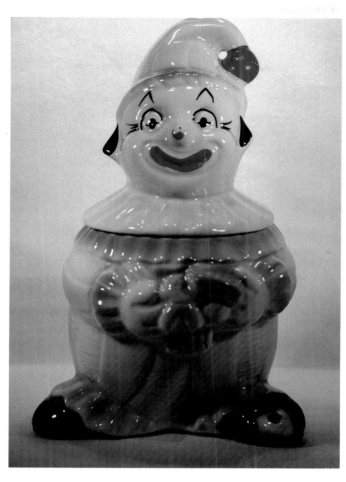

This Clown with the exposed toe can be found in a number of different color schemes. Standing 12" high he is marked "USA".

Very similar in style to the APCO Clown with indented dots, this Clown stands 12" high on typical ABC wedges. It is marked "USA".

Also known to exist in a number of color schemes the Happy Clown is 11" high and marked "USA". This is another jar being reproduced and the reproduction tends to be 1/2"-3/4" larger.

Similar in style to the previous jar, note the lid change. Completely detailed in cold paint, the Clown with Patches measures 11 1/4" and is marked "Design Patent 137,119 AB CO"; interestingly, the patent was applied for by J.B. Lenhart of APCO.

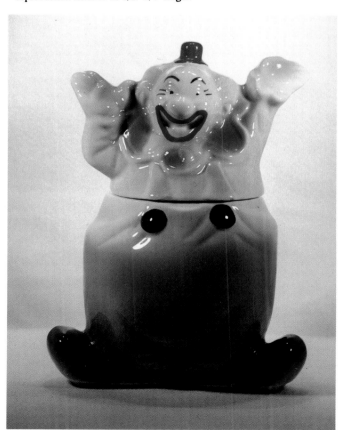

Cookie Jars w/Serving Tray
(Pat. Pend.)

#601
Basket w/Cookie Tray

#602
Modern w/Cookie Tray

#603
Chef w/Cookie Tray

Packed assortment of your choice or
6 of an item to carton. Each jar in-
dividually boxed, 6 to master carton.
7" high, 9½" wide
Weight 24#

#603

Cookie Tray Lid

Tray
9½" Long, 7" Wide

Each jar has cover that is ideal for cookie serving tray, also each tray is fitted
with cork feet so it will not scratch table—jars also shipped with cork pads.

Jars are packed with pressure
sensitive cork pads, to be used
on bottoms.

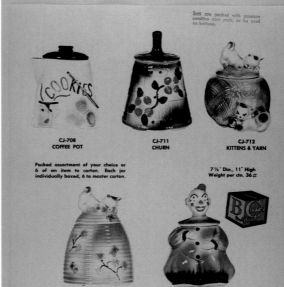

CJ-708
COFFEE POT

CJ-711
CHURN

CJ-712
KITTENS & YARN

Packed assortment of your choice or
6 of an item to carton. Each jar
individually boxed, 6 to master carton.

7½" Dia., 11" High
Weight per ctn. 36#

CJ-713
KITTEN & BEEHIVE

CJ-715
CLOWN

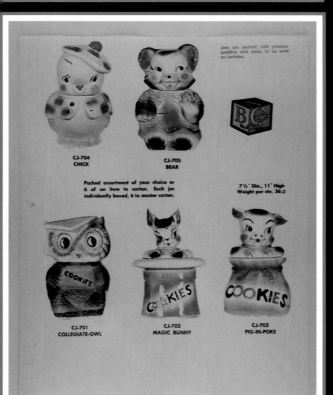

CJ-704
CHICK

CJ-705
BEAR

Packed assortment of your choice or
6 of an item to carton. Each jar
individually boxed, 6 to master carton.

7½" Dia., 11" High
Weight per ctn. 36#

CJ-701
COLLEGIATE-OWL

CJ-702
MAGIC BUNNY

CJ-703
PIG-IN-POKE

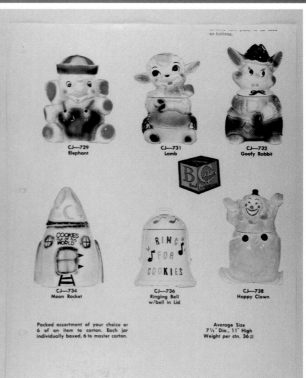

CJ-729
Elephant

CJ-731
Lamb

CJ-732
Goofy Rabbit

CJ-734
Moon Rocket

CJ-736
Ringing Bell
w/bell in Lid

CJ-738
Happy Clown

Packed assortment of your choice or
6 of an item to carton. Each jar
individually boxed, 6 to master carton.

Average Size
7½" Dia., 11" High
Weight per ctn. 36#



Jars are packed with pressure sensitive cork pads, to be used on bottoms.

CJ—739
Sweethearts

CJ—740
Milk Wagon

CJ—741
School House
w/bell in Lid

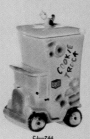

CJ—742
Cowboy Boots

CJ—743
Sentry

CJ—744
Cookie Truck

Packed assortment of your choice or 6 of an item to carton. Each jar individually boxed, 6 to master carton.

Average Size
7½" Dia., 11" High
Weight per ctn. 36#



NEW CHALK BOARD COOKIE JARS
(Pat. Pend.)

Jars are packed with pressure sensitive cork pads, to be used on bottoms.

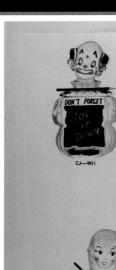
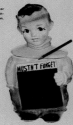

CJ—901

CJ—903

CJ—902

Packed assortment of your choice or 6 of an item to carton. Each jar individually boxed, 6 to master carton.
7½" Dia., 11" High
Weight 36#

CJ—904

CJ—905

Panel 3 (bottom left):

PAN-EYE-MATIC—COOKIE JARS
PAT. PEND.

Each Cookie Jar has an action piece as attached example.

Jars are packed with pressure sensitive cork pads, to be used on bottoms.

#801 T.V. Screen
#802 Girl Faces
#803 Rabbit Face
#804 Bear Face
#805 Clown Eyes
#806 Moon Face

#801
T.V. Bedtime

#802
Cheerleaders

#803
Rabbit & Log

Packed assortment of your choice or 6 of an item to carton. Each jar individually boxed, 6 to master carton.

Average Size
7½" Dia., 11" High
Weight per ctn. 36#

#804
Bear & Beehive

#805
Clown

#806
Cow & Moon

The cat on the ball of yarn is rumored to have been modeled after Walt Disney's Figaro the cat from Pinocchio. We have not been able to substantiate licensing from Disney; therefore, the speculation remains. If not truly Figaro this little black and white kitten certainly fits the bill and is referred to as Figaro, licensed or not. The cookie jar pictured in this set differs from the standard light green colored jar, which can be found with either brown or gray kittens (see Chapter 6), in size which is larger and color of the kittens which is always black and white. This set is also available with the ball of yarn in yellow and though we have seen the cookie jar also done in a pinkish/maroon color, we have not seen any of the other pieces in pink. We consider the salt and pepper shakers scarce. All pieces have standard wedge bottoms with the exception of the shakers which have a "U" shaped footing.

The large strawberry cookie jar is commonly known as the "Sears Strawberry", as it was sold through Sears and Roebuck Company in their 1948 Christmas catalog. Long called simply "the Sears Strawberry" it was not until 1991 that the manufacturer was known. Claimed by American Bisque this may actually be one of those items produced at American Pottery as the strawberry has a circular dry footed base typical of mold casting rather than pressing. The bottom of the jar is marked "Sears Exclusively, USA, patent pending".

The set of range shakers was originally sold with complimentary grease jar in reverse color, white with red and green detailing (see catalog reprints). Both sets of salt and pepper shakers have a "U" shaped footing. The jar, range shakers and table shakers featured here show exceptional paint, they are rarely found in this condition. Without benefit of underglaze years of soap and water have generally rendered these pieces faded and washed out or completely white.

A matchbox holder, teapot and creamer and sugar in reverse color were produced by American Pottery to complete this set. Strawberries must have been big in 1948, note the wide variety of complimentary strawberry items available from Sears.

It is interesting to note that this strawberry cookie jar is the only figural fruit or vegetable jar we've found. Other potteries of this era made just about any fruit and vegetable jar imaginable, not so for American Bisque.

The churn set is perhaps the most common of all. These pieces are abundant in the marketplace with perhaps the exception of the coffee mugs which probably suffered a high mortality rate. All pieces featured were also produced with a blue flower done in underglaze rather than the red cold-painted version. The blue variety, though less common, still remains plentiful and collectors should have no trouble locating these pieces. All pieces in this set have the standard wedge bottom, the only exception being the salt and pepper shakers which have a full circular footing.

The complete set consists of cookie jar, pitcher, tea pot, grease jar, sugar and creamer, range size salt and pepper and coffee mugs.

Unlike the "Figaro" pitcher which is close to the same size as the cookie jar, the Santa Claus pitcher dwarf's the Santa cookie jar. We have seen many Santa cookie jars and for whatever reason the jolly old fellow always appears jaundiced. Whether the underglaze used was mislabeled or this was intentional we do not know, but we have never seen the face of the cookie jar done in anything but yellow. On the other hand, the mugs and pitcher represent a more true to life color scheme with Santa looking somewhat healthier with flesh tones. Both the cookie jar and pitcher have the standard wedge bottom, the mugs have a "U" footing. We are also aware that there are salt and pepper shakers available to this set. We believe all the pieces shown in this set to have had the red repainted.

Not shown here but also available, is a set similar to the churn set in the brown Coffee pot with red flower (See Chapter 6).

The "lattice" pieces shown next are all products of American Pottery Company. These pieces also exist in a swirl pattern.

Decorated with cold paint, the strawberry pitcher sits 6 3/4" on a full circular footing. The pitcher is marked "USA".

The range shakers measure 5" and sit on a modified "U" footing.

Measuring 8 1/2", the Sears strawberry cookie jar sits on an outline footing. The jar is marked "Sears Exclusively U.S.A. Patent Pending".

Also sitting on modified "U" footings, the table shakers stand 3". Neither pair of shakers are marked.

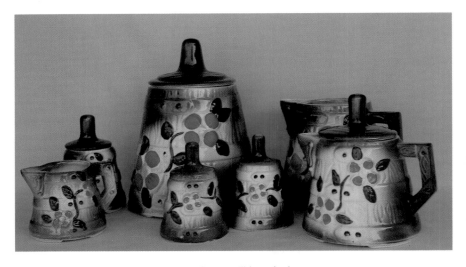

The churn set shown with red cold painted flowers. This set is also available with blue flower petals.

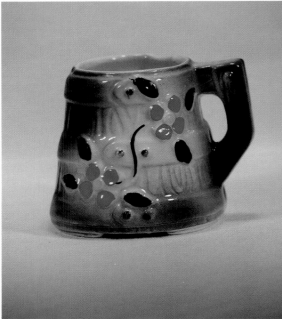

The coffee mugs for this set stand 4" high on wedges.

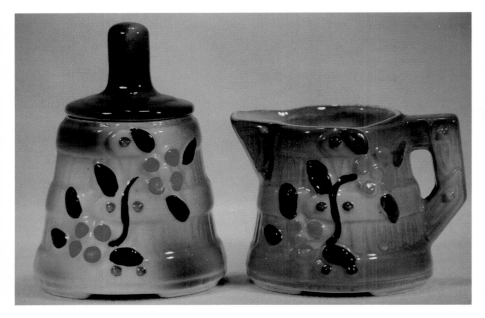

Both creamer and sugar in this set sit on wedge bottoms. The creamer measures 3 3/4" and the sugar 5 3/4". Neither piece is marked.

The shakers are clearly range size at 5". We have not been able to locate the table size shakers. Each sits on a full circular footing with center stopper and are incised "USA".

The teapot is 7" on wedges and is marked "USA".

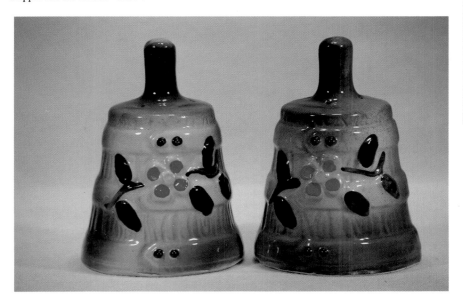

Unmarked, the milk pitcher stands 6 1/4" on wedges.

Also unmarked is the 6 1/2" grease jar.

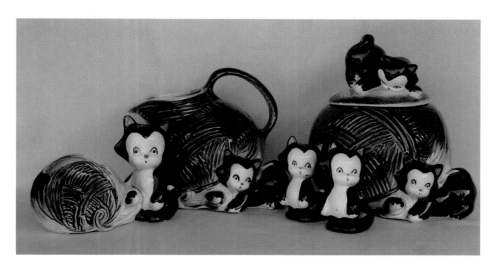

"Figaro" in greenish brown.

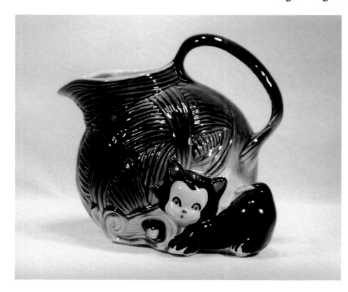

Also unmarked, the milk pitcher stands 8 1/4".

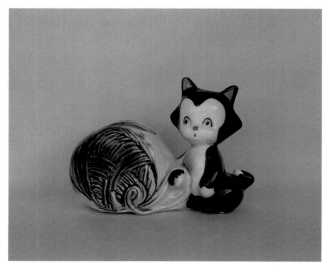

Half again as large as the shaker figures, the planter is unmarked, standing 6" on wedges.

The "Figaro" salt and pepper shakers are close to range size at 4 3/4". Unmarked "U" footing.

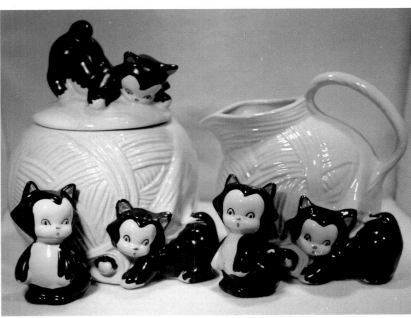

"Figaro" in yellow.

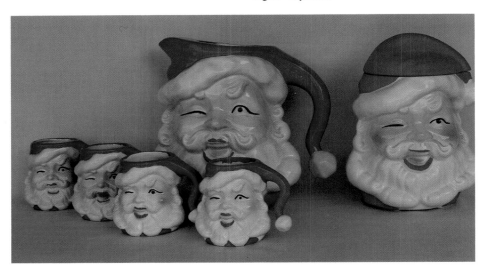

The Santa Claus set. Not shown but also available are salt and pepper shakers.

The Santa pitcher is unmarked, standing 9 3/4" on wedges.

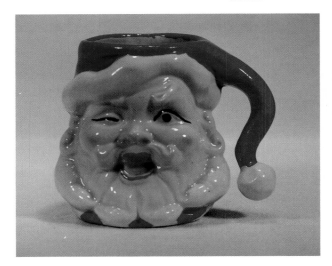

The Santa mugs are unmarked, standing 4" on "U" shaped footings.

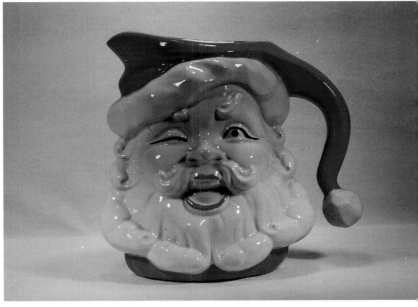

Large in size these lattice pattern salt and pepper shakers stand 4 1/2" on a "U" shaped footing. Produced by APCO. *Cloud Collection*

The lattice pattern teapot was available in other colors. The red on this one is cold painted. Standing 7 1/4" on wedges, this piece was also produced at APCO. *Cloud Collection*

The reverse view of the previous shakers.

Shown are a lattice pattern creamer, 3" high and a 5 3/4" diameter casserole minus the lid. This casserole was also made in a 7 3/4" diameter. Produced by APCO. *Cloud Collection*

Matching creamer stands 3". *Cloud Collection*

Etcetera

This chapter deals with the wide variety of collectible pieces that somehow don't fit any other category.

Many of the pieces shown in this chapter are "dinner bucket" pieces. To those of us on the west coast that translates to "lunch box" pieces. Literally hundreds of items in various stages of finish, came home from the factories in employees dinner buckets. While it may or may not have been an acceptable practice, we are thankful as it has allowed us to pinpoint, in many cases, just which factory produced which piece.

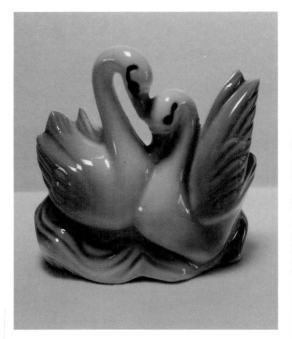

These lovely swans are actually a "frog" for use in flower arrangements. There is a large center hole in the bottom so that, when placed in a bowl full of water, the stems of the flowers remain wet. This frog is available in many different color schemes and with a flat bottom as well as wedges. Measuring 5 3/4" high, it was produced by APCO.

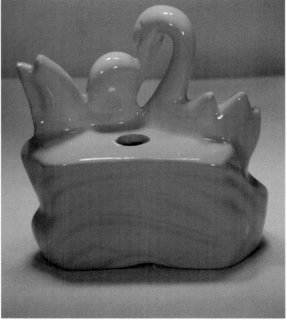

The reverse side of the Swan frog.

This model of a shaving brush is actually a receptacle for used razor blades. Produced by APCO, it stands 6 1/4" high on a circular footing and is marked "USA". *Cloud Collection*

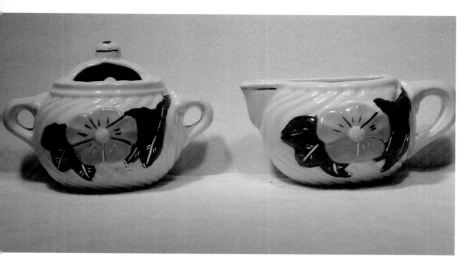

The creamer and sugar shown here are actually wallpockets. The sugar is 4" tall and the creamer 3". Produced by APCO the pair shown is detailed in gold. A creamer and sugar bowl in this pattern is also available. *Cloud Collection*

This pair is probably the match to the Bear with Eyes Open/Bear with Eyes closed cookie jar. They are unmarked and stand 3 1/2" high on a U shaped footing.

The hurricane lamp is also a wallpocket. Produced by APCO it is 6" high and marked "USA". *Cloud Collection*

We think these shakers are bears, but they may also be dogs. Produced by APCO, they are slightly taller than the other bears at 4 1/4". They are unmarked and stand on a U shaped footing.

The pair of bear salt and pepper shakers are a match to the turnabout bear cookie jar. Made by APCO they were originally cold painted. They are 3" high, unmarked and sit on a U shaped footing.

Again a match to a cookie jar. The bear's holding the cookies are 3 1/2" and unmarked.

The fat little tumbling bear is a small condiment or mustard jar. The spoon is missing from this example. Sitting on an outline footing, it is 3" high.

Obviously repainted, the little APCO chicks stand 3 1/2" high on a U shaped footing.

Marked "© APCO", the clown shakers are 3 1/2" high on a U shaped footing.

Marked "© APCO", the 3 1/2" lambs also match the lamb cookie jar.

Another cookie jar match are the pig shakers. Unmarked, they stand 3 1/4" on a U shaped footing, APCO.

The little dancing pig is probably looking familiar by now. Done with indented dots, clover blooms and shamrocks. This pair is available in both table and range size. This unmarked pair stands 4" high on an outline footing.

Made by APCO the underglazed duck shakers stand 4 1/2" high. A pie bird with open bottom and larger opening through the beak was also produced. *Cloud Collection*

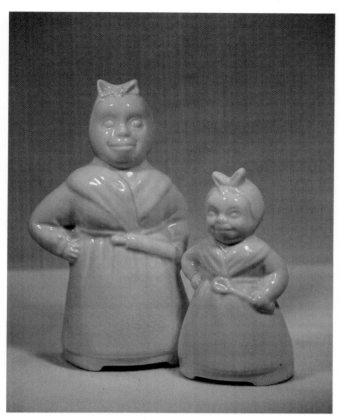

The large mammy stands 7" tall and the smaller one with the spoon is 5". We thought the size difference in this set was an oddity and after recently seeing a mammy and chef set in the 5" size have come to believe the set was originally three pieces. The large shaker was probably intended for use as a flour or sugar shaker. The set is unmarked.

This pair of pig shakers is decorated totally with 24K gold. Note the similarity in design to the pig with dimpled knees bank. Unmarked, this pair stands 3 1/2" high on a U shaped footing.

The chef shakers stand 5" high on a U shaped footing. They are incised "USA" on the back of the head.

The bottom and rear view of the previous set. Also available in the same pink as the next set.

Matching the elephant cookie jar that originated at Ludiwici, these shakers were produced at APCO. Unmarked they are 3 1/2" high on a U shaped footing. *Cloud Collection*

The flower sugar bowl produced at APCO probably had a lid. Available in different color flowers, with and without gold trim. This bowl stands 3" high and has a 3" opening. *Cloud Collection*

The reverse side of the previous sugar bowl. Complimentary pieces in this swirl pattern such as teapot, creamer, salt and pepper, etc., are also believed to exist.

Purchased as a creamer and sugar, we note from the patent sketch that what we are calling the sugar bowl was applied for as "Design for a Flower Holder or the like." Of Ludiwici origin the creamer stands 5" and the sugar 3". The creamer sits on a flat bottom and the sugar on wedges.

The pig creamer and sugar were most probably decorated at different times because of the color difference. The creamer is 5" on a flat bottom and the sugar 3" on wedges. Neither are marked.

Note the wedges on the bottom of this refrigerator container. Made at APCO it stands 8 3/4" high and is unmarked.

This little cigarette snuffer/ashtray is hand lettered in gold on the top surface "Marietta Ohio, Feb. 23, 1948".

Though difficult to see in the photo this tea set is heavily decorated with 22-24K gold. All three pieces sit on wedge bottoms. Though purchased this way, we believe the sugar bowl may have originally had a lid. The Teapot stands 8 1/2" high and both the sugar and creamer are 3 3/4".

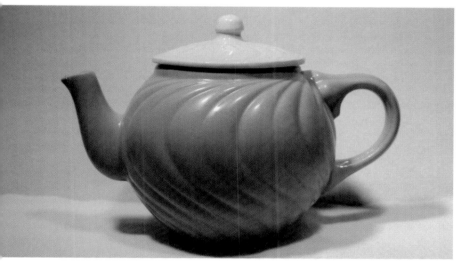

Another view of the previous ashtray. The base has a 4" diameter.

The swirl pattern teapot was produced at APCO. This one stands 6" and the lid is believed to be incorrect. *Cloud Collection*

The Buckeye State of Ohio depicted in ashtray form. Produced at APCO it sits on a completely flat bottom and measures about 5" across the middle. *Cloud Collection*

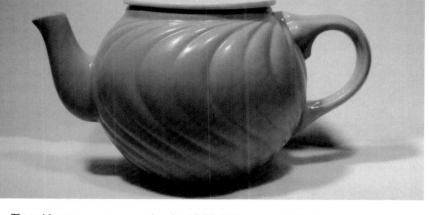

The underside of the same ashtray reads "American Pottery Co."

Another style and glaze of a Marietta Modern ashtray. It measures 6 3/4" across. *Cloud Collection*

The tepee ashtray has openings on two sides. A great compliment to the various Davy Crockett pieces, this one was probably intended for use at a card table as it is incised with a spade, diamond, heart and club. A cigarette placed in one of the side openings causes the smoke to rise out of the top of the tepee. Sitting on a full wedge bottom it stands 6 1/4" high. Quite a novelty.

The bottom of the previous ashtray shows the Marietta Modern marking along with the number 702-A.

A third example of the Marietta Modern line. This one measures 7" across and is marked 704-R. *Cloud Collection*

The free form ashtray is one of many in the "Marietta Modern" line. Marked 715-A it was produced at APCO. *Cloud Collection*

When we first laid eyes and hands on the Flintstone ashtrays the American Bisque homing device in our heads went off. Clearly marked © Hanna Barbara Productions 1961, Arrow Houseware Products, Inc., Chicago, ILL. USA, we were disappointed. After some thought and a little digging we realized the Arrow Houseware Products was not a pottery company but a distributor. We asked sales representative Bill Schneider, Sr. if he could verify the manufacture of these ashtrays and he told us that he had in fact seen them before and that it was American Bisque Vice President/General Manager, Mike O'Brien who had shown them to him. While not proof positive, we believe if Mr. O'Brien had them in his possession they were from his pottery. We'll let the collector make the decision on these pieces. Each of these ashtrays measures 8 1/2" and there was probably also a Fred Flintstone produced.

Betty and Barney Rubble ashtray.

Betty Rubble on the telephone.

Barney Rubble bowling.

Probably stocked by many floral shops, the all occasion baskets are beautiful even without flowers.

The rectangular gift basket stands 6 3/4" high not counting the metal bail. *Cloud Collection*

Similar basket, different verse.

A bottom view showing, "copr. Marietta Pottery Co. Marietta, Ohio." Produced at APCO.

An alternate shape to the previous rectangular baskets. This style stands 7" high excluding bail. *Cloud Collection*

Same basket with alternate color and greeting. *Cloud Collection*

Again the same basket with alternate greeting. *Cloud Collection*

Much less traditional is this beautifully airbrushed basket done in golden yellow and shades of pink. Unmarked the basket stands 5 3/4" high and 12" long.

One of our favorite pieces, this APCO pitcher stands 12 1/2" high and is underglazed.

Similar in color and line to the basket is this pitcher which appears to be a tree trunk with entwined branches for the handle. Unmarked, it stands 10 1/2".

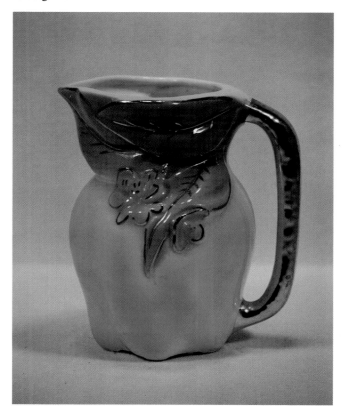

One of a very few fruit pieces, this apple pitcher is heavily laden with 24k gold. Standing 6" high on three wedges it is marked "USA". Produced by APCO.

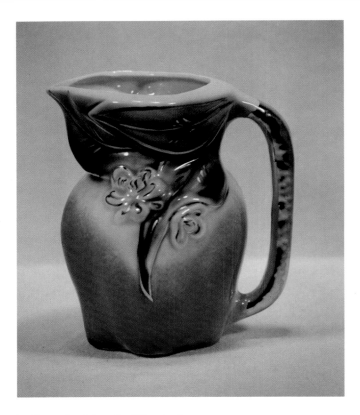

Another apple pitcher of a different color.

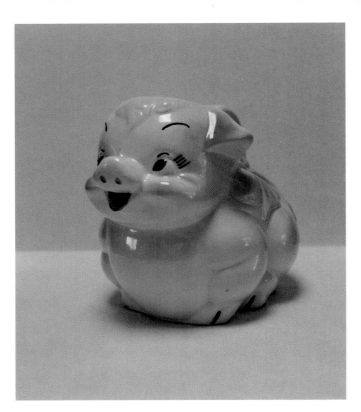

Similar in style to the previous pitcher, this one is airbrushed and the motif is the clover bloom. Slightly taller at 8 1/2" it also sits on a circular footing and is unmarked.

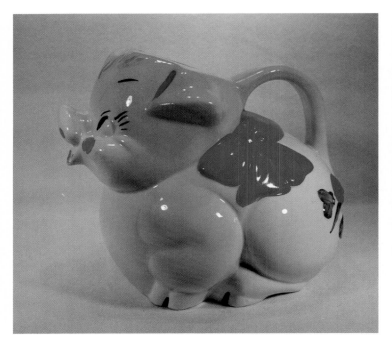

A familiar face done in pitcher form. This one stands 8" high on a circular footing.

Remember the bank? Here she appears again with a large hat which doubles as a pouring lip. The cream pitcher stands 7 1/4" tall on a circular footing, marked "USA Pig". Produced by APCO.

Standing 7 3/4" this chick cream pitcher is the perfect match to the salt and pepper shakers shown previously. This particular piece is a repaint and is marked "USA."

Front and back views of the chick cream pitcher.

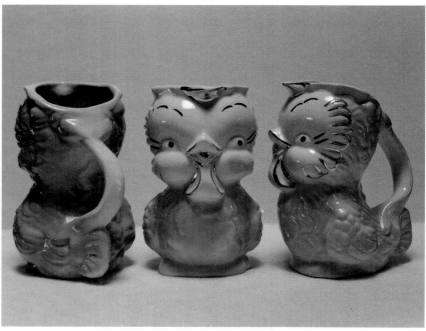

At one time or another everyone has seen these chick pitchers. The three pictured here are all detailed in 22-24k gold. Also found detailed in cold paint, these APCO chicks stand 6 1/4" tall and can be found both with flat and wedge bottoms.

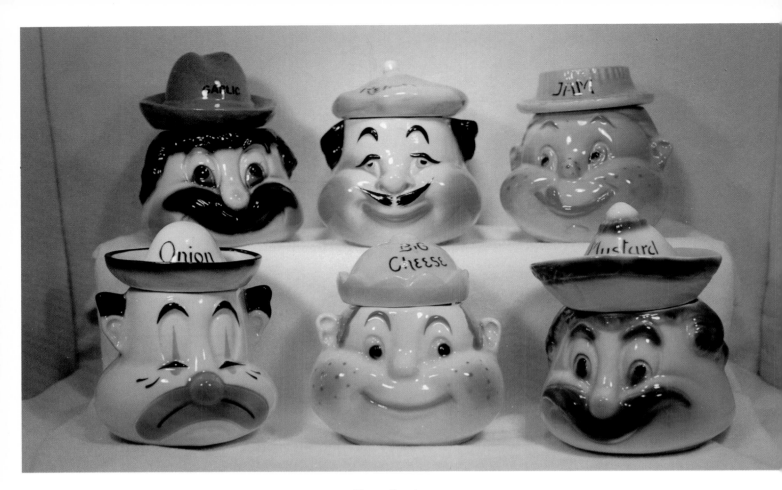

The condiment crew.

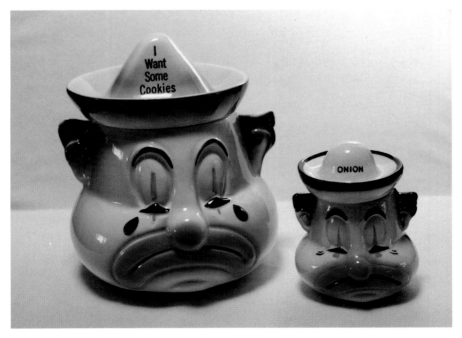

The Cardinal Sad Clown cookie jar and condiment shown together for size comparison.

The little girl jam jar appears to be looking anxiously for a piece of toast. Unmarked, 4 3/4".

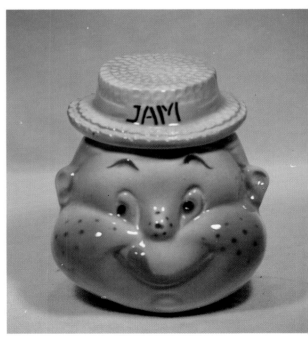

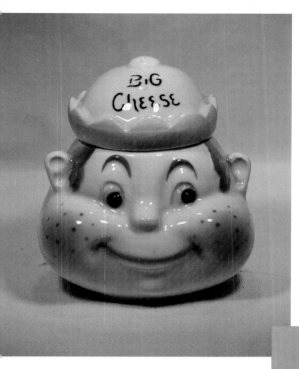

Big Cheese reminds us of the Little Rascals. Without benefit of mark it is 5" tall.

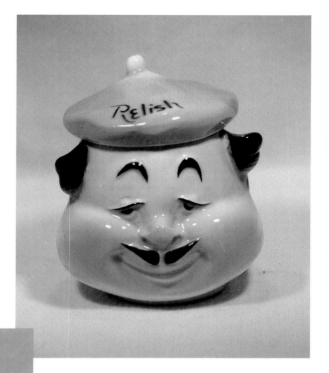

The french chef looks to be relishing something. Also unmarked, 5".

Last but not least, Mr. Mustard. Though identical to Mr. Garlic, a change of hair color and hat make a world of difference. Unmarked, 5 3/4".

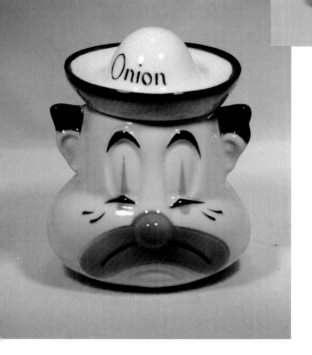

Appropriately labeled Onion, the sad clown has good reason to cry. Unmarked, 5 1/4".

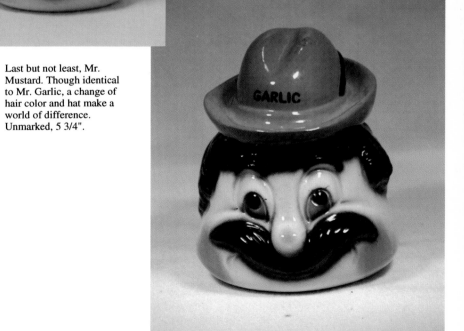

Mr. Garlic looks like he could produce wonderful spaghetti. Unmarked, 5 1/4".

Younger collector's may have never seen or heard of sprinkle bottles. Steam irons, so common today, were non existent until the 1950s. Prior to that time clothes were sprinkled with water, rolled and placed in a plastic bag, often placed in the refrigerator and then ironed damp. Sprinkle bottles were made by many companies in many forms. Sprinkle bottle collectors tell us that they are especially prized possessions when they are complete with the metal and hard rubber sprinkler. The sprinkle bottle in our home wasn't nearly so wonderful as these, we had a pop bottle with a plastic sprinkler.

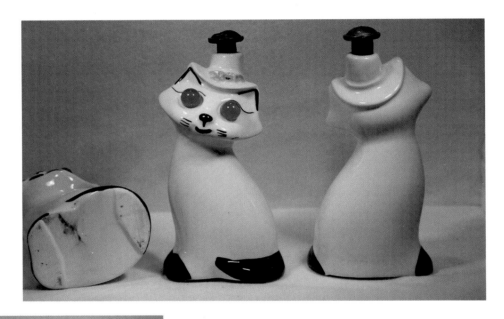

Cat sprinkle bottles showing front, back and bottom views. Marked "Cardinal", 7 1/2".

The same sprinkle bottles showing green, blue and orange eyes.

The trunk of the happy elephant sprinkle bottle provides a natural handle.

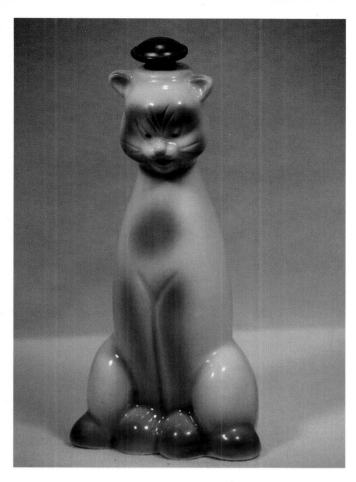

The Siamese cat sprinkle bottle stands 8 1/4".

The figural door-stops are seldom seen. In view of the fact that they were intended for use on the floor in doorways, we can imagine a very high mortality rate. We consider these to be very scarce.

The back view of the Siamese cat shows in inscribed mark "Cardinal" on one side of the tail and on the other "© USA".

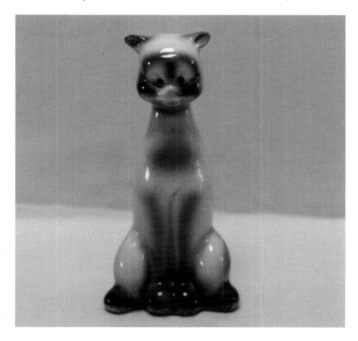

Slightly shorter than the sprinkle bottle is the Siamese Cat door-stop. Unmarked, it stands 8".

The rear view shows the placement of the rubber door-stop.

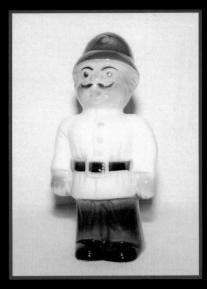

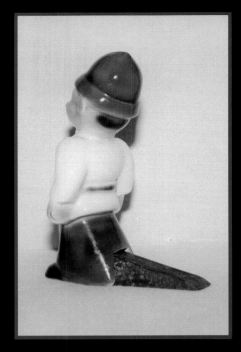

The Bobby door-stop stands 8 1/4" and is unmarked, although it was found in Carteret, New Jersey in its original box marked "Cardinal". *Silagyi Collection*

The rear view of the Bobby.

Let there be light!

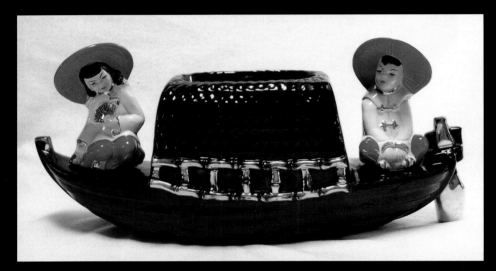

The top of the Chinese Junk T.V. lamp is a bowl. This one is stamped in gold "copr. Fuhry & Sons, Inc. Cleveland 3, Ohio". Produced at APCO it measures 8"H X 17"L. When turned on, the small interior bulb shines light through the windows on the front side of the lamp. The little oriental figurines were done in two sizes.

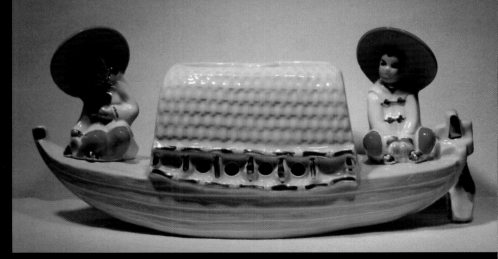

The same lamp done in yellow, this one is unmarked. *Cloud Collection*

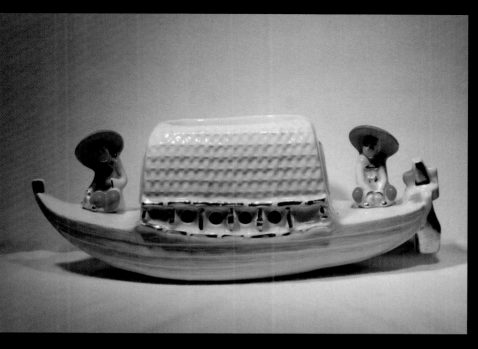

Though difficult to read, this lamp
is clearly inscribed "Marietta".

Again, in white this time. Note the smaller figures on this lamp. *Cloud Collection*

The Happy Face Clock nursery lamp stands 7 1/4" excluding the fixture and is unmarked.

Another lamp produced at APCO for Fuhry & Sons, Inc. is this lamp heavily laden with 22-24K gold. Marked "Fuhry & Sons, Inc.", it stands 8 3/4" excluding the fixture. *Cloud Collection*

The Shoe night light is also available with a blue roof. Produced at APCO it stands 6", unmarked. *Cloud Collection*

Made by APCO, this little bear, which was also done in bank form, still bears the original brand name tag "Totline, Brooklyn". Unmarked, it stands 6" excluding fixture.

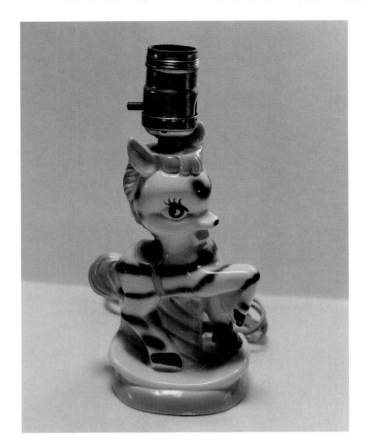

The Zebra lamp was produced at APCO and stands 7 1/4" excluding fixture.

Mother and child say their bedtime prayers as the pup listens in. Unmarked, the bedtime lamp stands 5".

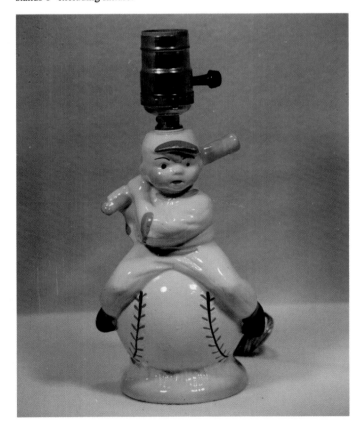

Perfect for a boys room is the Baseball Boy lamp. Unmarked, it stands 7 1/2" excluding fixture.

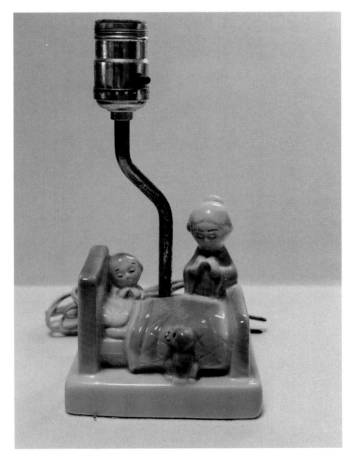

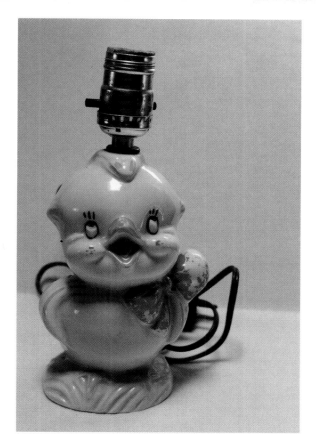

Decorated with cold paint, the little chick lamp stands 6 3/4" and is unmarked.

Unknown cowgirl or Annie Oakley? This lamp is unmarked.

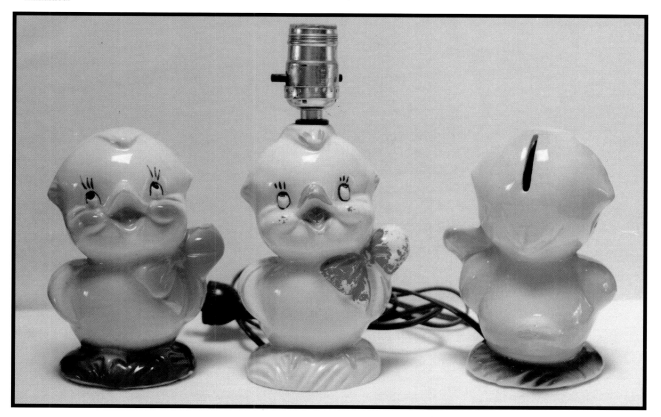

What a difference underglaze can make. Shown here is the chick lamp with the identical bank.

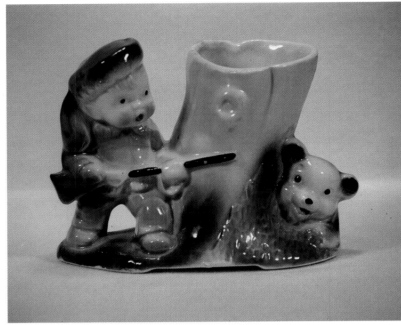

Almost identical to the planter, the Davy Crockett night light stands 4 1/2".

This Davy Crockett lamp was found with the original paper shade intact. Unmarked, it stands 7 1/2".

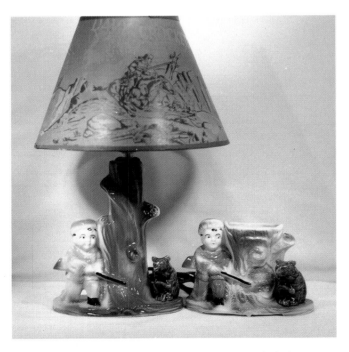

Shown from the rear you can see where the small bulb inserts and the cord exits. This piece is marked "©" on the back of the stump. Probably intended for sale as a souvenir piece in Limestone, Tennessee the inscription was done in 22-24k gold.

The lamp and planter shown together. Note the difference in the bases, the planter sits on wedges while the lamp in on a hollow flat base.

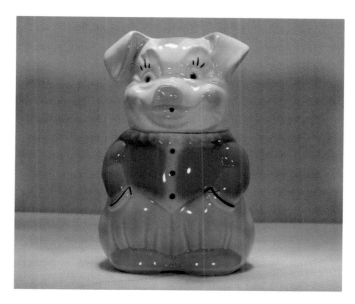

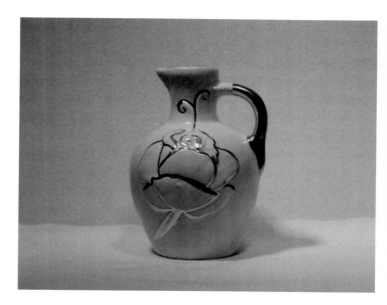

Very similar in style to the hands in pockets cookie and candy jars, the lid on this lamp is factory fused. Made at APCO, there are holes in the eyes and mouth. Unmarked, 8 3/4".

The rose motif vase is also decorated in 22-24K gold. Produced at APCO the bottom of this 5" piece is flat. *Cloud Collection*

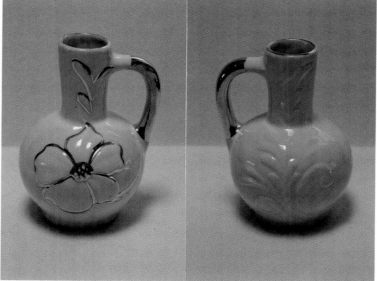

Shown from the rear view, most of the light from this night light comes through the back.

This little two handled vase with thistle motif is decorated with 22-24k gold. Produced at APCO it stands 5" on a circular footing. *Cloud Collection*

A change of flower and neck produce yet another variety of vase. Produced at APCO this 5" piece also has a flat bottom. *Cloud Collection*

The reverse side of the previous vase.

Similar in style to a genie's lamp, this gravy boat has been entirely covered with 22-24k gold. Produced at APCO it stands 5" high. *Cloud Collection*

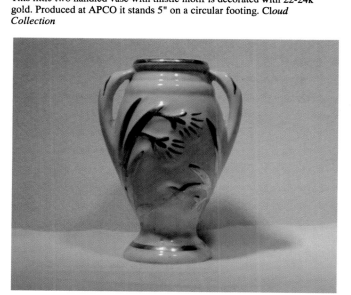

This miniature 1 3/4" duck figurine was produced at APCO, probably found in other colors. *Cloud Collection*

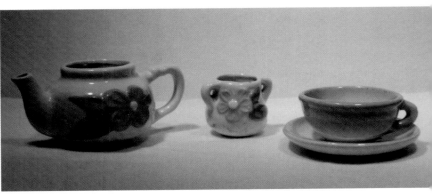

A few pieces from a childs tea set. The teapot is 2 3/4" high and sits on wedges, the sugar bowl is 2" high on a flat bottom and the cup and saucer stand 2" high and are marked "USA". Produced at APCO. *Cloud Collection*

Made at APCO the toothpick holder is decorated in 22-24k gold and stands 2 1/2" high. *Cloud Collection*

Probably intended for use in a potted plant the bird figurine is totally decorated in 22-24k gold. Produced at APCO it stands 4" high. *Cloud Collection*

Purchased at American Bisque, the Christmas tree plate is detailed in red cold paint and 22-24k gold. Unmarked, it is 14 1/2" long. *Cloud Collection*

This little condiment jar with spoon slot stands 3 1/4" on a flat bottom. Produced at APCO. *Cloud Collection*

Planter or bowl? The top rim of this piece is decorated with 22-24k gold. Sitting on a circular footing it is marked "USA". Produced at APCO. *Cloud Collection*

A vase from the Marietta Modern line, this vase was probably done in many colors. Produced at APCO. *Cloud Collection*

The bottom view of the vase shows the Marietta Modern inscription along with the number M-104.

These twin rose vases are APCO products. Unmarked, they measure 3"H X 5 1/2"L. *Cloud Collection*

One of our greatest surprises was learning that the familiar corn ware we commonly call Stanfordware was produced, at least in part, at the American Pottery Company in Marietta. Once again "dinner bucket" pieces have aided in proof positive. The cookie jar pictured here is simply marked, "512".

Stanfordware cookie jar. The leaf on this one is in the shape of a "C" for cookies. Marked 512.

We have also seen this jar marked, "512 STANFORDWARE". Since Stanford Pottery of Sebring, Ohio ceased production in 1961 when it was leveled by fire, one could surmise that production went elsewhere, however we can date corn ware production at American Pottery before 1960.

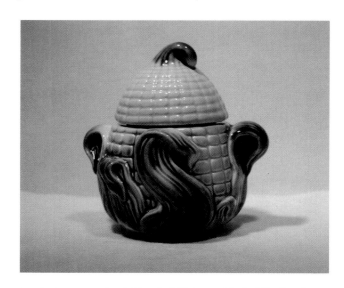

Stanfordware sugar bowl. Note the "S" shape of the leaf. Produced at APCO. *Cloud Collection*

Leeds

We have chosen to give Leeds Pottery a separate chapter because it is unique. The pottery in this section is exclusively Disney. It is not uncommon to hear a collector refer to a Dumbo turnabout cookie jar as a Leeds Dumbo or have someone inquire about a Leeds Donald Duck. It comes as a surprise to many collectors, as it did to us, to learn that Leeds was a Chicago based distributor **NOT** a manufacturer. They operated from approximately 1944 to 1954.

Leeds was licensed by Walt Disney Productions to use their characters in pottery pieces. Not having to actually produce any pieces themselves gave them the ability to shop around or bid out a job thus obtaining the best production price, best time line and the ability to produce many different pieces in quantity by not overloading one facility. It is not an uncommon practice for a distributor to hold the patent rights to a product. Sears Roebuck is another example that clearly defines distributor.

We know that Leeds Pottery pieces were produced by Ludiwici Celadon, American Pottery, American Bisque, Regal China, Ungemach and quite possibly other potteries we are not aware of. Though we wish we could say which individual pieces were produced by which company, in most cases we can't. Therefore we will simply continue calling them "Leeds" and hope that someday further research will tell us which pieces were produced by whom.

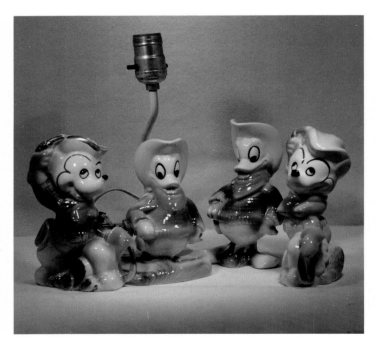

Cream of the crop cowboys.

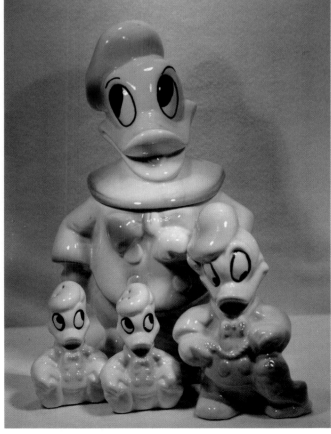

Donald Duck..Duck..Duck.

Dopey seems to be the favorite of the Seven Dwarves as we have yet to see a rendition of the other six. This Dopey bank is marked "© Dopey, Walt Disney Productions", 6 3/4".

Side view of the Thumper bank.

Thumper bank. Unmarked, 6 3/4".

Bambi bank. Marked "© Walt Disney Productions", 7 1/2".

151

Alice in Wonderland bank. Though not easy to read, the front of her skirt is inscribed "Alice in Wonderland". The back of the bank is marked "WD Prod", 6 1/4".

Cinderella Bank. Marked "Cinderella USA © Walt Disney 1950", 6 1/2".

Snow White Bank. Unmarked, 6 1/4".

Two Mickey Mouse banks shown together. So close - yet so far!

Mickey Mouse with Coin bank detailed entirely in cold paint. Unmarked, 6 3/4".

Cowboy Mickey Mouse bank. This version is not only done in airbrushed underglaze but also topped with 22-24K gold. Unmarked, 6 1/2".

Mickey Mouse with Flower bank. This version is decorated in underglaze. Unmarked, 6 3/4".

Front and back views of the previous bank.

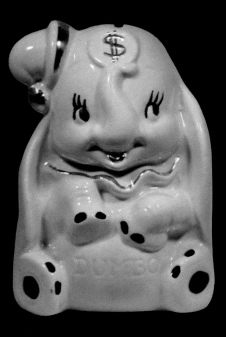

Another version of a Dumbo bank. This one is inscribed "Dumbo" on his tummy and detailed in 22-24K gold. Marked "Walt Disney ©", 6 1/4".

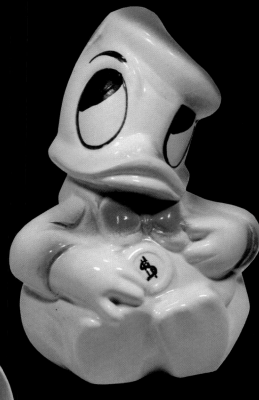

Front view of the previous bank.

Dumbo bank. Marked "Walt Disney", 7".

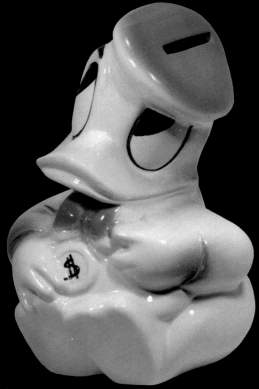

Sitting Donald Duck bank. Unmarked, 6 1/4", this version is airbrushed underglaze.

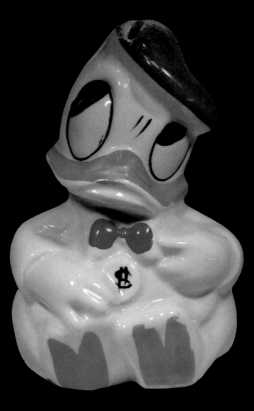

Another version of the Sitting Donald Duck bank. This one is done in cold paint. Marked "© Walt Disney", 7 1/2".

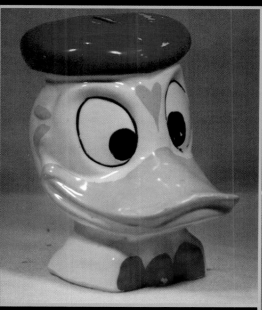

Donald Duck head bank. Detailed in cold paint. Unmarked, 6 1/4".

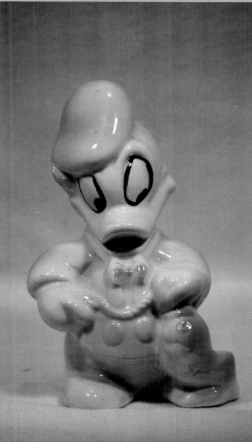

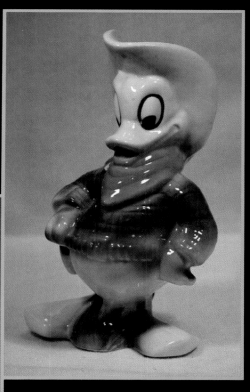

Cowboy Donald Duck bank. Similar in styling to the Cowboy Mickey Mouse, this Donald is devoid of the 22-24k detail. Unmarked, 7".

Fishing Donald Duck bank. Marked "Walt Disney Productions", 7 1/2".

Same bank, front view. The decorator on this one probably needed glasses as the pupils were placed in a cross-eyed position.

Donald Duck with Coin is a perfect companion to Mickey Mouse. Detailed in cold paint it is unmarked, 6 1/4".

155

Roy Rogers and Trigger bank. Unmarked, 7 1/2".

Donald Duck with Flower planter. The simple addition of a basket turns bank to planter. Marked "Walt Disney USA", 6 3/4".

Front and back view.

Double Donald's.

Donald Duck with Blocks. Marked "© Walt Disney Productions", the front of the "A" and "C" blocks are also incised "Donald Duck", 5"H X 6 1/2"L. Yoder Collection

Snow White planter. Marked "Snow White, © Walt Disney", 6 1/2" full outline footing.

Pluto with Cart wallpocket. We speculate this piece can also be found in planter form. Marked "© PLUTO, Walt Disney Prod", 6 3/4".

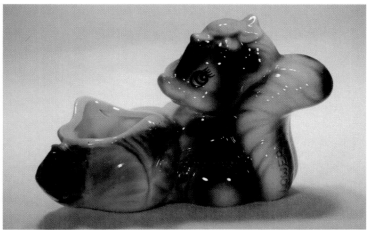

Flower planter. Marked "Flower, © Walt Disney", 4 1/4" flat bottom.

Reverse side of the Pluto wallpocket.

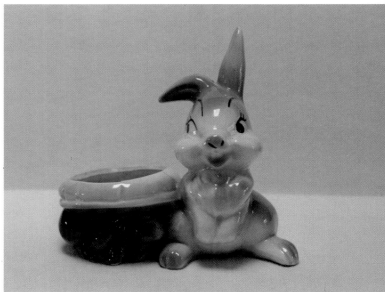

Thumper planter. Marked "Thumper, © Walt Disney Production", 6 1/2" full outline footing.

Bambi planter. This one is interesting in that it is actually two pieces, the figurine and the planter, which have been fused together during the glazing process. Unmarked, 6 1/4"H X 8 1/2"L.

Bambi and Thumper wallpocket. Marked "BAMBI", 7 1/2".

The Bambi on the left is marked "USA", 7 1/2".

Donald Duck pitcher. It's just about the right size to hold milk for a bowl of cereal. Though it's also referred to as a creamer, where is the sugar bowl? Decorated in 22-24k gold it is marked "Donald Duck, © Walt Disney Productions", 6 1/2".

Reverse of the previous photo showing marking.

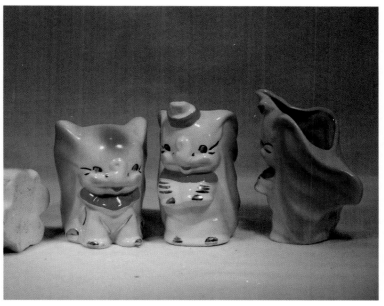

Front and back views of the Dumbo sugar and creamer. Note the tab type handle on the creamer.

Another version of the Donald Duck pitcher. Marked "© Walt Disney Productions", 6 1/2".

Dumbo pitcher. Trimmed in 22-24k gold. Marked "© Walt Disney USA", 6" on a flat bottom.

Dumbo sugar and creamer. Decorated with 22-24k gold. Marked "Walt Disney ©", 4" and 4 3/4" respectively. Flat bottom.

Mickey/Minnie salt and pepper shakers. We've looked long and hard for this pair in underglaze or gold trim to no avail. Unmarked, 3 1/2", U-foot.

Pluto salt and pepper in 22-24k gold trim. Also available in cold paint. Marked "© Walt Disney", 3 1/4". U-foot.

Sitting Donald Duck salt and pepper in cold paint. These are no doubt repainted as Donald always wears a blue cap. Marked "© Walt Disney", 3 1/4", U-foot.

Standing Donald Duck salt and pepper in 22-24k gold trim. Marked "© Walt Disney", 3 1/4", U-foot.

Sitting Donald Duck salt and pepper. Note the differences in collar, turn of the head and spread of feet from the previous pair. Underglazed and unmarked, 4", U-foot.

Standing Donald Duck salt and pepper in cold paint. Marked "© Walt Disney", 3 1/4", U-foot.

Same as the previous shot, this one showing the U-foot.

Thumper salt and pepper in cold paint. Marked "© Walt Disney Productions", 3 1/2", U-foot.

Dumbo salt and pepper in cold paint. Marked "© Walt Disney", 3 1/2", U-foot.

Dumbo salt and pepper in cold paint, range size. Marked "© Walt Disney USA", 4 3/4", U-foot.

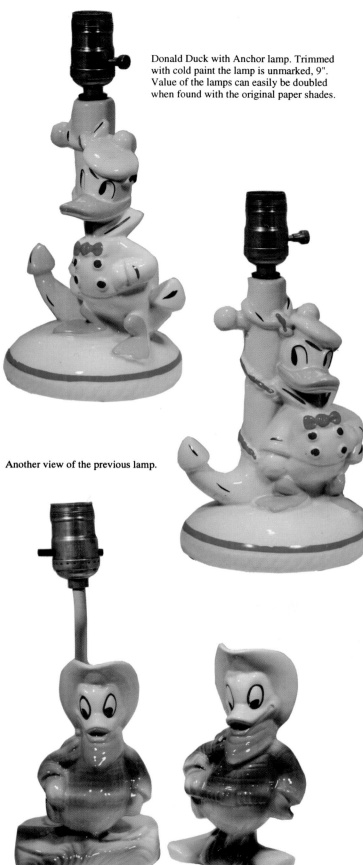

Donald Duck with Anchor lamp. Trimmed with cold paint the lamp is unmarked, 9". Value of the lamps can easily be doubled when found with the original paper shades.

Another view of the previous lamp.

Cowboy Donald Duck lamp and bank together. The lamp is marked "Donald Duck Walt Disney Prod", 6 1/2" and 7" respectively. Note the differences in the bases

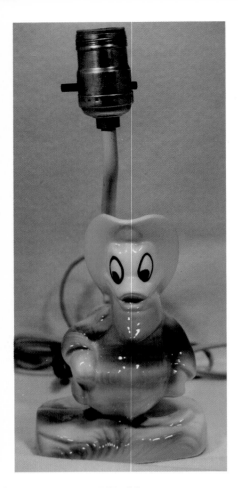

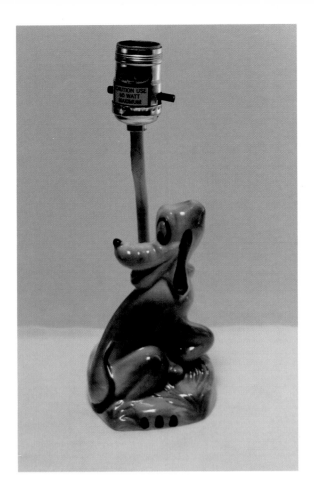

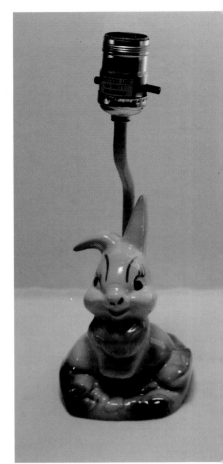

Cowboy Donald Duck lamp.

Pluto lamp. Marked "PLUTO, © Walt Disney Productions", 6 1/2". We recently found another Pluto lamp which is not pictured. He sits on a brass base and the grass is missing from around his feet.

Thumper lamp. Marked "THUMPER, © Walt Disney Productions", 6 1/2".

Cowboy Mickey Mouse lamp. Marked "Mickey © Walt Disney Prod", 6 1/2".

Dopey lamp. Marked "DOPEY, © Walt Disney Productions", 6 1/2".

Snow White lamp. Unmarked, 6 1/2".

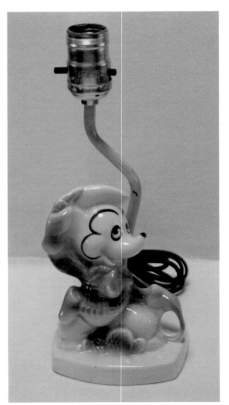

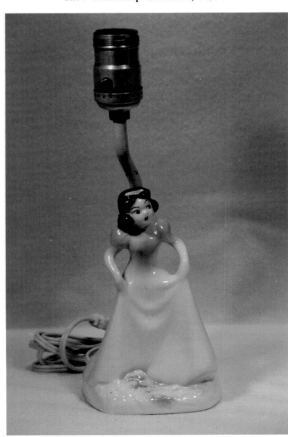

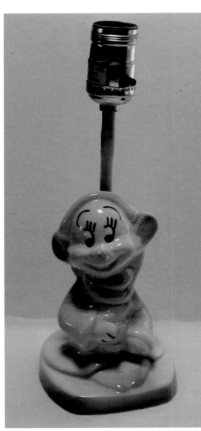

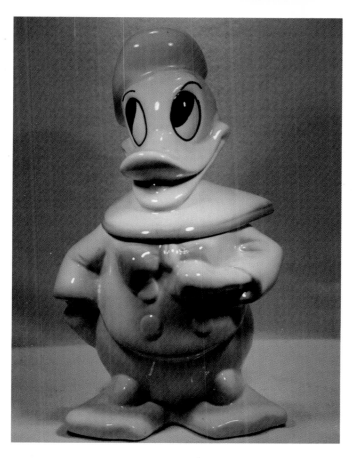

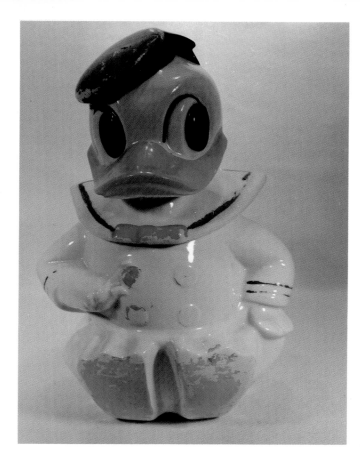

Standing Donald Duck cookie jar in underglaze. Unmarked, 12 1/2", full outline footing.

Sitting Donald Duck cookie jar in cold paint. Marked "Reg. U.S. Pat. Off. Celebrate" around a seven point crown, 11", full outline footing.

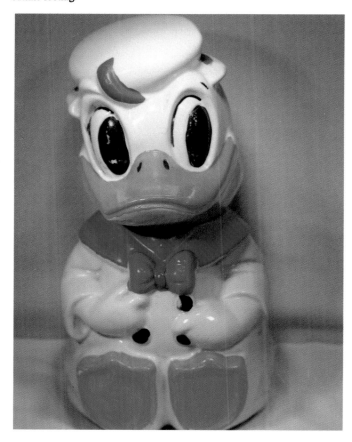

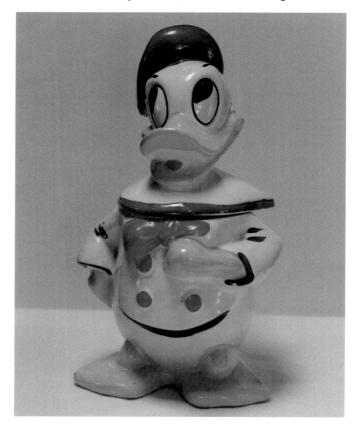

Donald Duck/Joe Carioca turnabout cookie jar.

Standing Donald Duck cookie jar in cold paint. Marked "Donald Duck © Walt Disney U.S.A.", 12 1/2" full outline footing.

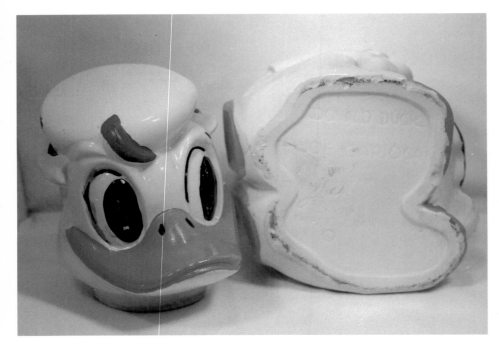

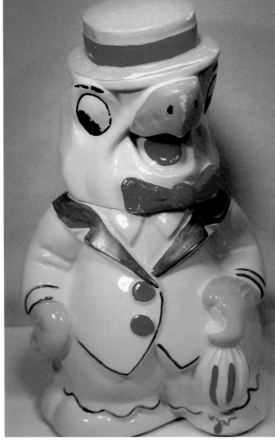

The marking on the Donald Duck/Joe Carioca turnabout cookie jar reads, "DONALD DUCK and JOE CARIOCA from the Three Caballeros © Walt Disney USA", 13".

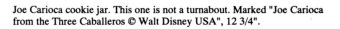

Joe Carioca cookie jar. This one is not a turnabout. Marked "Joe Carioca from the Three Caballeros © Walt Disney USA", 12 3/4".

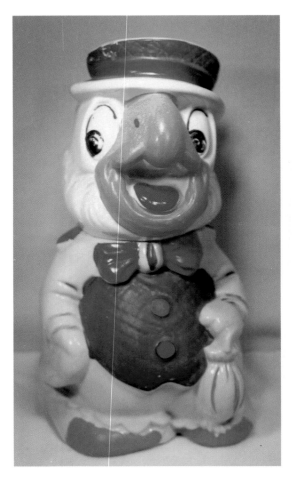

Donald Duck/Joe Carioca turnabout cookie jar, Joe Carioca side.

Mickey/Minnie Mouse turnabout cookie jar. Showing the bottom the marking reads "Patented/Turnabout 4 in 1/Mickey and Minnie/© Walt Disney", 13".

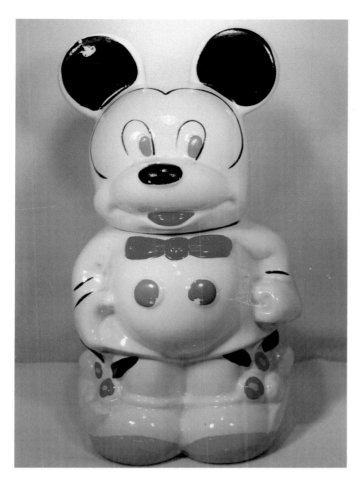

Mickey/Minnie, view one: Mickey face, Mickey body.

Mickey/Minnie, view two: Minnie face, Mickey body.

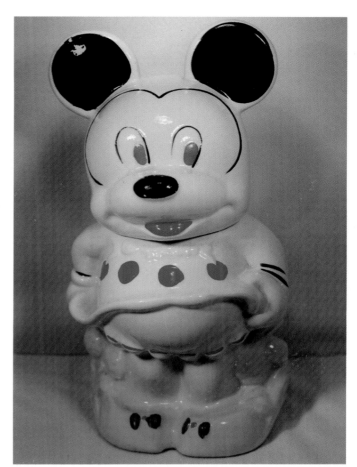

Mickey/Minnie, view three: Mickey face, Minnie body.

Mickey/Minnie, view four: Minnie face, Minnie body

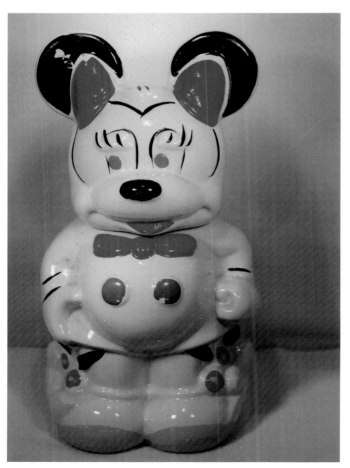

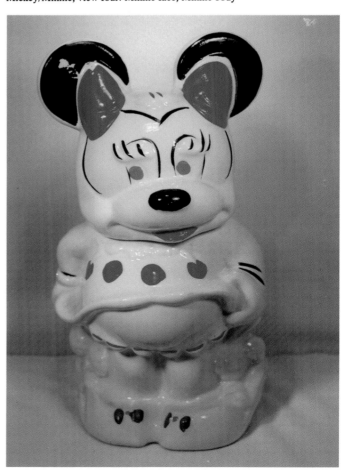

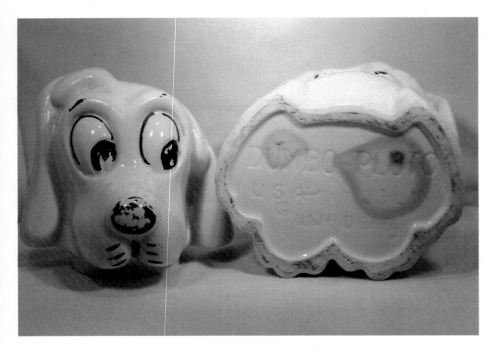

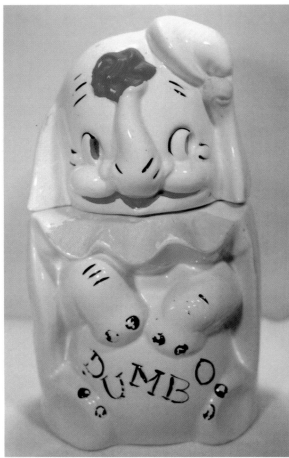

Dumbo/Pluto turnabout cookie jar. On a full outline footing the bottom reads "DUMBO-PLUTO/USA 23L/© Walt Disney", 13 1/4".

Dumbo/Pluto turnabout cookie jar. Dumbo side.

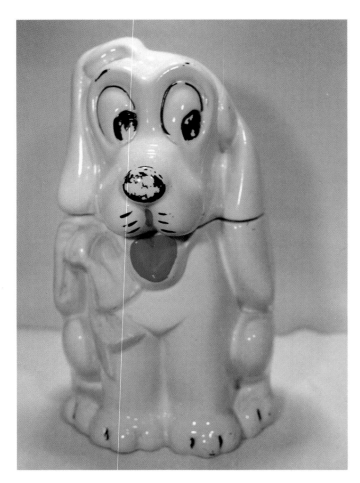

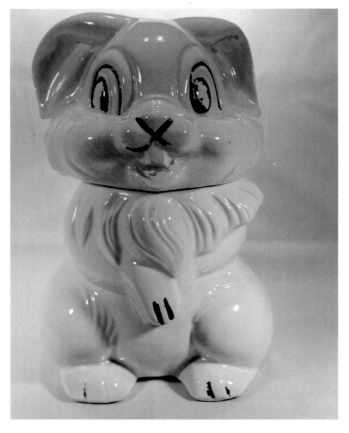

Dumbo/Pluto turnabout cookie jar. Pluto side.

Thumper cookie jar. Marked "Reg. U.S. Pat. Off. Celebrate, made in USA", 11 3/4", full outline footing.

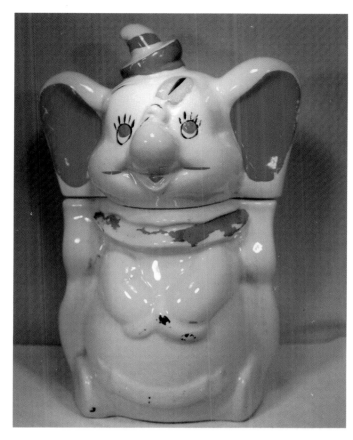

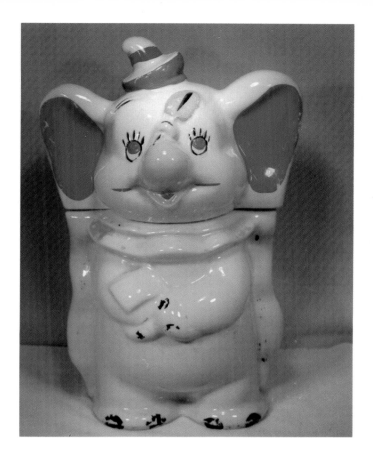

Dumbo turnabout cookie jar. View one: Trunk Up, empty hands. Marked "Patented/Turnabout 4 in 1/© Walt Disney", 13 1/2".

Dumbo turnabout cookie jar. View two: Trunk down, empty hands.

Dumbo turnabout cookie jar. View three: Trunk up, flag in hands.

Dumbo turnabout cookie jar. View four: Trunk down, flag in hands. Hands?!

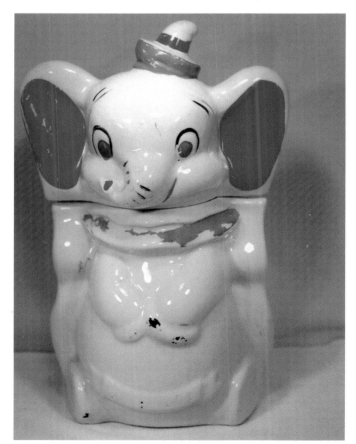

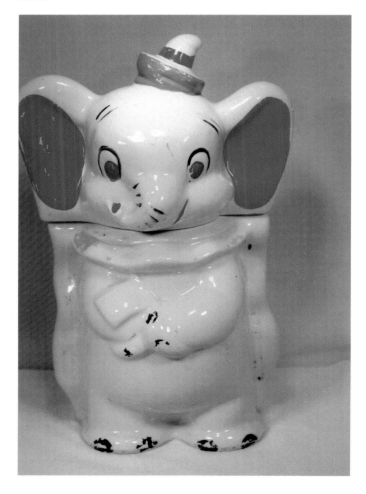

Berkley and Sequoia Ware

Berkeley and Sequoia ware came with the late 1960s. It was a major step toward the "modern" trend and the lines were advertised as Mod-colors and Mod-shapes. Vibrant colors along with many free-form shapes gave consumers many options.

Not presently thought to be particularly collect-ible, these pieces can probably be found for next to nothing. If they strike your fancy - find them now before they become the "Mod" thing to collect.

Featured last to perhaps signal "The End," is this food tray produced for use by Eastern Airlines after the pottery was purchased from the Allen family. Neither Sequoia or Berkeley, this was the last production piece from the American Bisque Pottery.

Still in greenware form this food tray had the bottom painted green and was used as an ashtray by the present tenants of the American Bisque Pottery building.

Done in woodtone is the Sequoia logo plaque.

Another angle of the same candy/nut dish.

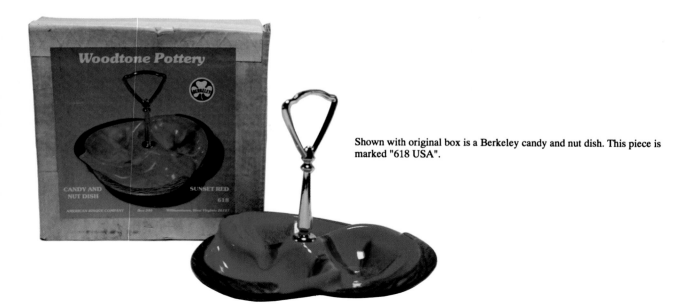

Shown with original box is a Berkeley candy and nut dish. This piece is marked "618 USA".

Bright and colorful is this two tiered Sequoia server. The bottom tier is marked "609-611 USA" and the top tier is marked "610 USA".

Bottom view of Eastern Airlines food tray. Marked "ABCO USA".

Berkeley ware ashtray marked "1014 USA".

Top view of Eastern Airlines food tray.

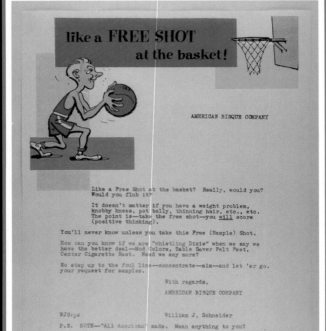

like a FREE SHOT at the basket!

AMERICAN BISQUE COMPANY

Like a Free Shot at the basket? Really, would you? Would you flub it?

It doesn't matter if you have a weight problem, knobby knees, pot belly, thinning hair, etc., etc. The point is—take the free shot—you will score (positive thinking).

You'll never know unless you take this Free (Sample) Shot.

How can you know if we are "whistling Dixie" when we say we have the better deal—Mod Colors, Table Saver Felt Feet, Center Cigarette Rest. Need we say more?

So step up to the foul line—concentrate—aim—and let 'er go. your request for samples.

With regards,
AMERICAN BISQUE COMPANY

WJS:ps William J. Schneider

P.S. NOTE—"All American" made. Mean anything to you?

We've got the magic formula!

The AMERICAN BISQUE COMPANY Inc.

SUBJECT: "Prestige Ceramics"

Yes, we've got "it" - The Magic Formula! Thanks to our imported Color Expert.

Thus we can offer with pride, "Colors" on Wood Tone Ceramics that are not "out of this world" but, definitely "in" and they are going to be "in" in many, many more homes in the future. Won't you help us in this respect?

Colorwise we take our hats off to no one.........

Reds, Oranges, Greens, Browns, Lemons - we've got 'em!!

Besides Mod Designs, little (table saver) Felt Feet, our new BIG PLUS is
THE "PICTURE BOX"

Please may we give you further particulars? No Charge Samples?

With regards,
THE AMERICAN BISQUE COMPANY

WJS:mu William J. Schneider

P.S. "A" "B" "C" Tops in Ash Trays, Serving Dishes, Susans, etc.

here's what's missing!

AMERICAN BISQUE COMPANY

Here's what's missing—The American Bisque Co. Put us in our proper place and it's go all the way.

You have top grade suppliers—first-rate companies—old-line outfits, etc., and it's right to build with this type people. How can you go on without us in the picture?

To have the complete picture you would need to know and see what we are boasting about

All American Ash Trays, Mod Colors, Felt Tips

Don't be puzzled. Put us in our proper place and complete the picture.

With regards,
AMERICAN BISQUE COMPANY

WJS:ps William J. Schneider

P.S. Samples?



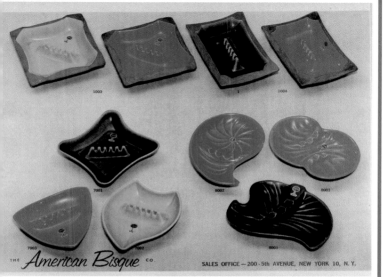

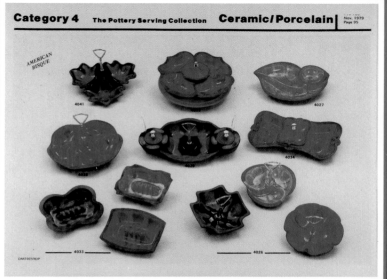

There are many reputable dealers to be found coast to coast. The following is a listing of those known personally to us.

Loretta Anderson
Pastimes
1208 Lakeshore
Rockwall, TX 75087

Betty Carson
Betty's Collectibles
4896 Westchester #1
Austintown, OH 44515

Mark and Trina Cloud
Cloud's Antique Mall
Rt. 269
Castalia, OH 44824

Wendy Ramsay Johnston
Jukebox Classics
6742 Fifth Avenue
Brooklyn, NY 11220

C. Keith & Judy Lytle
Cookie Jar Antiques
99 Greensboro Way
Antioch, CA 94509

Carol Silagyi
C.S. Antiques and Jewelry
P.O. Box 151
Wyckoff, NJ 07481

Charles Snyder
Charlie's Collectibles
R.R. 4, Box 79
Independence, KS 67301

Robin Stine
Classic Cookie Jars
1724 Watkins
Toledo, OH 43616

Denise Teeters
The Cookie Jar Addict
4313 Eddie Ave., S.W.
Canton, OH 44706

Glossary of Terms

Age Line:See Hairline.

Bisque firing:The first firing of greenware. Pottery fired once is known as bisque ware.

Blister:A glaze bubble that pops during firing causing a small shallow cavity.

Chip:A piece broken out of the pottery.

Cold Paint: Paint that is applied after the final glaze firing. Generally washes off or wears away with time.

Crack:A split or break in the pottery.

Crazing:A fine network of spider web or checker-board lines in the glaze. Generally caused by age and/or temperature extremes.

Factory Flaw:Any imperfection caused during manufacture.

Flake:A flat thin surface layer chip, this term can also apply to paint.

Glaze:The outer glossy or matte glass covering of pottery, generally the last process applied to a piece unless gold or decals are applied.

Glaze Miss:An area where the glaze did not adhere.

Greenware:Unfired pottery.

Hairline:A very slender line in the pottery, often seen on only one side.

Jiggering: A type of potters wheel used for produc-tion of fairly flat pieces. Clay is placed on a template representing the top surface of the piece then spun down. Then a template representing the bottom surface is placed against the clay to finish shaping.

Kiln Crack:Stress applied to wet greenware that causes a split or crack during firing. Also called Stress crack or Factory Flaw.

Mint:A piece as perfect today as the day it was manufactured.

Nick:Very small shallow notch.

Pitting:Pinholes in glaze surface, often caused by dust present on the glaze before firing.

Ram Press: The pressing of clay into a form, rather than pouring liquid slip.

Repair:A broken piece which has been put back together.

Restoration:A broken, chipped or cracked piece which has been restored to it's original condition by a professional.

Slip:Clay in liquid form used in the production of greenware.

Stain:Discoloration of pottery, often associated with heavy crazing.

Underglaze:Colors and designs applied to pottery, usually at the bisque stage before glaze is ap-plied. Can be applied by hand or with an air-brush.

Patents

DESIGN FOR A TOY BANK OR SIMILAR
ARTICLE
Joseph Burgess Lenhart, Marietta, Ohio
Application February 11, 1943, Serial No. 117,935
Term of patent 14 years
(Cl. D51—11)

The ornamental design for a toy bank or similar article, substantially as shown.

138,536 8/15/44
DESIGN FOR A COOKY JAR
Walter M. Chace, Pekin, Ill., assignor to Ludowici
Celadon Company, Chicago, Ill., a corporation
Application November 8, 1943, Serial No. 111,629
Term of patent 7 years
(Cl. D58—25)

The ornamental design for a cooky jar, substantially as shown.

138,537 8/15/44
DESIGN FOR A COOKY JAR
Walter M. Chace, Pekin, Ill., assignor to Ludowici
Celadon Company, Chicago, Ill., a corporation
Application November 8, 1943, Serial No. 111,630
Term of patent 7 years
(Cl. D58—25)

The ornamental design for a cooky jar, substantially as shown

137,120 1/15/44
DESIGN FOR A COOKIE JAR OR SIMILAR
ARTICLE
Joseph Burgess Lenhart, Marietta, Ohio, assignor
to American Pottery Company, Inc., Marietta,
Ohio
Application November 13, 1943, Serial No. 111,68
Term of patent 3½ years

The ornamental design for a cookie jar or sim

137,119 1/15/44
DESIGN FOR A COOKIE JAR OR SIMILAR
ARTICLE
Joseph Burgess Lenhart, Marietta, Ohio, assignor
to American Pottery Company, Inc., Marietta,
Ohio
Application November 13, 1943, Serial No. 111,68
Term of patent 3½ years

The ornamental design for a cookie jar or sim
ilar article, substantially as shown and described

139,018
DESIGN FOR A COOKY JAR OR SIMILAR
ARTICLE
Joseph Burgess Lenhart, Marietta, Ohio
Application June 19, 1944, Serial No. 114,088
Term of patent 14 years
(Cl. D58—25)

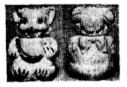

The ornamental design for a cooky jar or similar article, substantially as shown.

139,020
DESIGN FOR A COOKY JAR OR SIMILAR ARTICLE
Joseph Burgess Lenhart, Marietta, Ohio
Application June 19, 1944, Serial No. 114,090
Term of patent 14 years
(Cl. D58—25)

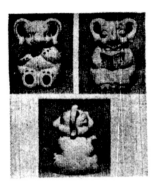

The ornamental design for a cooky jar or similar article, substantially as shown, and described.

138,998
DESIGN FOR A COOKY JAR OR SIMILAR ARTICLE
Joseph Burgess Lenhart, Marietta, Ohio
Application July 28, 1944, Serial No. 114,600
Term of patent 14 years
(Cl. D58—25)

The ornamental design for a cooky jar or simi-

141,455
DESIGN FOR A SALT SHAKER OR THE LIKE
Louise E. Bauer, Zanesville, Ohio, assignor to Butler Brothers, Chicago, Ill., a corporation of Illinois
Application January 17, 1945, Serial No. 117,467
Term of patent 7 years
(Cl. D44—22)

The ornamental design for a salt shaker or the

139,019
DESIGN FOR A COOKY JAR OR SIMILAR ARTICLE
Joseph Burgess Lenhart, Marietta, Ohio
Application June 19, 1944, Serial No. 114,089
Term of patent 14 years
(Cl. D58—25)

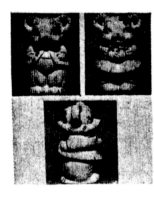

The ornamental design for a cooky jar or similar article, substantially as shown, and described.

139,103
DESIGN FOR A COOKY JAR OR SIMILAR ARTICLE
Joseph Burgess Lenhart, Marietta, Ohio
Application July 28, 1944, Serial No. 114,599
Term of patent 14 years
(Cl. D58—25)

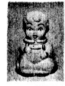

The ornamental design for a cooky jar or similar article, substantially as shown.

138,832
DESIGN FOR A COOKIE JAR OR SIMILAR ARTICLE
Frances Poe, Wilmette, Ill.
Application July 20, 1944, Serial No. 114,482
Term of patent 7 years
(Cl. D58—25)

The ornamental design for a cookie jar or similar article, substantially as shown.

138,998
DESIGN FOR A COOKY JAR OR SIMILAR ARTICLE
Joseph Burgess Lenhart, Marietta, Ohio
Application July 28, 1944, Serial No. 114,600
Term of patent 14 years
(Cl. D58—25)

The ornamental design for a cooky jar or similar article, substantially as shown.

141,200
DESIGN FOR A FLOWER HOLDER OR
THE LIKE
Louise E. Bauer, Zanesville, Ohio, assignor to
Butler Brothers, Chicago, Ill., a corporation of
Illinois
Application January 17, 1945, Serial No. 117,468
Term of patent 7 years
(Cl. D29—28)

The ornamental design for a flower holder or
the like, substantially as shown.

141,201
DESIGN FOR A CREAMER
Louise E. Bauer, Zanesville, Ohio, assignor to
Butler Brothers, Chicago, Ill., a corporation of
Illinois
Application January 17, 1945, Serial No. 117,169
Term of patent 7 years
(Cl. D14—21)

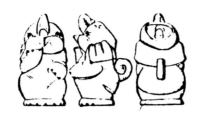

The ornamental design for a creamer, substan-
tially as shown.

141,289
DESIGN FOR A TOY BANK OR SIMILAR
ARTICLE
Joseph Burgess Lenhart, Marietta, Ohio
Application February 14, 1945, Serial No. 117,934
Term of patent 14 years
(Cl. D34—11)

The ornamental design for a toy bank or simi-
lar article, substantially as shown.

Bibliography

Guarnaccia, Helen, Salt & Pepper Shakers, Collector
 Books, Paducah, Kentucky, 1985.
Huxford, Sharon and Bob, Collector's Encyclopedia
 of McCoy Pottery, Collector Books, Paducah,
 Kentucky, 1976.
Lehner, Lois, A Cookie Jar Update, The Antique
 Trader, DuBuque, Iowa, February, 1984.
_____, Lehner's Encyclopedia of U.S. Marks
 on Pottery, Porcelain & Clay, Collector Books,
 Paducah, Kentucky, 1988.
Roberts, Brenda, Collectors Encyclopedia of Hull
 Pottery, Collector Books, Paducah, Kentucky,
 1989.

Roerig, Fred and Joyce Herndon, The Collector's
 Encyclopedia of Cookie Jars, Collector Books,
 Paducah, Kentucky, 1991.
Schneider, Mike, The Complete Cookie Jar Book,
 Schiffer Publishing Ltd., Atglen, Pennsylvania,
 1991.
_____, The Complete Salt and Pepper Shaker
 Book, Schiffer Publishing Ltd., Atglen, Pennsyl-
 vania, 1993.
Williamstown Historical Committee, Fruitful Valley,
 A Chronicle of Williamstown, West Virginia,
 Printed by Richardson Printing Corporation,
 Marietta, Ohio, 1976.

Index

Price Guide

We have a great dislike for price guides, this one included. Mainly because we have never found one that we felt was completely accurate or current enough to reflect ever changing market values. There are a number of books that devote themselves entirely to pricing, then you have a number of books that are item specific, such as cookie jar books or salt and pepper books which also contain price guides. None of them ever match! This one won't either.

Prices included here are for pieces in perfect condition. We have polled many dealers from coast-to-coast for input. The prices have been averaged here, as differences do occur regionally. They are "ballpark" at best and should be used with that thought in mind.

As well seasoned dealers we can tell you that people walk into booths at antique shows and malls with a books in hand proclaiming, "It's over book price." We generally just produce an alternate book with different pricing and say, "What book are you using?" As redundant as it sounds, we'll say it again - this price guide is not intended to set prices.

Obviously we hope this will be the very best book ever on the subject. It has been done with care and enthusiasm but being realists we know it is neither the "be all" or "end all" on the subject and as time passes the prices listed here will no longer be relevant. Shop smart!

The price of any collectible is really determined by the amount of money you have available and how badly you feel you need to own the piece, i.e., people have been known to pay ridiculous prices just because they wanted the article that badly. Purchases made under these circumstances should in no way determine or set future prices.

N/P = Not Priced. Too few in circulation to gauge price.

Page 14	Yarn Doll/block	$18-20		Puppy (24 k gold)	$36-38		Bird w/blossom	$28-30
Page 15	Yarn Doll/house	$18-20		Poodle	$18-20	Page 32	Lovebirds	$12-14
	Elf w/mushroom	$25-30	Page 25	Bear w/ragdoll	$22-24		Parrot	$12-14
	Winter couple	$25-30		Bear w/beehive	$16-18		Bird on Blossom	$12-14
Page 16	Elf figurine	$5-6		Bear w/ragdoll Gold	$34-36	Page 33	Birds in flight	$12-14
	Reclining elf	$$8-10		Bear w/beehive Gold	$26-28		Parrot	$12-14
	Gypsy w/cart	$10-12	Page 26	Bear at stump	$10-12		Bird of Paradise	$18-20
Page 17	Fish,top left	$10-12		Black bear cubs	$10-12	Page 34	Bird of Paradise	$18-20
	Fish,top right	$15-18		Bear in log	$10-12		Rooster	$16-18
	Fish, bottom left	$8-10		Brown bear cubs	$10-12		Birdhouse Wallpocket	$30-32
	Happy Fish	$20-25		Bear on log	$12-14		Rooster w/corn cob	$8-10
Page 18	Fish	$15-18		Bear cubs w/gold	$20-22		Hen w/chicks	$18-20
	Sailfish	$45-50	Page 27	Reclining deer	$12-14	Page 35	Chick	$24-26
	Happy Rabbit	$18-20		Gazelle	$20-22		Mallard Duck	$24-26
	Rabbit in log	$22-24		Deer	$10-12		Duck in flight	$12-14
Page 19	Circus Horse	$30-32		Gazelle w/flower	$24-26		Duck w/flower hat	$8-10
	Mare & Foal	$30-32	Page 28	Panther w/flower	$24-26		Duck Face	$8-10
	Bashful Donkey	$8-10		Little Elephant	$10-12		Duck, bottom right	$6-8
	Horse, APCO	$8-10		Panther	$22-24	Page 36	Duck w/flower hat	$6-8
	Reclining Horse	$10-12		Elephant in basket	$8-10		Swan	$6-8
	Whimsical Donkey	$10-12	Page 29	Circus Elephants	$12-14		Modern Goose	$6-8
Page 20	Donkey w/cart	$10-12		Farmer pig w/corn	$6-8		Graceful swan	$22-24
	Kitten w/fishbowl	$20-22		Sleeping pig	$16-18		Swan, bottom left	$8-10
	Sleeping kitten	$6-8		Three Little Pigs	$22-24	Page 37	Swan, top left	$6-8
Page 21	Sleeping kitten	$6-8		Piggy w/basket	$12-14		Swan, large	$26-28
	Wailing kitten	$20-22	Page 30	Sleeping Lamb	$16-18		Stork w/bassinet	$8-10
	Kitten and shoe	$14-16		Lamb w/cart	$8-10		Stork w/cradle	$8-10
Page 22	Kitten w/ball	$12-14		Lamb (large)	$32-36	Page 38	Davy Crockett, top left	
	"Figaro", airbrushed	$45-50		Little Lamb	$8-10			$48-50
	"Figaro" w/yarn	$45-50		Lamb w/watering can	$10-12		Davy Crockett, bottom	
Page 23	Dog & Cat at stump	$16-18	Page 31	Lamb w/sack	$12-14			$48-50
	Spaniel	$22-24		Parakeet	$12-14	Page 39	Pouch	$55-60
	Dalmatians	$30-32		Reclining Lamb	$18-20		Canoe	$55-60
Page 24	Puppy w/slipper	$16-18		Cockateil	$12-14		Powder horn	$55-60

	Moccasins	$55-60
Page 40	Dutch Girl	$6-8
	Dutch Boy	$6-8
	Southern Belle	$24-26
Page 41	Southern Belle, double	
		$34-38
	Lady head, cold paint	$20-22
	Lady head, solid gold	$46-48
	Lady head, gold detail	$32-34
Page 42	Hand vase	$24-26
	Cradle	$6-8
	Lone pine tree	$6-8
	Baby shoe	$8-10
	Flower pot	$3-5
	Cabbage	$4-6
Page 43	Golf bag	$12-14
	Mushrooms	$12-14
	Tree trunk	$32-34
	Log planters	$24-26 ea.
Page 44	Paddle boat	$22-24
	Rose motif	$20-22
	Steam fire engine	$20-22
	Rose wallpocket w/gold	
		$22-24
Page 45	Gardenia motif w/gold	
		$18-20
	Gardenia motif	$14-16
	Rose motif	$14-16
Page 46	Cornucopia	$12-14
	Calla lily w/gold	$20-22
	Cornucopia, large	$14-16
	Philodendron w/gold	$26-28
	Cornucopia w/gold	$22-24
Page 47	Heart & flowers wallpocket	
		$24-26
	Heart & flowers vase	$24-26
	Double cornucopia	$34-36
Page 50	Rainy day pig	$70-75
	Diaper pin pig	$150-175
	Bedtime pig	$38-40
Page 51	Mr. Pig	$28-30
	Floyd	$N/P
	Betty	$N/P
	Bow pig	$28-30
Page 52	Dimples	$30-32
	Little girl pig	$24-26
	Pig w/detachable lid	$100-125
	Fatsy	$75-80
Page 53	Attitude Papa	$70-75
	Attitude Mama	$85-90
	Attitude Baby	$60-65
Page 54	Pig, indented dots, lg.	$85-95
	Pig, indented dots, sm.	$30-35
	Pig, clover bloom	$110-120
	Pig, dancing, indented dots	
		$30-35
Page 55	Humpty Dumpty	$110-120
	Smokey the Bear, tall	$95-105
	Smokey the Bear, short	
		$80-85
Page 56	Popeye	$425-450
	Sweet Pea	$825-850
Page 57	Casper	$450-475
	Little Audrey	$750-775
Page 58	Dino	$500-525
	Fred & Wilma	$400-425
	Rag Dolls	$18-20
Page 59	Fluffy Cat w/gold	$40-45

	Girl/Boy turnabout	$165-175
	"Figaro"	$70-75
Page 60	Snowman	$30-32
	Polar Bear	$24-26
	Polar Bear w/gold	$36-38
Page 61	Sitting Teddy	$25-30
	Chick	$35-40
	Elephant	$40-45
	Chicken Feed	$20-25
Page 62	Ho-Ho	$N/P
Page 63	Blackboard clown	$275-300
	Blackboard bum	$275-300
Page 64	Blackboard saddle	$225-250
	Blackboard girl	$325-350
	Blackboard boy	$325-350
Page 65	Picnic basket	$300-325
	Chef head	$400-425
Page 66	T.V. Bedtime	$265-285
Page 67	Cheerleaders	$300-325
	Bear and beehive	$350-375
	Rabbit and log	$500-525
Page 68	Clown	$265-285
	Cow & moon	$750-775
Page 69	Girl head	$100-125
	Graduate	$100-125
	Sad clown	$100-125
	Chef head	$100-125
Page 70	Pig head	$75-95
	Castle	$150-175
	Garage	$75-85
	School bus	$325-350
Page 71	Safe	$100-110
	Sack of cookies	$50-60
	Telephone	$65-75
	Soldier	$175-195
Page 72	Train w/gold	$85-95
	Milkwagon, yellow	$95-115
	Milkwagon, standard colors	
		$75-85
	Train, airbrushed	$70-80
Page 73	Train, smily face	$125-135
	Tall bus	$200-225
	Tall train	$175-200
	Tall truck, 13"	$100
	Tall truck, 11 1/2"	$75
Page 74	Spaceship w/man	$750-775
	Moon rocket	$250-275
	Stern wheeler	$200-225
Page 75	Recipe jar	$90-100
	Square w/star	$35-40
	Blue birds	$45-50
Page 76	Snacks kettle	$50-55
	Colonial people	$50-55
	Pedestal	$30-35
	Cookie Barrel	$25-30
Page 77	Colonial people w/gold	
		$95-115
	School house	$65-70
	Bell	$45-50
	Carousel	$65-70
Page 78	Dutch shoe	$N/P
	Sea Bag	$150-175
	Treasure chest, small	$125-150
	Treasure chest, large	$175-200
	Ice Cream freezer	$225-250
Page 79	Spool of thread	$125-135
	Seal on Igloo	$250-275
	Animal cookies	$30-35

	Liberty bell	$90-110
Page 80	Oaken bucket	$100-125
	Saddle, no blackboard	$250-275
	Boots	$175-200
	Churn	$25-30
Page 81	Cup of Chocolate	$65-85
	Clock	$125-150
	Gift Box	$100-125
	Beehive, plain	$45-50
Page 82	Coach lantern	$125-150
	Cylinder w/rings	$25-30
	Basket of cookies	$100-125
	Sad Iron	$125-135
Page 83	Acorn & Oak leaf	$175-200
	Cylinder w/blue flower	
		$60-70
	Cylinder w/daisies	$35-40
Page 84	Coffee pot w/red flower	
		$40-45
	Coffee pot w/gold	$85-95
	Coffee pot w/cookies	$45-50
	Coffee pot w/pinecone	$45-50
Page 85	Feed sack	$95-105
	Modified cylinder w/gold	
		$75-85
	Sears strawberry	$30-35
Page 86	Girl, "Cookie"	$85-95
	Sentry	$125-135
	Cat w/tail finial	$125-145
	Poodle	$125-145
Page 87	Deer	$125-145
	"Candy Baby"	$125-145
	Clown	$450-475
Page 88	Cat	$110-120
	Elephant	$150-160
Page 89	Elephant	$125-145
	Pig	$110-120
	Lamb	$150-160
Page 90	Turnabout	$175-195
Page 91	Pig turnabout	$175-195
	Pig, indented dots	$100-125
	Pig, shamrocks	$125-150
Page 92	Pig, small	$100-125
	Lady pig	$85-95
	Pig w/gold	$175-200
	Boy pig	$85-95
Page 93	Boy pig w/overalls	$85-95
	Pig in poke	$75-85
	Farmer pig	$125-145
	S.S. Kookie	$150-175
Page 94	Elephant w/bonnet	$135-150
	Elephant w/sailor hat	$95-115
	Elephant w/baseball cap	
		$125-150
	Chick w/indented dots	$65-75
Page 95	Chick w/airbrushed vest	
		$65-75
	Girl lamb	$75-95
	Boy lamb	$125-150
Page 96	Sitting horse	$900-950
	Bear on beehive	$40-45
	Magic bunny	$85-95
	Bear w/visor cap	$75-85
Page 97	Bear w/cookie	$55-65
	Kittens on yarn	$55-65
	Kittens on yarn, "Figaro"	
		$125-150
	Kitten on quilted base	$100-125